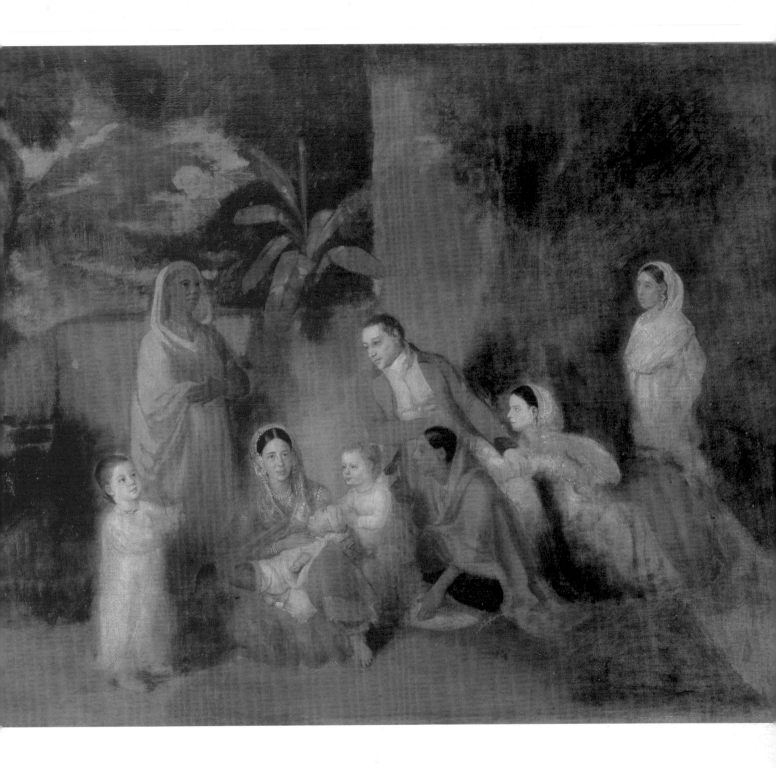

Previous page: Major William Palmer with his second wife, the Mughal princess Bibi Faiz Bakhsh and their children. A descendant opened Veeraswamy's Indian restaurant in London. (1785)

A N

y

Please return/renew this item
by the last date shown.
Books may also be renewed by
phone or the Internet.

www.bury.gov.uk/libraries

The Westbourne Press

In partnership
with

in association with
gettyimages®

Published 2013 by The Westbourne Press

1

ISBN: 978-1-908906-11-3

Printed in China by IP Media (Xiamen) Co., Ltd

The Westbourne Press

www.westbournepress.co.uk

in association with

www.gettyimages.com

In partnership with BRITISH LIBRARY

To Rozina Visram,
pioneering historian of Asian Britain

Preface

by Razia Iqbal

The success of Asians in British society over the past few decades, in fields as diverse as arts, media, politics, science and sport, is a function of both talent and hard work. Yet this success has emerged in a climate that has often been hostile, and despite the slow development of acceptance and tolerance. Moreover, this current visibility belies the sustained presence and achievements of Asians over the course of four centuries of settlement in Britain.

It is for these reasons that the current volume – a striking and often moving visual document of the journey and participation of Asians in British life – is vital as a resource and as a provocation.

The history of Asian Britain is still largely hidden. It is one I wish I had been aware of when I arrived in the UK in 1970, aged nearly eight. Growing up in an England that expected me to embrace it wholeheartedly – but didn't exactly do the same to me – I understand now that knowledge of past histories, and of the stories it told, would have offered me a prism of confidence through which I could have understood my own changing story.

My family came to London from Nairobi in 1970. We had some relatives here already, but the shock of the new still feels tangible in my memory, and the sometimes painful hostility with which I was confronted has never left me: the kids at school who wanted to give me an English name, 'Debbie', because they found mine hard to pronounce; the laughter at my fluent English, spoken with an accent; the

boy who told me I would be quite nice-looking if I had blonde hair and white skin. There was, too, the silent, unspoken knowledge that my parents must also have endured racism, hostility and a general sense of unease in the workplace.

The photograph of a family enjoying the sights in Blackpool, although more recently dated, took me right back to my own family driving up from London in the early 1970s and eating our Indian picnic food on the beach.

The advent of saris and samosas at school, as a way of creating an understanding of one aspect of Asian-ness, is single stratum in the story of the Asian experience.

My family's engagement with the majority culture, not to mention my own, was part of a continuum of connections. It is the tapping of this other, deeper layer of sediment that feels important. It is a history craved by those who are always on the margins, and one that those at the centre take for granted. This fact might still be difficult for mainstream society to acknowledge. Yet it would have given many little girls and boys, both beguiled and bewildered by their presence here, something that, even in the face of intermittent hostility, could have acted as a salve: knowledge and perspective.

No single book of photographs or otherwise could possibly claim to present a complete, documented record of the long and diverse settlement of Asians in Britain. However, whether it's the complex relationship between, say, Queen Victoria and her munshi Abdul Karim, or the thousands of lascar seamen who worked for the East India Company and were among the earliest of settlers, the intimacy of the connections between those who journeyed here from South Asia and those who were their masters underlines the richness in the weft and warp of this nation's history.

The long history of British Asians is full of fascinating personal stories, which these photographs nudge us to consider and reconsider. I am particularly compelled by the story of the Indian ayahs who, no

doubt, took loving care of their British charges. The photographs of the ayah of the Lawrence family provoke the imagination: she served the family from 1910, in India, until her death in Britain in 1955.

The large-scale presence of immigrant communities presents a challenge to all sides, and demands an acknowledgement of respect and exchange. It also forces a rethinking of what constitutes a nation's identity, which, surely, cannot be fully fashioned at any given time; it is continuously affected by history and culture, an ongoing production.

British identity is constantly mutating, perhaps because it has been so contested. Multiculturalism has had its ups and downs, and is currently experiencing a very bad press. There is an increasingly sceptical view of the consequences of what's been described as 'state multiculturalism', which is remembered as a project that emphasised difference and separatism and has therefore resulted in communities cutting themselves off from mainstream society. Geopolitics has become the focus, and religion has shown its capacity for attracting and holding communities together outside the mainstream; but this phenomenon is relatively new. At its best, multiculturalism is really about the ongoing creation of a national identity that has the confidence to incorporate a mixed population.

Fear of Islam's radical element, in particular, has prompted political debate notable for its heat if not its light. It is impossible to legislate for cohesion, yet narratives purporting to protect 'our way of life' abound; efforts to articulate such a national identity do not reflect the reality of cultures coalescing every day, especially in urban centres where the degree of mixing, tolerance and acceptance belies what the demagogues say and do. Yet politicians seem more interested in manufacturing nostalgia to feed a strong collective identity and shared values. It can be argued that it is often white reticence, not minority separatism, that is an obstacle to inclusive national identity; without overcoming this problem, confident multicultural nation-building is difficult. The small as well as the big stories in these

photographs well depict the half-hearted embrace I experienced as a child growing up here.

History can offer something akin to a collective view of a national narrative, and these photographs contribute to that project. For instance, when we next commemorate the anniversaries of World War One (as we do every year), what could be more reflective of shared values and strong collective identity than remembering – amidst the larger narrative – the 1.4 million troops from the subcontinent, the largest force outside Britain, who participated in all theatres of the war? There are photographs in this book that illustrate how war was a leveller, but which also expose sharp racial divisions and fears of miscegenation.

The complexities of the marginal position at the centre are in each and every story, and of course there are many examples of social and economic activity that defy being bound by, or solely seen through, a frame of reference consisting of the struggles experienced by black and Asian communities. The stories of economic and business success, of cultural infiltration and Asian cool, and of chicken tikka masala becoming the nation's favourite dish in supermarket ready-meals are some of the obvious ones.

The cover of this book depicts two men and a child of Asian origin standing outside Westminster Hall in 1952, paying their last respects to King George VI alongside white Britons. They represent a fully functioning part of a grieving nation, and indicate the possibility of future peaceful coexistence. In a moment of national sadness, it is a signal of hope. While there were many tribulations after this image was taken, it captures a reality that is at once poignant and provocative. It is an individual story, as are many in this book; but the individual is always living and experiencing some larger narrative, whether he or she likes it or not.

Introduction

Asians have been living in Britain for over 400 years yet surprisingly little is known about the long history of their settlement. This fascinating visual archive opens up the complex formation of Asian Britain, documenting a vital legacy which continues to inform today's culturally diverse present. Coinciding with the advent of photography, this record largely begins to emerge during the well-known era of the British Raj after Queen Victoria officially assumed the direct government of India in 1858. Even though it is a narrative that has been less exposed, this same period witnessed the gradual growth of an 'empire within' characterised by an increasingly substantial Asian presence in Britain. The continuities of this diverse history remain integral to the nation today.

Stretching across several decades of Empire to today's period of postcolonial settlement, the images collected here provide insights into the activities of a wide spectrum of different groups and individuals as they sought strategies to survive and negotiate their commonplace encounters with unequal social and racial hierarchies. At the same time, they highlight the wide range of key political, cultural and economic movements with which Asians engaged on British soil, the global and domestic networks they forged as well as the enduring significance of their contributions and influences.

Offering a wider-angled lens on the often indistinct outlines of a frequently eclipsed history, this visual record seeks first and foremost to provoke questions and stimulate dialogue. It also aims to invite

reconsideration of the still prevalent and popular misconception that Britain's present-day Asian communities only 'arrived' due to labour shortages after World War Two, the oft-cited but oversimplified narrative of economic 'push and pull' factors said to determine migration patterns following Indian Independence and Partition. As will become clear, the making of Asian Britain has been the culmination of a far more complicated series of interconnections.

Although variously 'named' or categorised over time, the focus here is specifically on those peoples of South Asian heritage linked to Britain through Empire and subsequent patterns of post-World War Two settlement. In other words, the histories represented include those of India (pre- and post-Independence) and the new nations of Pakistan, Bangladesh, Nepal, Sri Lanka and their diasporas. Such a designation can only go some way towards embracing what is a range of far more complicated geographies, whose cultural, religious, regional and linguistic backgrounds are significantly different. Pointing to shared contexts as well as recurrent questions of national identity and belonging, the title of this book is not intended to limit scope or be prescriptive of what are obviously multifaceted and complex identities. Rather, it suggests a broad continuum which is open to multiple and still changing interpretations. Such continuities are not only apparent in the tightly interwoven political and economic histories of Britain and the subcontinent, but also manifest themselves in the personal stories of family settlement which cross and link several generations.

In fact, clear markers of this shared history are not just embedded in the genetic body of the contemporary nation; they have, over time, been woven into the hybrid lexicon of English itself. Hundreds of words like 'bungalow', 'verandah' , 'shampoo' or 'pyjamas' have Indian origins and stem from cross-cultural connections which continue to travel in both directions. Similar traces are manifest elsewhere – in architecture and the style of national monuments, street names, textile designs or culinary tastes. Notably, these various influences

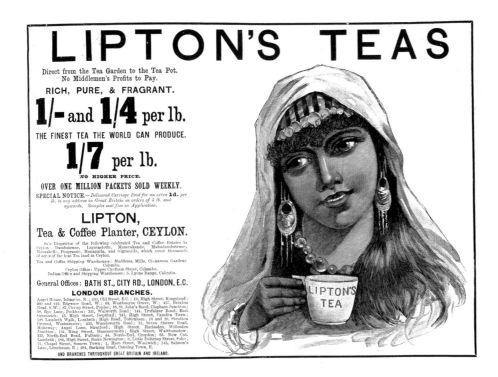

Advertisement for the tea company Lipton, which had branches across Britain. (1892)

have transformed what are now commonly seen to be quintessentially British cultural practices, whether sitting down for a 'cuppa' or going out for 'an Indian'.

The images this book presents can only touch the edges of a much bigger story. Reliant as it is on a series of revealing but scattered photographic records, it offers a partial window on a history that still remains incomplete. A small population had already arrived as early as the formation of the East India Company in 1600, which began to introduce tea, spices, silk and other luxury goods into many British homes. Some of the earliest known settlers in Britain were the lascar seamen, sailors who provided the labour force for this early trade and, later, stoked the engine of Empire on British steamships. There was also a fashion for Indian servants among returning English nabobs, traders who had made their fortunes in India. These usually docile-looking figures occasionally appear in eighteenth-century paintings as the 'exotic' and frequently commodified status symbols of their masters' continuing affluence and power. Then there were the ayahs, whose lives were intimately involved with those of their young charges,

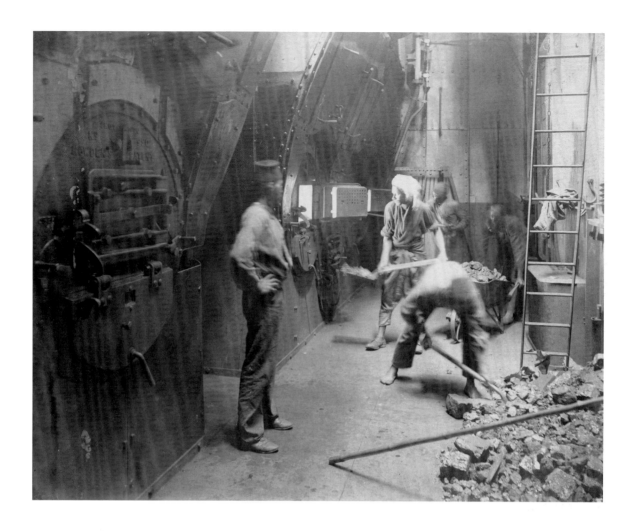

Lascar stokers in the hold of a P&O steamer. The opening of the Suez Canal (1869) increased employment of Indian seamen. (1900)

while working as nannies for English families on the long sea voyage home. Some of these women were left to fend for themselves soon after arrival and began to live in working-class areas such as the East End of London. In the case of the lascars, some were transients but others chose to jump ship, due to relentlessly harsh and exploitative labour conditions, staying on and seeking alternative means of survival. Although often depicted as 'aliens' or 'strangers' from the East, some overcame this hostility and even intermarried with local women. While such liaisons were frowned upon due to racist fears of miscegenation, mixed-race families became increasingly familiar during the nineteenth and early twentieth centuries in many port cities such as London, Liverpool, Cardiff and Glasgow. Few surviving records provide detailed information on the day-to-day lives of

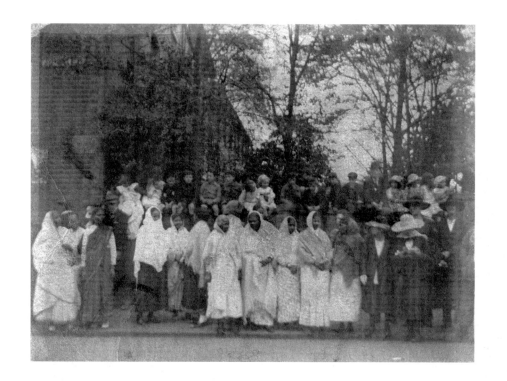

A group of nannies outside the Ayahs' Home, 26 King Edward Road, Hackney. Originally at 6 Jewry Street, Aldgate, it moved to larger premises in 1921. (1910)

this embryonic working-class community or their descendants. Technically British citizens, they were not treated as such, beginning a pattern of discrimination that was to continue into the present day. It is easier, of course, to trace connections back to the ancestors of figures at the other end of the social spectrum, such as the family of Major William Palmer (1740–1816), secretary to Warren Hastings, first Governor General of India, who brought his Indian wife, Begum Faiz Buz, and their six children back to live in Britain. An early twentieth-century descendant, Edward Palmer, opened Veeraswamy's in 1926, one of the first Indian restaurants in London.

Unlike the majority of early settlers who came from relatively humble origins, Sake Dean Mohamed, an early nineteenth-century resident, also achieved significant visibility in British society. Born in Bihar in 1759, he worked his way up in the East India regiment before moving to Cork, Ireland, in 1793, where he published the first known Indian travel narrative in English. A shrewd entrepreneur, he migrated to London in 1808 with his wife, Jane, and their children, opening

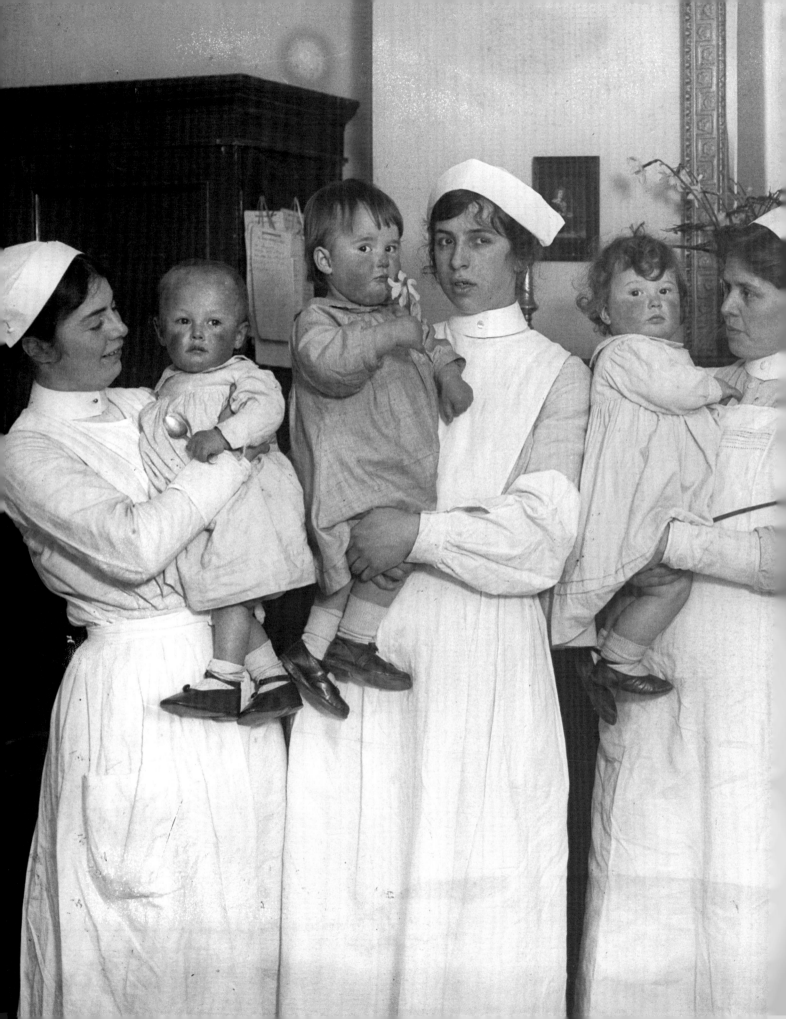

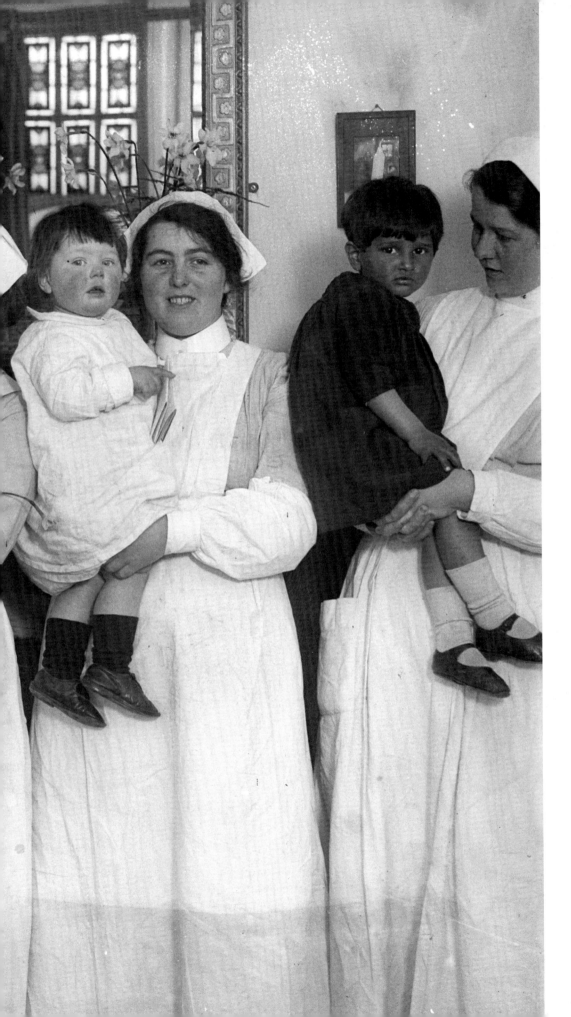

Babies of different nationalities at St Mary's Nursery College, Hampstead. The children are Japanese, Scottish, Belgian, English and Indian. (1916)

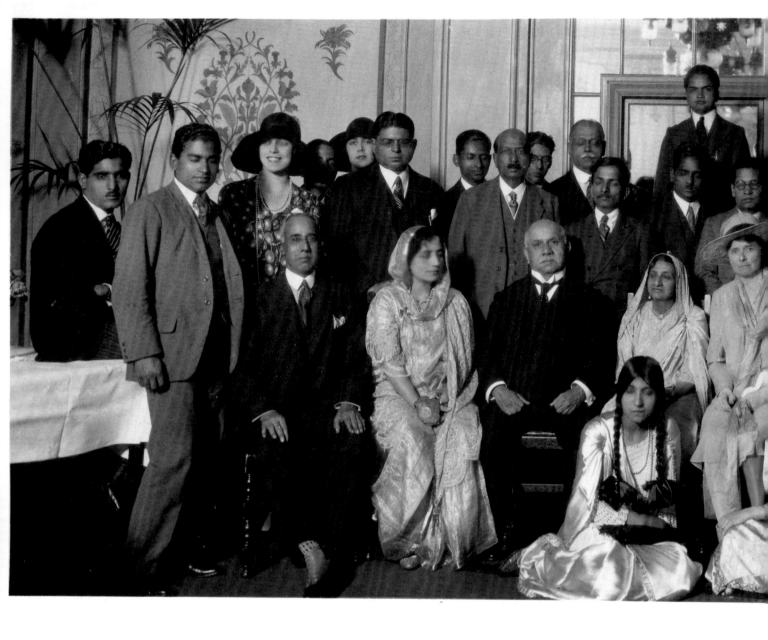

the first Indian coffee house in London's Portman Square. When this business began to fail, he reinvented himself as an Indian doctor and moved to Brighton, opening his Vapour Baths in 1821 and touting his medical specialism in Indian steam and massage cures. After becoming the much sought-after 'shampooing surgeon' of George IV, these baths – perhaps the first example of what is today a popular spa culture in Britain – increasingly drew in the higher echelons of society. Self-consciously exploiting the duality of his position and playing on his Eastern mystique, Sake Dean used his 'Hindu' or 'Mohamedan' cures (as they were called) to feed the orientalist fantasies of his clients,

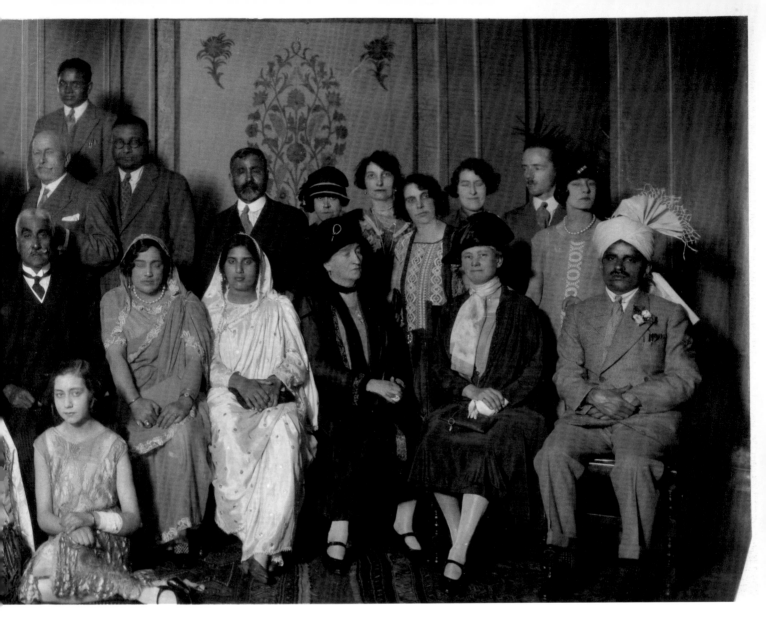

though he had in fact converted to Christianity many years earlier. At the same time, putting on a different face, he participated as stalwart Georgian citizen in a number of benevolent charitable roles. One of his sons continued his Brighton trade – although he was not seen as being 'Indian' enough due to his mixed race – while another set up oriental baths in London. A grandson, Frederick Akbar Mohamed, was notable for being the first doctor to identify the bases underlying the development of high blood pressure; sadly, perhaps due to his ethnic origins and an early death, he was not given full acknowledgment for the significance of his medical insights at the time.

Veeraswamy's restaurant in Regent Street, London, catered for high society and Indian royalty. Here Punjabi students meet Lady Hailey at an 'At Home' event. (1928)

Sake Dean Mahomed in oriental dress, playing on his identity for his business ventures. (1825)

Facing page:
Above left: Sake Dean Mahomed opened his Vapour Baths in Brighton in 1821. (1826)

Above right: Frederick Akbar Mahomed was assistant physician at Guy's Hospital, London, and made pioneering discoveries in high blood pressure. (1880s)

Below: Mahomed's Vapour Baths were popular with Georgian high society. (1826)

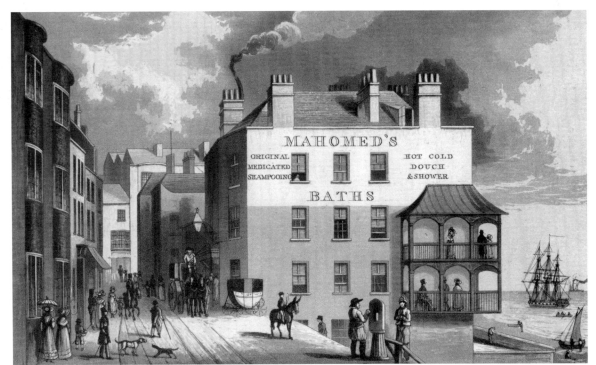

Indian officers riding in a procession
to celebrate Queen Victoria's Diamond
Jubilee. (1897)

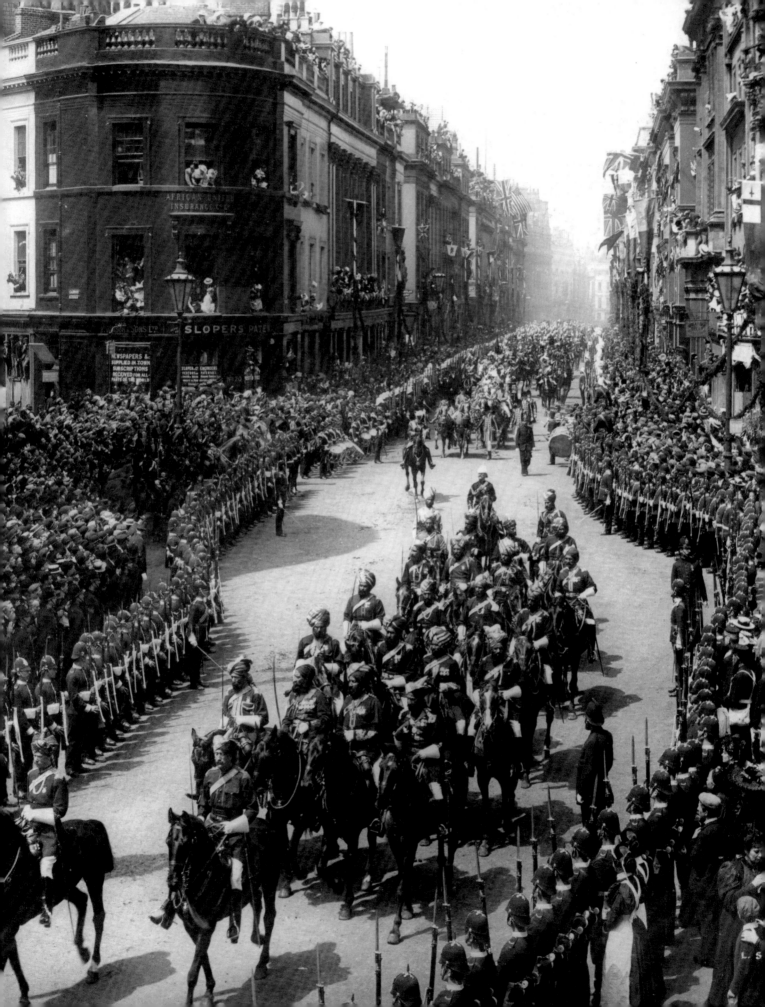

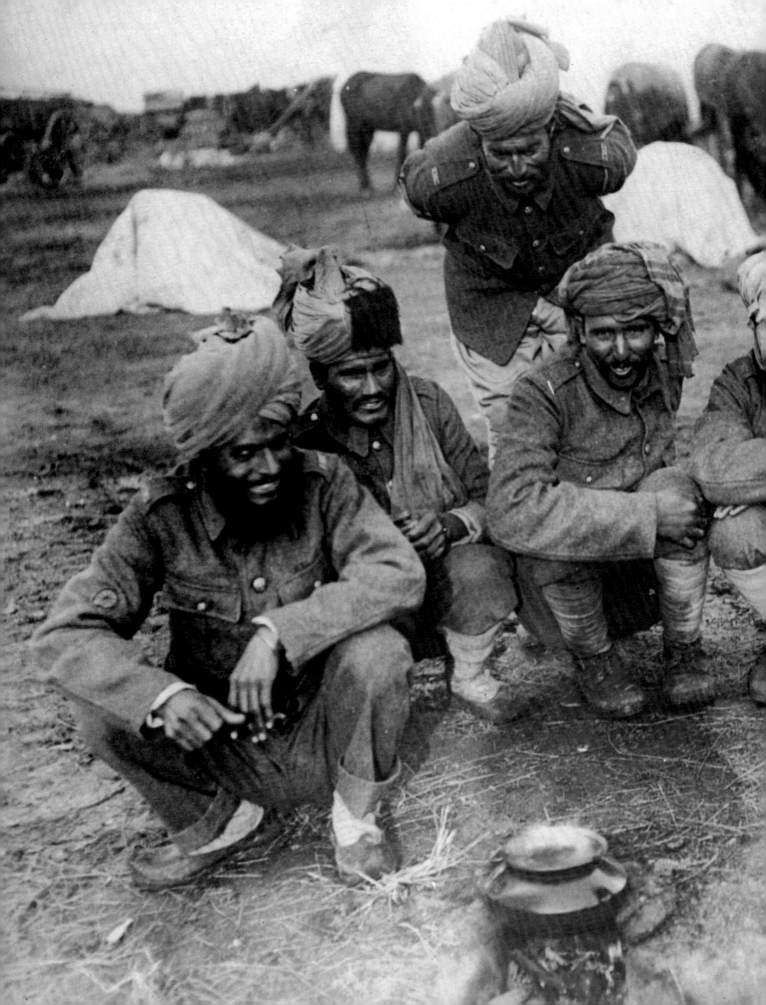

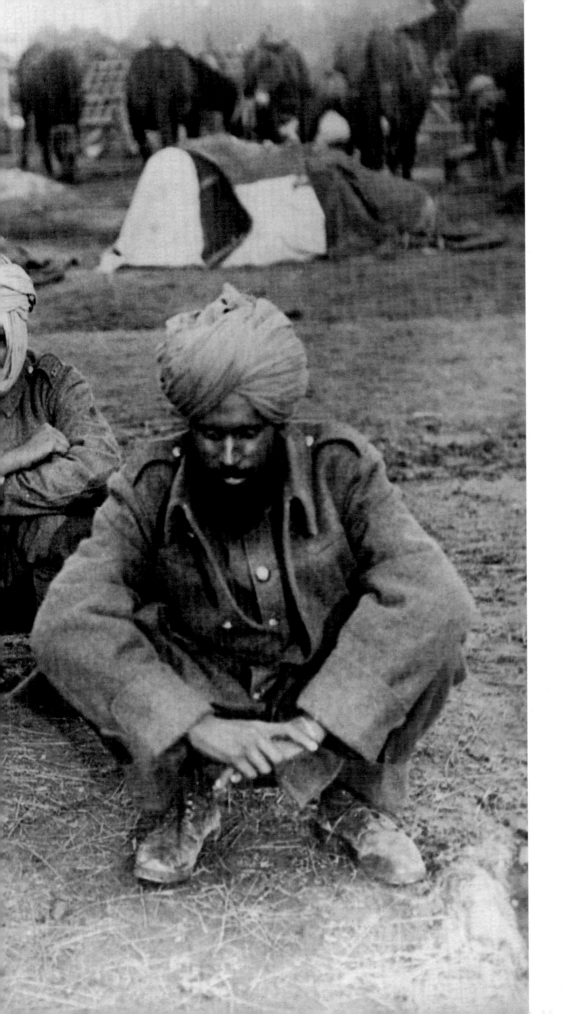

Indian soldiers serving with the British Army, at camp during World War One. (1916)

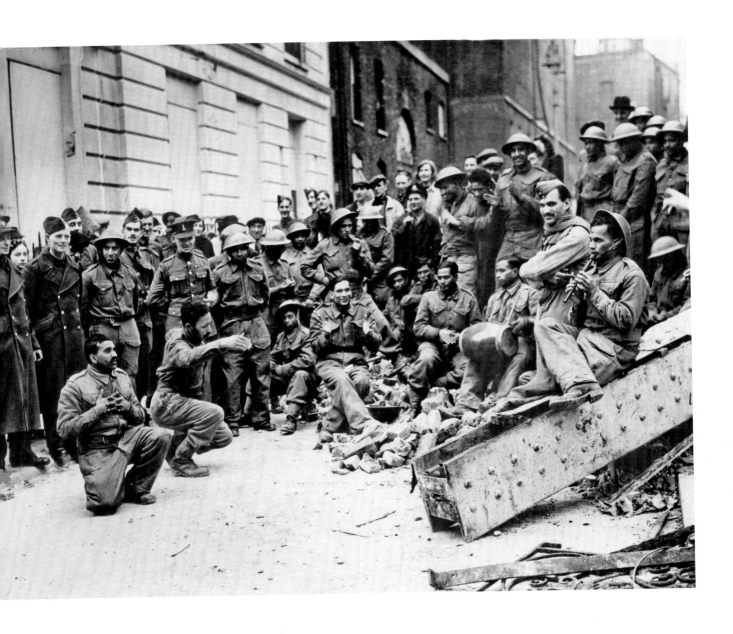

Indian soldiers evacuated at Dunkirk and stationed in England helped clear bombsites in Blitz-ravaged London. Here they entertain onlookers with songs and music. (1940)

As noted above, the coverage of this book has partially been determined by the resources available. The still photographic image only began to be deployed in some public media, newspapers, magazines, books and private collections from the mid-nineteenth century onwards. It was a period, particularly after Queen Victoria was declared Empress of India in 1877, which coincided with a desire to highlight the wealth and grandeur of the imperial imaginary, although there is some representation of the other side of this pomp in images of working-class colonial citizens. It was these groups who formed the backbone of Britain's early Asian communities, a presence

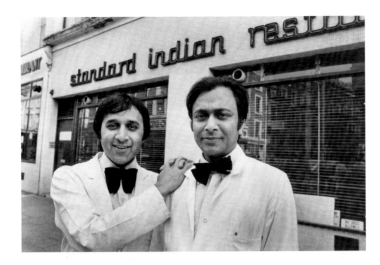

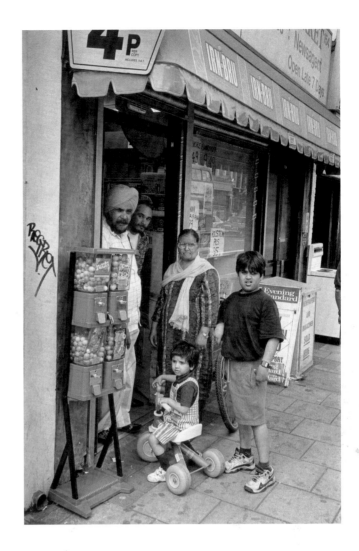

that became more variegated following the arrival of an increasing number of students, lawyers, doctors, merchants and political figures who voyaged to the heart of Empire after the opening of the Suez Canal in 1869.

The archives expand considerably with the more widespread use of public photography in the early years of the twentieth century and we begin to see the extent to which Asians were active participants in a number of key elements of political, cultural and domestic life. Although seldom remembered today, there was significant coverage of India's major contribution to the war effort during the two World Wars. During the interwar period, several were also prominent activists, supporting a variety of causes, whether fights for equality,

Above left: Two members of staff outside the Standard Indian restaurant, Westminster. (1984)

Below left: James Cann is a British-Asian entrepreneur, investor and television personality famous for being a backer on television programme, *Dragons' Den*. (2010)

Above right: A family outside their shop on Camberwell Road, South London. (1997)

Two Indian ayahs from Madras (now Chennai) with their young charges on Great Western Road, Glasgow. (1925)

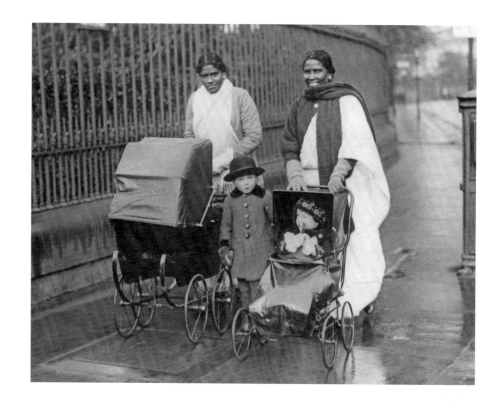

freedom from colonial rule or taking a stance on wider global issues such as the Spanish Civil War. As cheap labour from the subcontinent was sought to rebuild a war-torn Britain after World War Two, workers propped up waning manufacturing industries or bolstered the staff of the fledgling National Health Service and transport systems. Many also began to serve the needs of their local communities by developing grocery shops, opening restaurants and launching successful textile businesses. It is perhaps now a cliché to point to the large numbers of corner shops, newsagents, post offices, pharmacies and restaurants in most British towns or the high profile of Asian magnates in British industry, politics, art, literature, film, journalism, fashion, music and sport. This widespread participation is now taken for granted, but in the early days of settlement, its profound impact might not have been so easily imaginable.

While featuring many well-known and often elite figures, the book pays equal attention to the ordinary, everyday existences, past and present, of those who remain unnamed and are often unrecorded

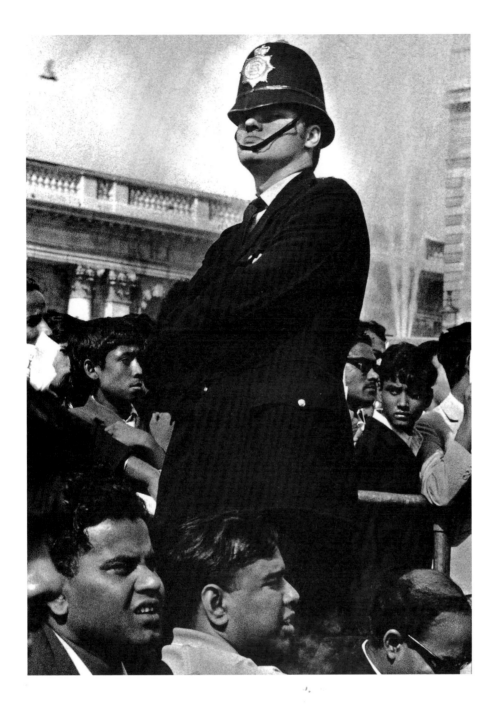

An impassive
policeman in a
crowd of protesters,
London. (1971)

in photo captions. It is important not to forget that, whatever the
class, gender or educational backgrounds of the subjects framed –
whether ayahs or lascar seamen, princely maharajas, entrepreneurs,
reformers, activists, politicians, students, lawyers, doctors, nurses,
artists, shopkeepers, factory workers or restaurant workers – many
have persistently had to live out their lives in Britain by navigating the

Families arrive from East Africa before new restrictions are passed by the British government. (1968)

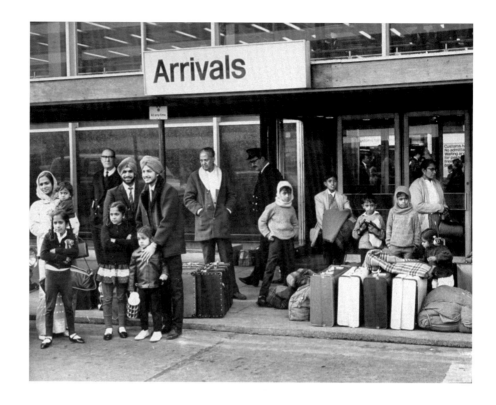

contradictions of the unequal social and political contexts imposed on them. Such exclusionary and oppressive racial hierarchies were, no doubt, most blatantly and unashamedly clear in the period of Empire, yet such inequalities continued well into the postcolonial period. For, despite the liberal directives of a series of well-meaning Race Relations Acts, the slippery discourse of a series of government-endorsed immigration acts attempted for several decades to deny Britain's Asian subjects equality and full citizenship rights.

Alert to the politics involved in any representation, the images work both as documentary record and provocative resource to stimulate questions about how the long history of the Asian presence in Britain has previously been framed and sometimes forgotten. As John Berger once put it, the relationship between what we know and what we see is never settled. Images which may appear to be frozen in time can also speak to us now in terms of what stories lie beyond their immediate objects of view, beyond the edges of how and why they have been framed as well as the original contexts in

which they appeared. And if we shift the angle of vision slightly, it is worth asking what new questions surface which may throw light on prevalent discourses and cultural perspectives today. We may need to think about who constructed a particular image, for what purpose and in what context. And do the subjects have any agency outside the captions through which the original meaning was encased? While images themselves do not change, our interpretations of them may shift, offering a challenge to preconceptions already embedded in cultural memory. Importantly too, while an image may offer the viewer a surface entry point, the larger story surrounding it regularly hovers outside the frame, cut off from view. Whether such absences are created by the historical moment of capture, the agenda of the original media story or the perspective of a particular photographer is a question that continues to reverberate through time.

A good way of thinking about how questions of power can operate in visual iconography is particularly apparent in the blinkered news coverage of the late 1960s. Although this may not be remembered now, it was a time when the media consistently circulated visual evidence of the large number of new immigrants arriving after the Ugandan expulsions of Idi Amin. As with similar renditions today, such figures are normally framed to reinforce difference, whether it is through their strange dress, their poorly made bulging suitcases or their destitute plight as they wait to secure entry at the nation's doors. Little is ever asked about their backgrounds, the reasons for their enforced migration, the full lives they might have left behind, their expectations – or their citizenship rights.

The political agenda lying behind such images was strengthened, of course, by the context in which they first appeared. A succession of swiftly passed immigration acts had reneged on the promises of the 1948 Nationality Act that granted all Britain's ex-colonial citizens rights of entry regardless of 'colour' or background. By the late 1960s, the racist rhetoric of right-wing politicians like Enoch Powell

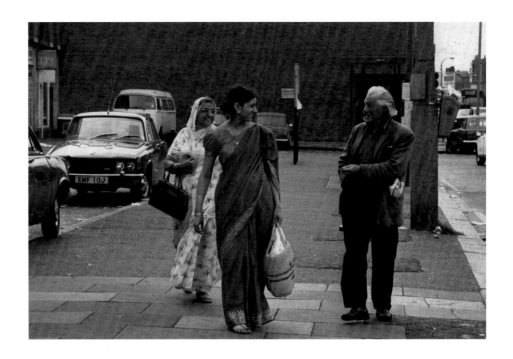

deliberately used the East African expulsions as ammunition to stoke fears of the nation being further 'swamped'. Significantly too, these 'newcomers' were frequently cast into one undifferentiated mould – that of an uneducated and non-Western underclass likely to create problems and impose a burden on the state.

Although always reductive, this kind of blanket perspective was particularly ironic in the case of the East African migrations as many were experienced urban professionals, bringing with them a variety of skills that have since transformed British economic and cultural life. The hostility cited here is just one rather stark example. But it would not be difficult to point to frequent recurrences of this kind of perspective today. As stories escalate about the large numbers of asylum seekers taking British jobs, new stereotypes frame the figure of the British Muslim, now seen, in the aftermath of the terrorist attacks of 11 September 2001 and 7 July 2005, to monolithically represent a security threat in our midst.

The broadly chronological sequence of this book may initially suggest coherent patterns of a linear history as it highlights political and social continuities, the lives of prominent individuals or notable

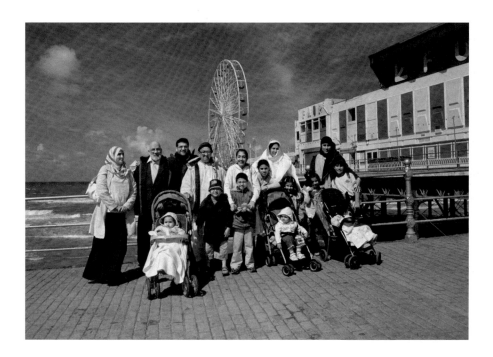

A family on a
day out together
in Blackpool,
Lancashire. (2007)

events in particular decades. However, its compilation has been more problematic and uneven. Firstly, its coverage has largely been determined not only by the nature of the resources available but also the permission to use them. In addition, the bulk of the photographs derive from publicly available archives such as the wide-ranging collections held by Getty, including Hulton, Keystone or *Picture Post*. We have supplemented the angle of these records with a variety of archival sources held in the British Library. These both augment gaps in the little-known period prior to Independence in 1947 and add rarely seen images, such as from *Indian Information*, a war propaganda periodical produced to showcase the extent of India's engagement with the war effort during World War Two. On the other hand, photographs donated by individuals and a few private family collections provide more intimate angles on individual lives.

The process of selection has also inevitably involved a number of difficult choices. Much of the archive, first published in the public media, was used not to celebrate the long presence of an Asian community in Britain but, instead, as the visual evidence to illustrate perceived moments of national crisis. In other words,

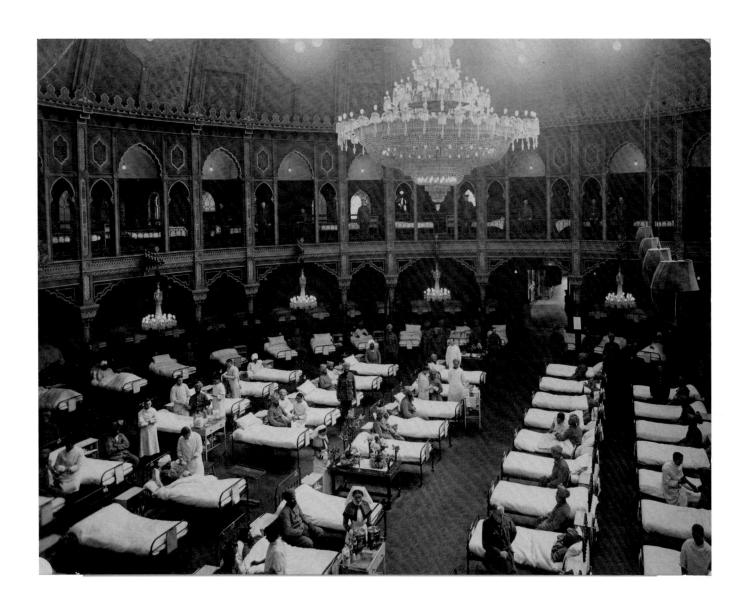

Indian Army soldiers wounded on the Western Front were cared for in hospitals in Britain, including Brighton's Royal Pavilion. (1915)

the original motivation lying behind the initial circulation of such images was not, as intended here, to broaden knowledge and deepen understanding but, rather, to distance and typify the 'Asian' as 'outsider', the object and signifier of cultural difference, a marker against which the 'pure' identity of the white British nation could be measured. In fact, there is often a disturbing double standard at work, one which fails to flag up how the subjects caught within the frames are frequently intimately linked to the oft-forgotten consequences of Britain's imperial past and its ongoing continuities, which have determined patterns of settlement today.

A veteran attends the remembrance service in London's Hyde Park for soldiers from the subcontinent, Africa and the Caribbean who served with Britain in the two World Wars. (2006)

Such disingenuous contradictions in the angle of vision are vividly apparent in the failure to pay adequate attention (until recently) to the substantial contribution to the two World Wars. The 1.4 million who made up the largest colonial army in World War One and fought alongside the British in the trenches at Neuve Chapelle, Ypres and Loos are seldom remembered or referenced in orthodox histories of war heroes. Though much propagandist coverage was circulated praising the special military hospitals set up for their care, such as the one housed in the grand Brighton Pavilion, these men were in fact largely segregated and separated from the life of the country they had risked their lives to serve. Chaperoned when leaving the hospital precincts, they were only allowed limited contact with white women and nurses due to fears of miscegenation. A similar pattern

of exclusion continued at the end of World War Two. As India moved towards Independence and Britain faced the decline of Empire, Britain swiftly abandoned any social or economic responsibility for those servicemen and women who had served the nation during its 'finest hour'. This issue continues to provoke strong emotions, as was evident in recent controversies around Gurkha pensions in 2009.

As statistics from the 2012 census confirm, peoples of South Asian heritage currently constitute the largest ethnic minority in Britain. Although the makeup has diversified considerably over time, many present-day patterns of settlement and diasporic affiliations relate directly to a complex legacy of already existing historic connections. Many lascars, for instance, originally of Sylheti roots, have kinship links to British citizens of Bangladeshi or East Pakistani descent. And, for some Punjabi and Sikh pedlars, common sights in 1930s Britain, the choice of where to settle was sometimes determined by regional links already established in World War One. Naturally, there are many different stories to tell of how such networks can be traced among the diverse groups that constitute present-day communities, whether in Southall, Wembley, London's East End, Liverpool, Glasgow, Cardiff, Leicester, Bradford or Leeds.

The aim of this visual history is not simply one of cultural reclamation, although that is undoubtedly a necessary task. Rather, the cumulative impact offers a powerful testimony to the barriers different individuals and communities encountered over time, the struggles they undertook in negotiating their multiple identities as British citizens and the various ways in which their presence has shaped Britain today. On one hand, we might simply wish to view the windows this volume opens as an illuminating portrait of a hidden history that is only belatedly beginning to form part of a wider political awareness of the undeniable plurality of Britain's mixed cultural past. On the other, these photographs continue to pose a series of urgent questions. For, even though we currently live in a new millennium

world seemingly content to parade the latest Asian British fashions, the celebrity culture of Bollywood or the fusions of Asian music and culinary taste, this much-profiled celebration of Britain's diversity has, at the same time, been undercut by an increasingly sceptical view of the consequences of multiculturalism. We can only hope that current fears of ethnic separatism, generated by a global climate of religious, political and cultural suspicion and conflict, will be surpassed by the wider understanding of Britain that this book intends to stimulate.

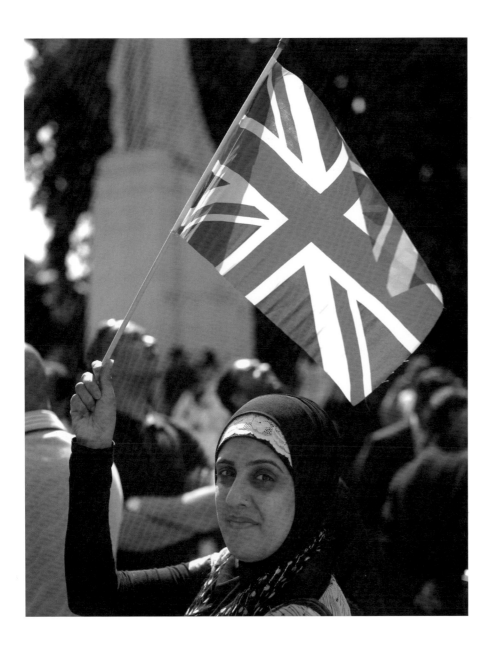

A protester waving the Union Flag, London. (2011)

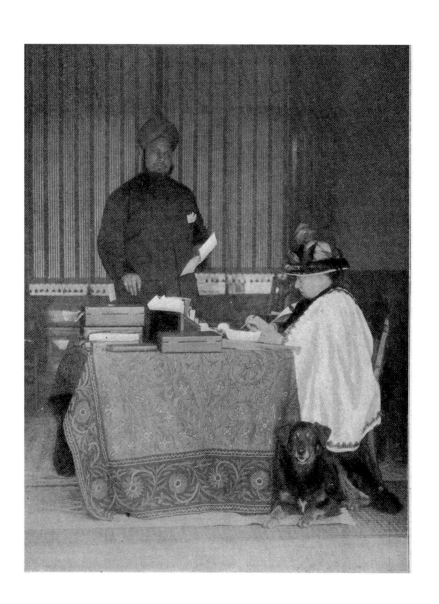

Asian Britain

Exotic representations of the Raj, the most precious jewel in the imperial crown, are familiar icons in Britain's national memory. Though nostalgically replayed in numerous films and television series, our frequent exposure to its conjured grandeur often screens out the other side of the story. A history paralleled by a growing empire within. The striking image of Queen Victoria with her Indian servant, Abdul Karim, may seem at first glance to reinforce fantasised notions of the imperial imaginary. We might be surprised, however, to find the setting is a cottage in Balmoral, Scotland, and its subject an Indian royal servant in Britain.

Taken a few years after the lavish imperial pageants of Queen Victoria's 1887 Golden Jubilee, the Queen is unusually depicted here seated to the right of a handsome young turbaned Muslim, standing above her in attendance. Most people at the time would probably have known that Abdul Karim first arrived in the royal household as an ordinary waiter. What is intriguing here is that Abdul Karim is clearly not being showcased in the menial role befitting his subservient colonial status but, rather, as the Queen's chosen companion, taking centre stage in the photograph. In fact, the image seems to celebrate the rise of this humble Indian clerk from Agra to munshi, the Queen's elected teacher of Hindustani and personal Indian secretary. In the light of the controversies that Abdul Karim's position provoked in the royal household as well as the taboos of race and class that surrounded him, this picture raises a number of complex questions.

The elevation of an Indian servant to Queen's teacher and advisor

Facing page: Queen Victoria with Abdul Karim, who taught her Hindustani. He was one of several Indian servants who arrived shortly after the Golden Jubilee. (1880s)

Queen Victoria holds a garden party in the grounds of Osborne House, Isle of Wight, which featured the famous Durbar Room. (1887)

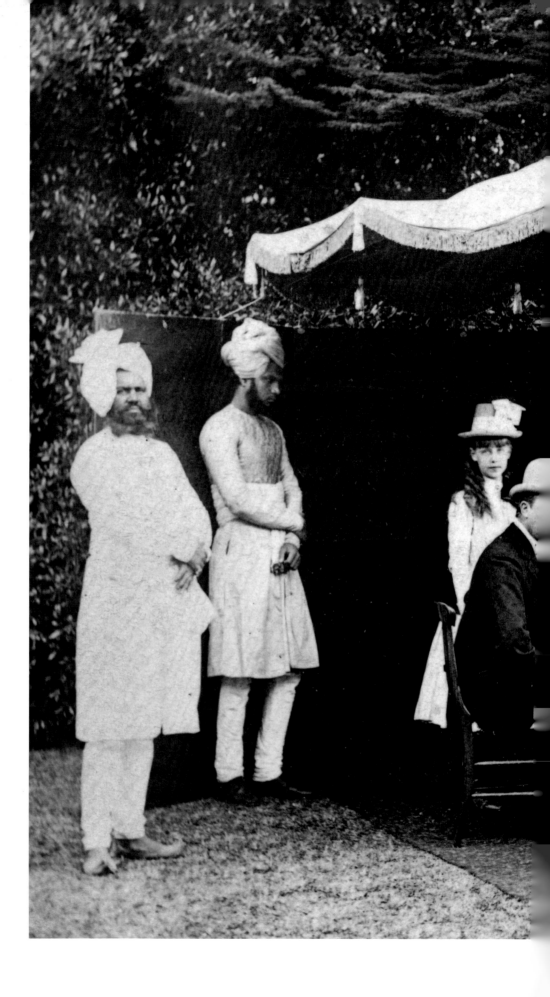

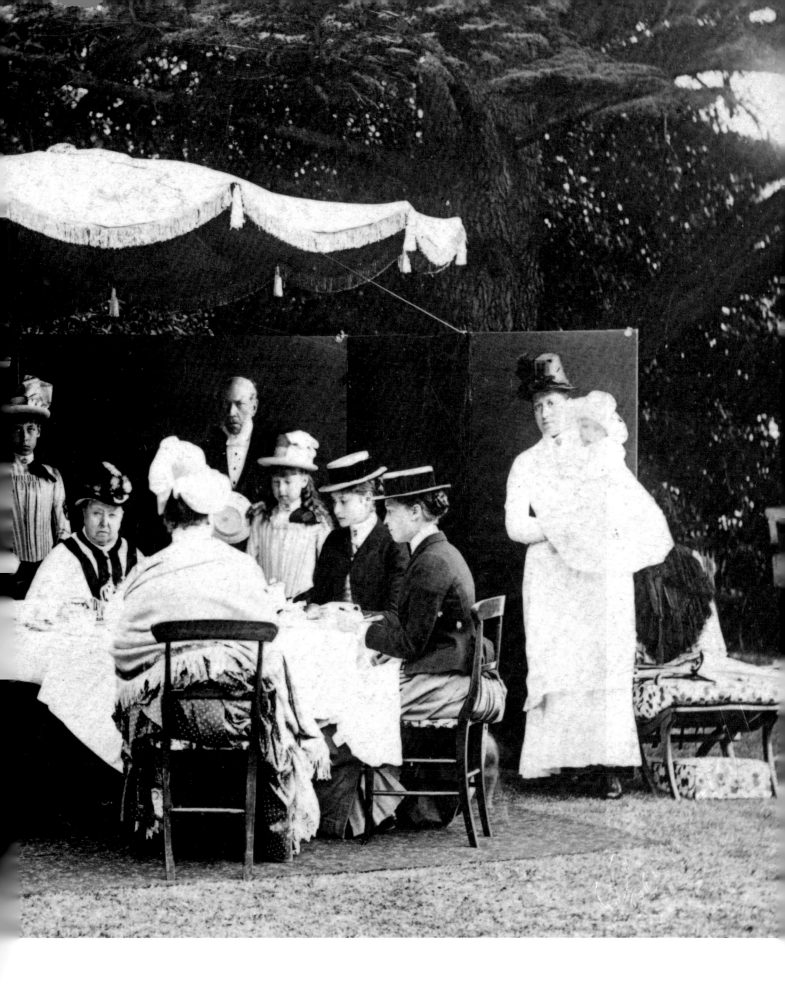

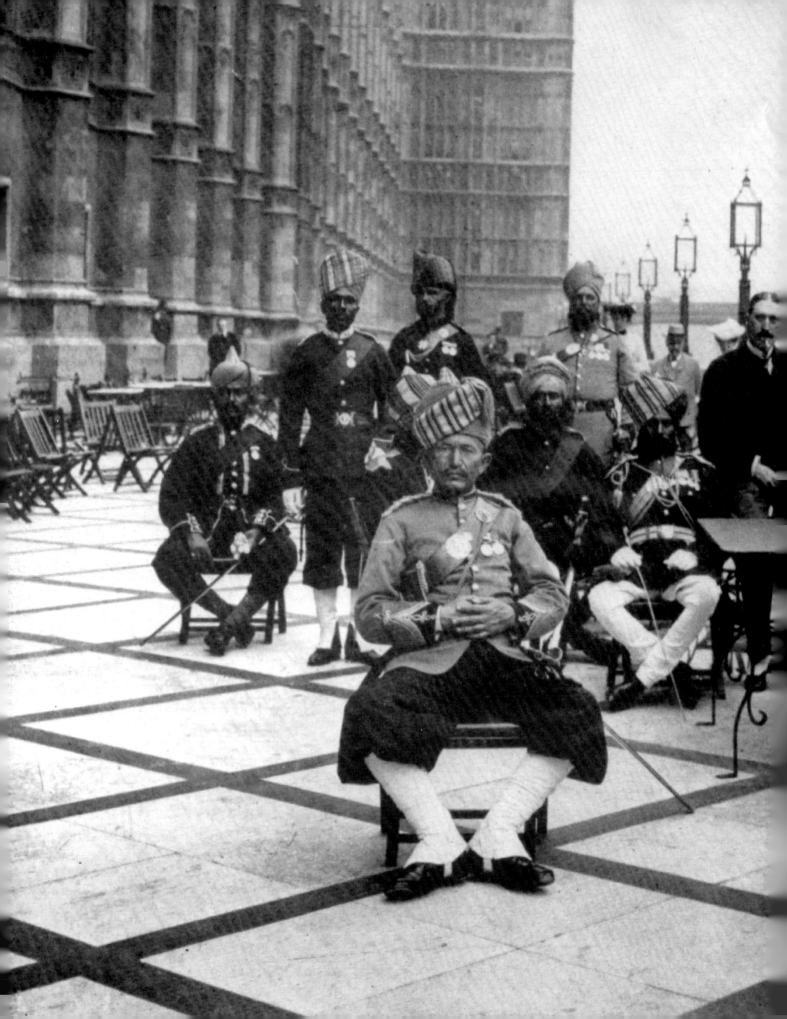

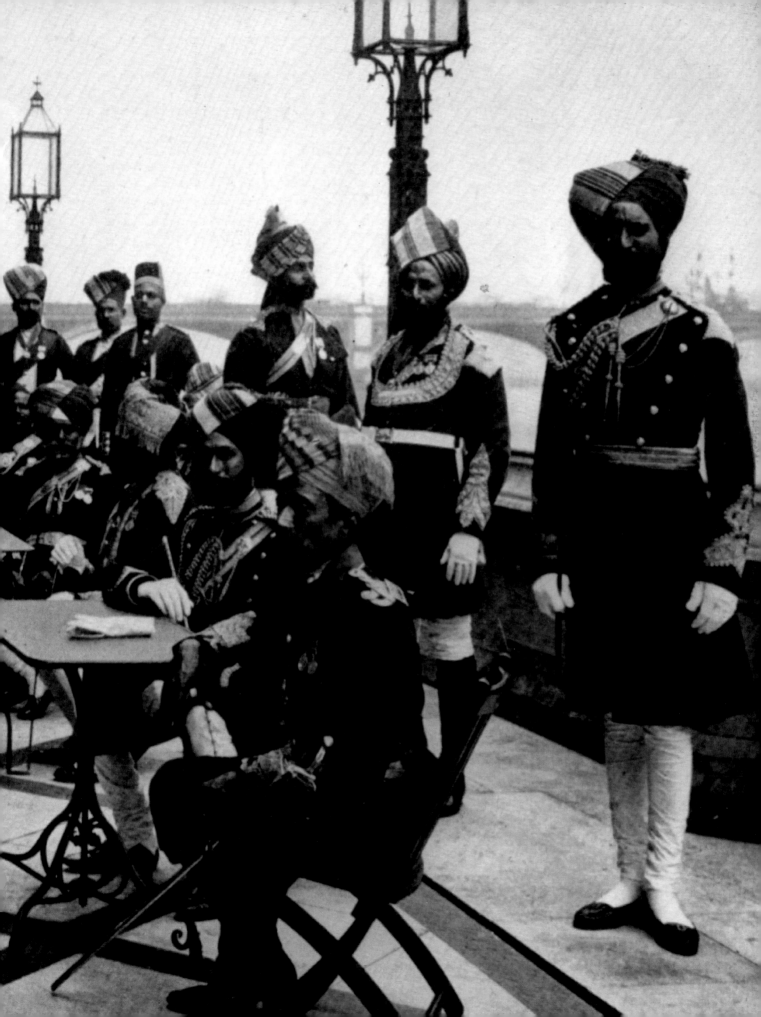

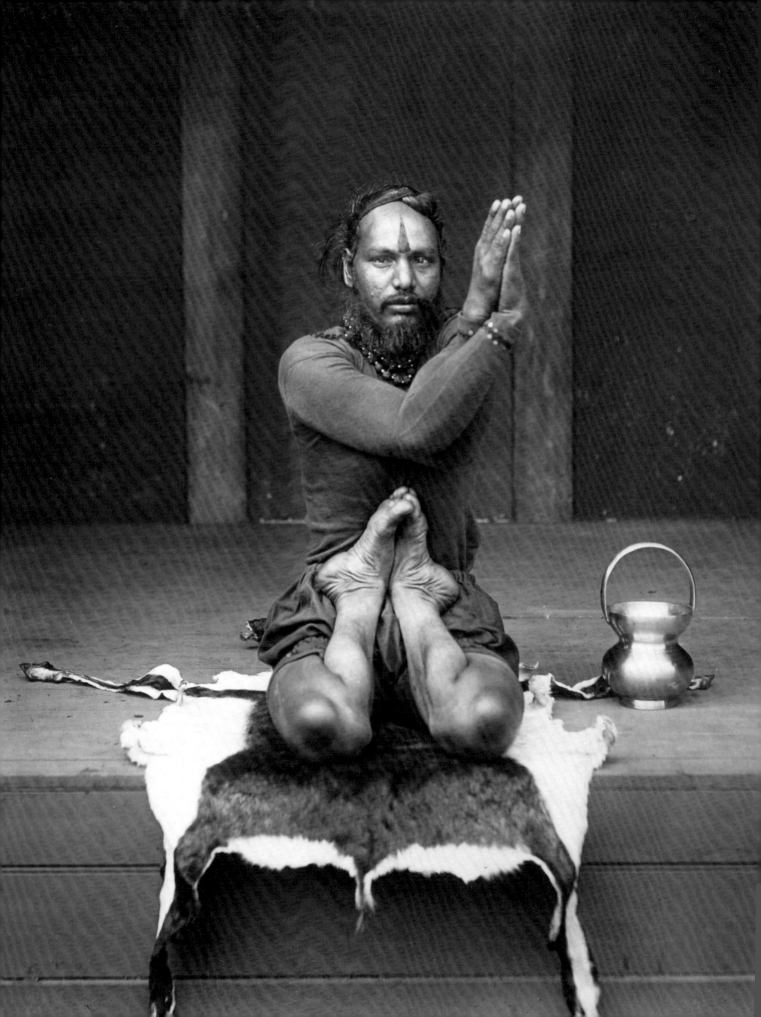

might superficially be read as an early example of successful race relations or productive cultural exchange. We might also view this as a scene which, thirty years on from the 1858 Proclamation of Britain's direct rule over India, countered the growing disenchantment with the Proclamation's empty rhetoric that had offered the promise of equality to the Crown's colonial subjects. The Indian-style fabric of the tablecloth and Queen's shawl certainly create the sense of a fluid and implicit bond between servant, symbolic representative of Empire, and Queen Empress. However, this apparent interweaving is also indicative of a much more divisive reality. We know from its context that the imperial drain on India's trade and natural resources had already resulted in widespread impoverishment, unemployment and a growing disenchantment with the promised benefits of colonial rule. And, while some suggest that Abdul Karim's wilful exploitation of this image was an indication of his agency and confident self-advancement, his position was considerably more insecure than it appears.

Lascars in the waiting room of the Seamen's Hospital Dispensary in Well Street, Hackney. (1881)

Facing page: Imperial exhibitions were a regular feature. This Yogi participated in the Bombay Theatre of Varieties at the India and Ceylon Exhibition, London. (1896)

Previous pages: Indian military representatives at the coronation of King Edward VII in 1902 on the Terrace of the Houses of Parliament. (1902)

Lascars on board ship in the Port of London. Some 20,000 Asian and African sailors arrived in and departed from London annually. They stayed in local seamen's lodging houses. (1908)

Among the Queen's closest political advisors, Abdul Karim's elevated status was frequently the subject of harsh criticism. His inappropriate social position in the royal household as well as his perceived inferior racial status not only violated embedded Victorian hierarchies, but also symbolically challenged the Empire's ideology of economic, political and cultural dominance. The Queen's own son and her private doctor were busily engaged in creating conspiracy theories to discredit his reputation. Alleged to be contaminated by venereal disease and a spy, it was rumoured he was exploiting his position to spark Islamic unrest in both India and Britain. The Queen's dogged determination to protect her favourite resulted in a long battle which threatened to entirely derail her 1897 Diamond Jubilee. As

she attempted to honour Abdul Karim with a full knighthood, her intentions created shockwaves. She was eventually forced to back down and, after her death in 1901, her much-loved munshi was swiftly dispatched back to India by the Prince of Wales. All material traces of his special relationship with the Queen were immediately destroyed.

In one sense, this image could be seen as an ironic version of imperial spectacle, an ideology propagated through numerous exhibitions and military pageants which sought to enshrine the reach of the Empire's power, trade and influence but which, nevertheless, persistently reduced the racial and cultural status of its objects of vision. It is worth remembering that the 1886 Colonial and Indian Exhibition had taken place in London only a year before Abdul Karim arrived and some of his less fortunate countrymen had been featured as exhibits to the many hundreds of visitors it attracted. One, described pejoratively as 'Native 16: Sweetmaker from Agra', had made the long voyage to personally petition the Queen on a land rights issue. Failing to gain any response, this particular property owner, Tulsi Ram, was arrested as a destitute vagrant when the exhibition closed.

Abdul Karim's position was certainly atypical. Yet the wider public and political issues his situation raised – questions of race, class, equality as well as the rights of Britain's imperial citizens – did not go away. In fact they reverberated across the early twentieth century and beyond as inequalities of colonial subjugation and a growing scepticism with the liberal façade of British justice and democracy began to create a common cause which unified Britain's early Asian residents beyond their significantly different circumstances and class backgrounds.

With the opening of the Suez Canal in 1869 and the use of steam-powered ships, Britain's dependence on a cheap Asian labour force to support its global trade networks increased. At the same time, the duration of the journey between the subcontinent and Britain significantly decreased, encouraging a variety of different groups from

A group of post-graduate Indian Civil Service trainees at the University of Oxford. (1928–29)

Facing page: Nawab Farid-Uddin Khan, student of forestry, University of Edinburgh, with Scottish wife Helen Allan and sons Muneer and Amir. (1920s)

across the subcontinent to embark on this voyage. Among them were high-profile aristocratic elites – who frequently figure in photographic archives – social reformers, merchant traders and businessmen, politicians and students. One such traveller was Mohandas Gandhi who, interestingly, arrived in the same year as Abdul Karim.

Often already the products of an Anglicised education, many sought self-advancement in the legal, engineering and medical professions by experiencing British education and culture first hand. Their presence began to influence all walks of British life, whether in parliament, the Inns of Court, universities or artistic circles. Some came to gain the recognised qualifications they required to serve in India as doctors or civil servants, others were lured by the promise of

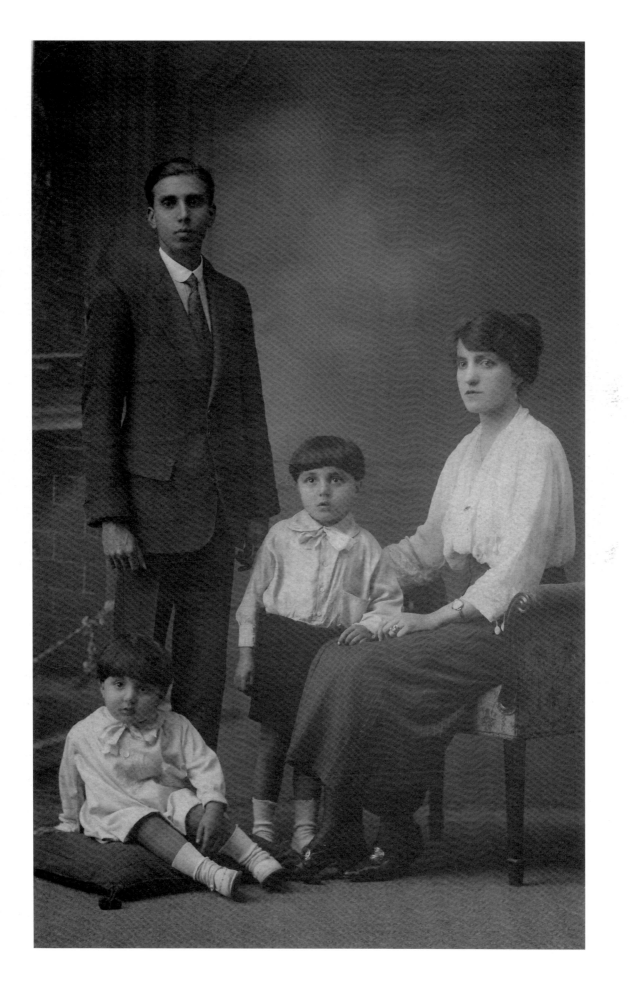

Jawaharlal Nehru in school uniform. He attended Harrow School from 1905 to 1907 and continued his university education in Britain. (1906)

Facing page: Thinker, statesman and nationalist leader, Mohandas Karamchand Gandhi as law student in London. (1887)

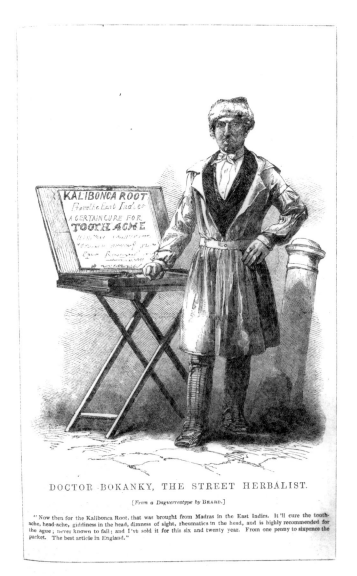

DOCTOR BOKANKY, THE STREET HERBALIST.

[*From a Daguerreotype by* BEARD.]

"Now then for the Kalibonca Root, that was brought from Madras in the East Indies. It'll cure the tooth-ache, head-ache, giddiness in the head, dimness of sight, rheumatics in the head, and is highly recommended for the ague; never known to fail; and I've sold it for this six and twenty year. From one penny to sixpence the packet. The best article in England."

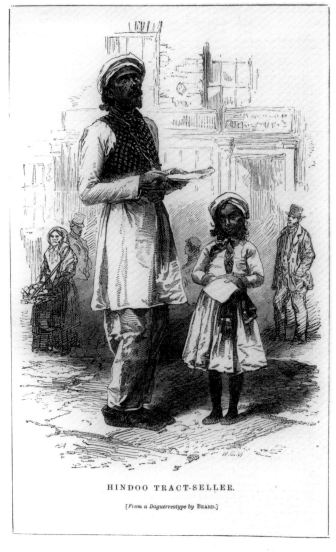

HINDOO TRACT-SELLER.

[*From a Daguerreotype by* BEARD.]

Left: Dr Bokanky, a herbal doctor, selling medicines from a street stall, London. (1862)

Right: A man and child selling Christian tracts on the streets of London. (1862)

higher wages as domestic servants, seamen and factory workers. Many put down long-term roots and their living descendants can still be traced today. Following the formation of the Indian National Congress in 1885, disenchantment with colonial rule had become more vociferous. Some of the politically minded intelligentsia thus exploited their dual allegiances as both British and imperial subjects, later becoming influential figures keen to educate the British public about the realities of the conditions affecting India as well as to contest the inequalities of Empire from within.

No uniform pattern marks this early period of Asian settlement, although some were certainly perceived to be more equal than others.

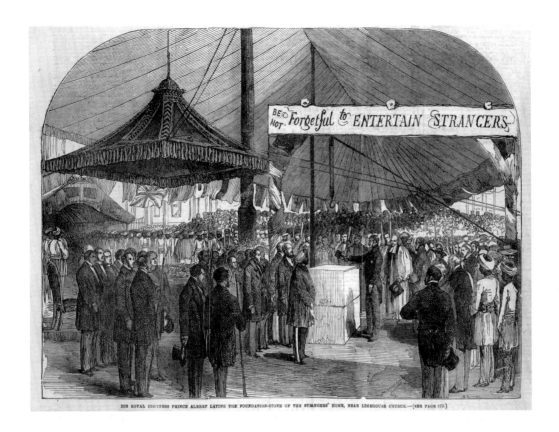

HIS ROYAL HIGHNESS PRINCE ALBERT LAYING THE FOUNDATION-STONE OF THE STRANGERS' HOME, NEAR LIMEHOUSE CHURCH.—(SEE PAGE 670.)

Above: Prince Albert laying the foundation stone for the Strangers' Home for Asiatics, Africans and South Sea Islanders at East India Dock Road, Limehouse, East London. It provided accommodation until 1937. (1856)

Below: Three Indian men dressed in oriental costume, ready to provide a 'traditional' soothsaying service for tourists in Blackpool. (1910)

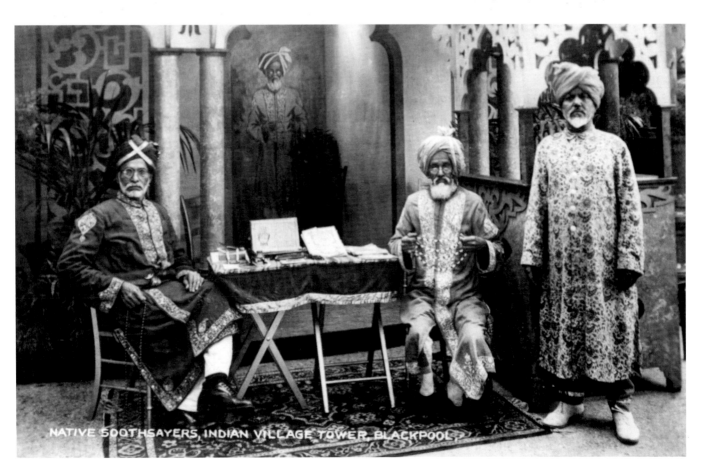

NATIVE SOOTHSAYERS, INDIAN VILLAGE TOWER, BLACKPOOL.

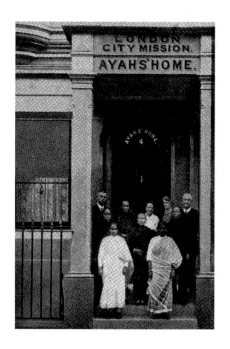

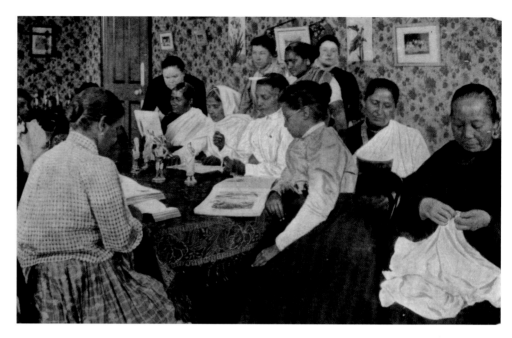

Left: The Ayahs' Home in Hackney, East London, was set up for destitute ayahs, awaiting return to their home countries. (1921)

Right: Inside view of the Ayahs' Home, which had 30 rooms for over 100 Indian and Chinese nannies. (c. 1904)

What is clear is that by far the largest numbers constituting Britain's growing Asian population in the period of Empire were the working classes. While, for example, the student numbers in British universities such as Oxford, Cambridge, London and Edinburgh rose from four in 1845 to around 700 in 1910, to 1,600 in the 1930s, the number of lascars employed on British merchant vessels was already over 51,000 by 1914. Though it is difficult to precisely track the specific numbers of Asians in these figures, there is little doubt that the great majority came from the subcontinent. As a consequence, the population of lascar seamen living in British port cities increased substantially. Entrapped by the stranglehold of discriminatory 'Asiatic' labour contracts, many chose to escape the arduous conditions on board ship to find more lucrative sources of employment. Some became destitute, but many reinvented themselves as itinerant entertainers or street sellers of religious tracts and herbal remedies. Others set up cafés and lodging houses, became crossing sweepers or took on the role of 'oriental' soothsayers at fairgrounds.

Due to rising public concern about the growing numbers on British streets, the Strangers' Home for Asiatics, Africans and South

Sea Islanders was opened in Limehouse, East London, in 1857. This institution was founded to contain the so-called 'problem' of the nation's distressed colonial subjects and to offer welfare and spiritual guidance from specially appointed and proselytising Christian missionaries. Although offering a form of refuge, the very name of the home signified difference, heightened by the increasing popularity of Darwinist theories of a biologically determined notion of racial supremacy.

Even though British subjects, the desire to prevent these seamen from becoming an integral part of the population was manifested through the adoption of a series of stringent shipping laws which consistently attempted to deter permanent settlement. Such moves culminated in the Aliens Acts of 1914 and 1919, precursors to many similar discriminatory immigration controls which were to follow in the post-war period after Indian Independence in 1947. These acts certainly imposed restrictions on freedom of movement, but also reflected the major fear of racial mixing and miscegenation, as they insisted that any English woman marrying such an 'alien' would forfeit her nationality.

With similar intent perhaps, benevolent organisations such as the London City Mission took over and reopened a permanent lodging house for stranded ayahs in Hackney in 1900. Many held no identity papers or contracts of employment, but their demanding jobs meant they had to be extremely resilient and resourceful, contrary to some picturesque representations of them as docile servants. Often left in sole charge of English children for long periods, it was reported that one had escorted families on the passage back and forth to India over 54 times. The Ayahs' Home, which continued to operate until 1945, in practice acted like a modern employment agency, making income from offers of ayah services to returning families. Not all ayahs were abandoned. Frequently seen in parks or on city streets, a few chose to remain and settle, working as carers in British homes over several decades.

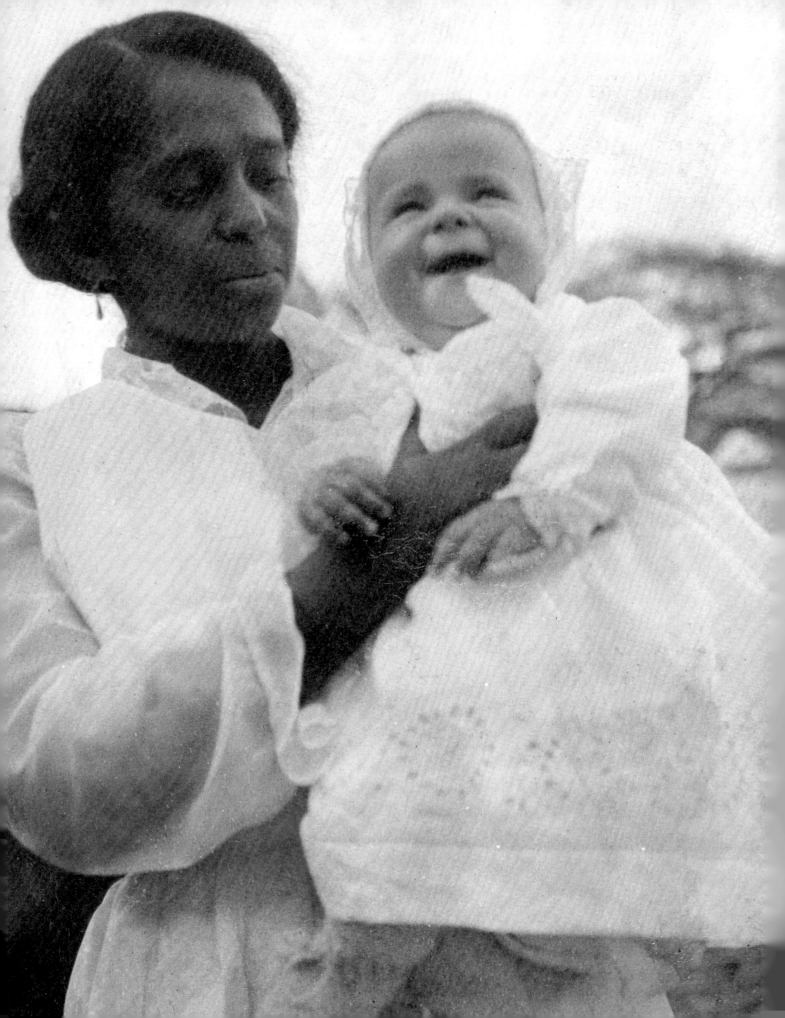

The Lawrence family brought their ayah with them to England. First employed in India in 1910, she lived with them for the rest of her life. (1955)

Facing page: The Lawrence family ayah, with her English charge. (1920)

Interestingly, such ventures to ease conditions for these workers, caught up like chattels in the webs of Empire, were supported by the civilising missionary ethos of white Christian organisations, whose efforts at conversion were certainly met with covert, if not explicit, resistance. However, some already resident Asian Christians were also invited to participate, including Reverend Bose, chaplain to the London Lascars' Mission in 1887, and Aziz Ahmad, another convert based in Glasgow. The plight of the seamen and ayahs also frequently attracted the attention of affluent Indian elites. The Maharaja Duleep Singh was one of these benefactors. With many aristocratic connections and an established celebrity status as gentleman squire of a Norfolk country estate, his lifestyle was often featured by journalists. Similarly well-established Indian merchant companies, such as the Zoroastrian Cama & Co., offered contributions, but only if continued attempts at

The Strangers' Home was used by Christian societies for missionary work. Sailors from the home participated in food distribution to destitute local residents. (1868)

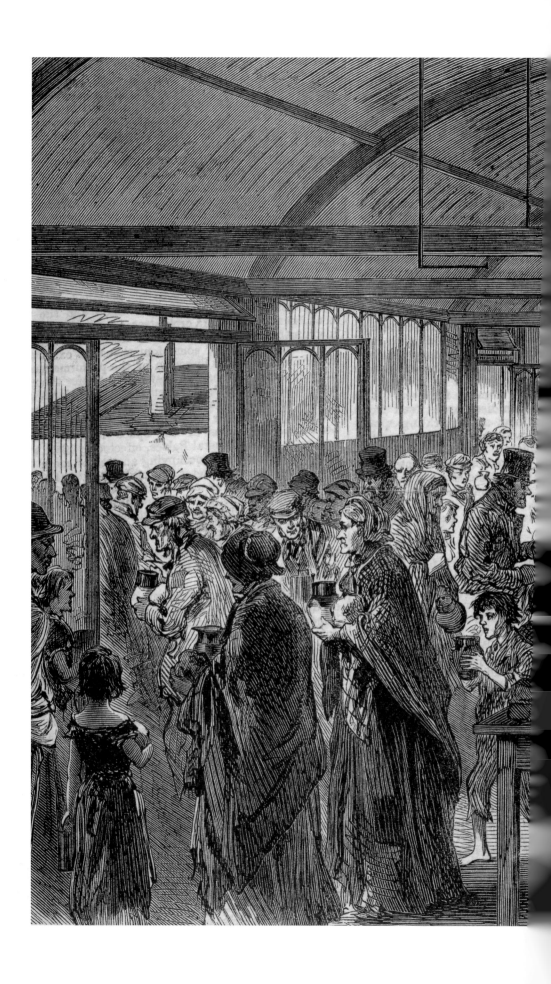

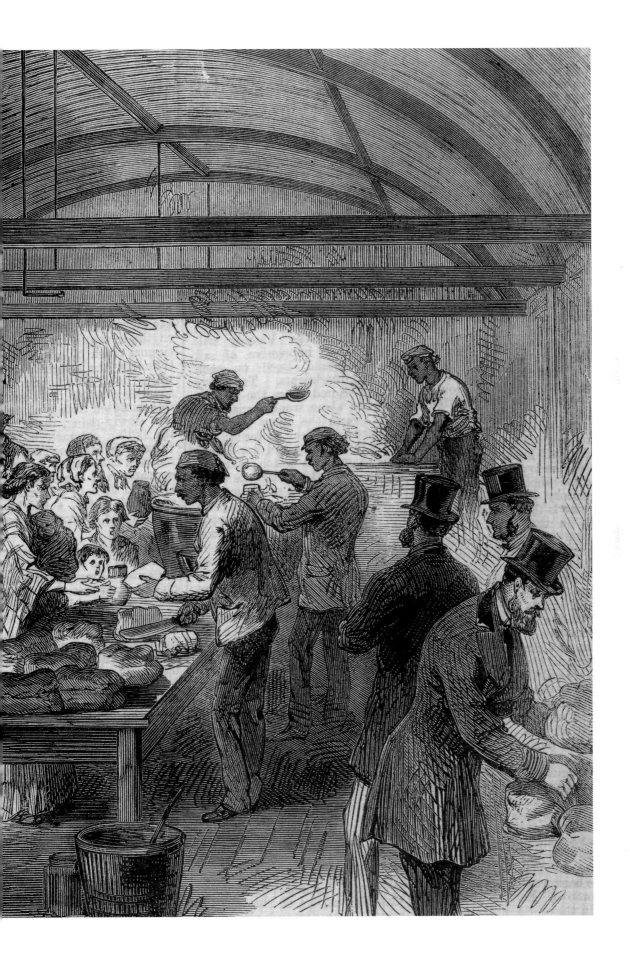

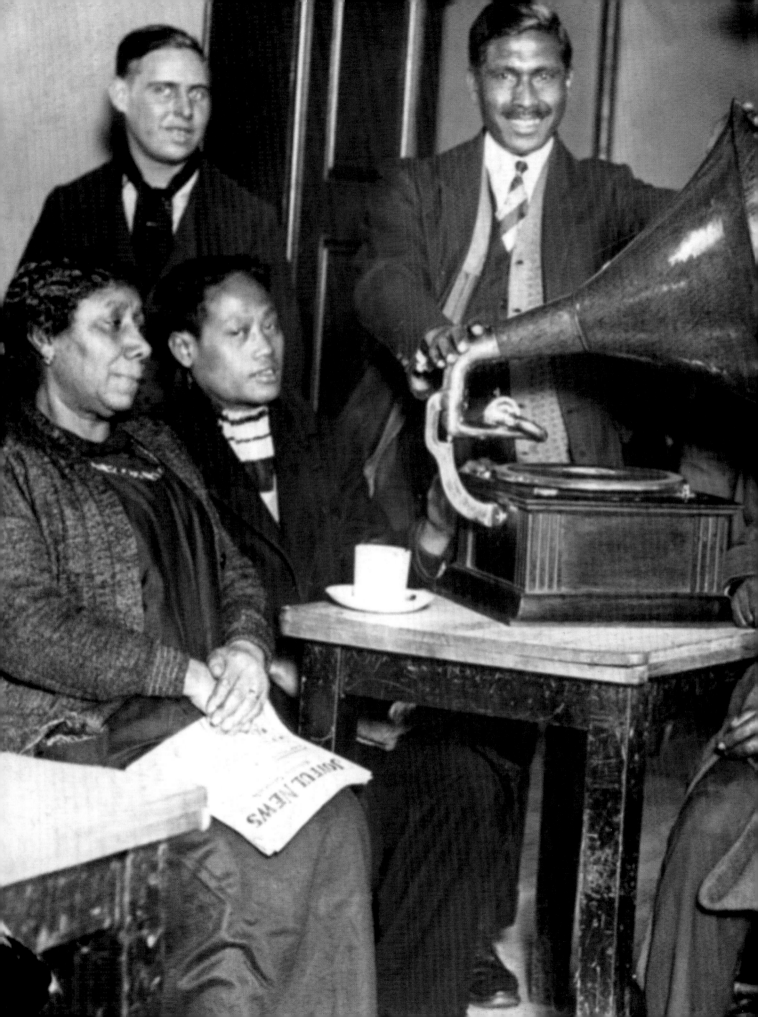

Kamal Athon Chunchie was a Docklands pastor who established the Coloured Men's Institute, a religious, social and welfare centre for the local black community, in Canning Town. (1930)

Dadabhai Naoroji was elected MP for Central Finsbury in 1892. Known as Member for India, he supported the liberal agenda in parliament. (1870)

Christian indoctrination were stopped. Yet, while the Strangers' Home appeared in one sense to segregate, everyday realities in the community where it was based were more fluid. Some early images depict its residents mixing with and serving many of the equally destitute white working classes around Limehouse, who regularly sought nourishment in its soup kitchens. It is important to remember that such initiatives and the agendas driving them were always complex, as was evident in Kamal Chunchie's setting up of the Coloured Men's Institute in Canning Town in 1926. From an elite Ceylonese Muslim background, Chunchie had fought as part of the Middlesex Regiment

Reformer, economist and lecturer at University College London, R. C. Dutt is known for his ground-breaking critique of colonialism. (1911)

on the Western Front during World War One, becoming pastor to the Wesleyan Mission in the Port of London in 1921. An early community centre, the institute organised social events for the children of isolated mixed-race families. A powerful speaker and fundraiser, Chunchie challenged the Christian doctrines of equality and brotherhood to combat the myopic hypocrisies of racial discrimination. Drawing on multiple identifications and allegiances across the racial and class divides, he raised consciousness and pioneered early political alliances between Britain's black and Asian communities, a strategy which was to become increasingly important as the century progressed.

Maharaja Duleep Singh's daughter, Sophia, selling copies of *The Suffragette* outside Hampton Court Palace. (1913)

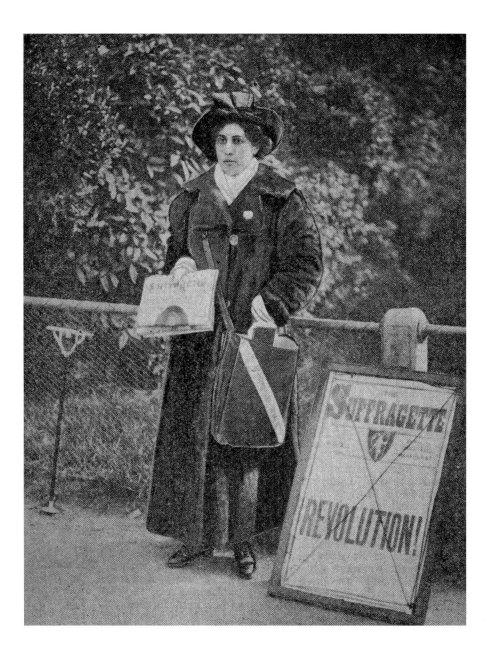

Wider questions of politics, equality and social justice fired the activities of several prominent Asians at the other end of the Victorian social spectrum too. The multidimensional interventions of figures such as Dadabhai Naoroji, Britain's first Asian MP, or Sophia Duleep Singh, a high-profile suffragette activist, impacted on a range of different constituencies as their political campaigns spoke both to domestic and broader global concerns. Asians had already become increasingly vocal at the centre of political life prior to Naoroji's

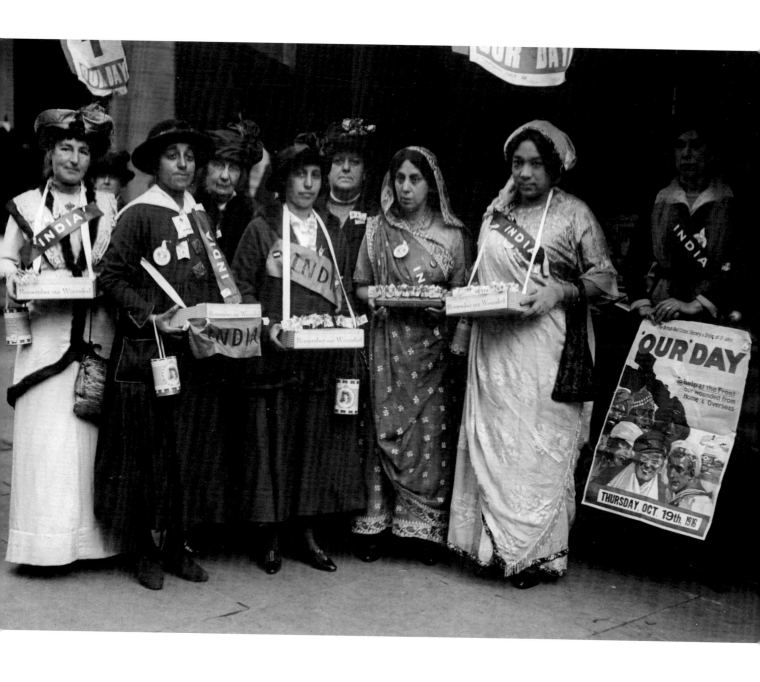

election to the House of Commons as Finsbury Liberal candidate in 1892. For example, Lal Mohan Ghosh contested a closely run seat in Deptford and W. C. Bonnerjee, a moderate Anglophile, whose family were all later to settle in Britain, twice stood for parliament.

Following an illustrious career in Bombay, Naoroji came to Britain in 1855 and took up the position of Professor of Gujarati at University College, London. Elected three times as president of the Indian National Congress, Naoroji established a variety of platforms

From left to right: Mrs Salter Khan, Princess Sophia Duleep Singh, Ms P. Roy and Mrs Bhola Nauth collect funds for 'Our Day', in aid of soldiers at the front during World War One. (1916)

to inform the British public about the injustices inflicted on the Indian people in their name. Like the economist and historian R. C. Dutt, Naoroji's main objective was to make transparent the imperial drain of £30–40 million per year of India's resources, which made economic self-advancement impossible. This intellectual concept later influenced the ideas of the British economist John Maynard Keynes. Although Naoroji was single-minded in his vociferous articulation of India's position, his election to parliament was primarily won through his domestic engagement with wider Liberal policies, as he campaigned for free education, public housing, women's suffrage and Irish Home Rule. Highly respected by mainstream figures such as Labour politician Keir Hardie, socialist pioneer H. M. Hyndman and Florence Nightingale, his position was simultaneously dogged by the racist jibes of Conservative Prime Minister Lord Salisbury, who famously claimed that the British people would never accept a 'black man' as MP. Ironically, Salisbury's use of the 'race card' to defame Naoroji had the opposite effect, both strengthening his public profile as well as his following among his working-class Finsbury electorate. It also demonstrated the ambivalence of Naoroji's predicament as an early Asian politician in Britain. For, like others who followed on, he had to negotiate the double standards of a political climate that could simultaneously accept and reject the claims of its colonial subjects. Naoroji only kept his seat for three years. Nonetheless, his election marked an important milestone in British politics. Many images of Naoroji exist in archives, but they either stage him as assimilated Victorian Indian gentleman or instead over-emphasise his Parsee background. Interestingly, no images have yet emerged which feature this pioneering figure in the broader domestic contexts with which he actively engaged or alongside his predominantly white Finsbury constituents.

Sophia Duleep Singh's much-publicised activism as an Indian suffragette also did not escape press notice or representation. One of Maharaja Duleep Singh's three daughters, Sophia lived in a grace

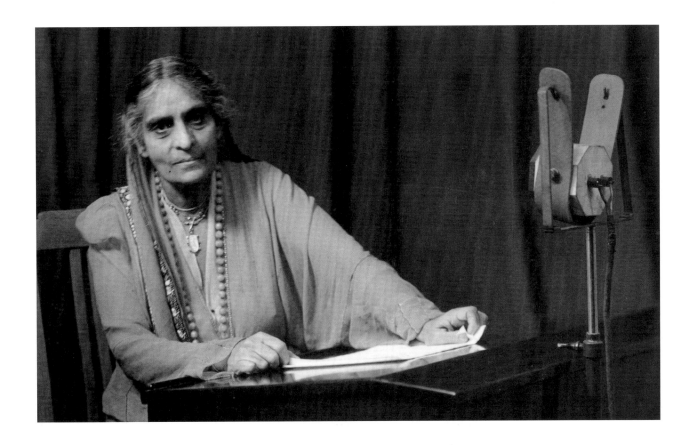

and favour house outside the grounds of Hampton Court Palace provided as part of her father's disputed pension settlement following the annexation of his kingdom in the Punjab. Exploiting her public profile as Queen Victoria's god-daughter to draw attention to her fight for women's rights, she was often to be seen selling *The Suffragette* with a billboard outside the palace. She was also much featured with Emmeline Pankhurst in the famous 'Black Friday' march. Her resistance to the payment of taxes and her support of the Women's Tax Resistance League led to several strategically staged prosecutions when some of her most valuable possessions were impounded. Like her brothers, Frederick and Victor, she supported several charitable causes, donating money to the East End Lascars Club and collecting donations to support Indian soldiers fighting for another King and Country during World War One. Sophia was just one of several Asian women who became centrally involved with campaigns for women's rights at this time.

Legal professional, campaigner and writer, Cornelia Sorabji is seen here broadcasting for BBC radio. (1931)

The activities of such figures stretched across a range of networks. While issues of racial and social equality created common causes, political viewpoints were by no means uniform. Cornelia Sorabji, a committed British loyalist, writer and advocate on the complex issues surrounding the often misunderstood conditions of women living in purdah, was the first-ever woman (Indian or British) to read for a law degree at Oxford University and pioneered the removal of the bar to women. Complex in her views, she frequently critiqued what she perceived to be the narrow Western feminist stance of the suffragettes while at the same time creating professional platforms to represent the claims of the female imperial subject. The Tory line of Mancherjee Bhownagree, who followed Naoroji into the House of Commons as Conservative MP for Bethnal Green, is a further case in point.

From another perspective, Syed Ameer Ali played an instrumental role as first Indian Privy Councillor in bringing the wider concerns of the Muslim community to the attention of the government, though he was not in any sense a separatist. The founder of the London branch of the All India Muslim League in 1908, Ali later settled permanently in Britain with his English wife. Chairman of the Woking Mosque Committee, he founded the British Red Crescent Society, an early Muslim version of the Red Cross. Like many other politically minded Victorian Asians, Ali was passionately engaged with global concerns and frequently drew attention to the predicament of the indentured 'coolies' in South Africa, a cause famously taken up by Gandhi, who used his British education and intimate knowledge of constitutional law to later contest and resist the Raj.

Most Asians in the Victorian political spotlight operated from a predominantly moderate and reformist constitutional stance and, as such, had some success making inroads into shifting public opinion across a range of issues. However, the establishment of India House in Highgate in 1905, a hostel for Indian students, saw the beginnings of a more radical and revolutionary wave of activity. This came to a head

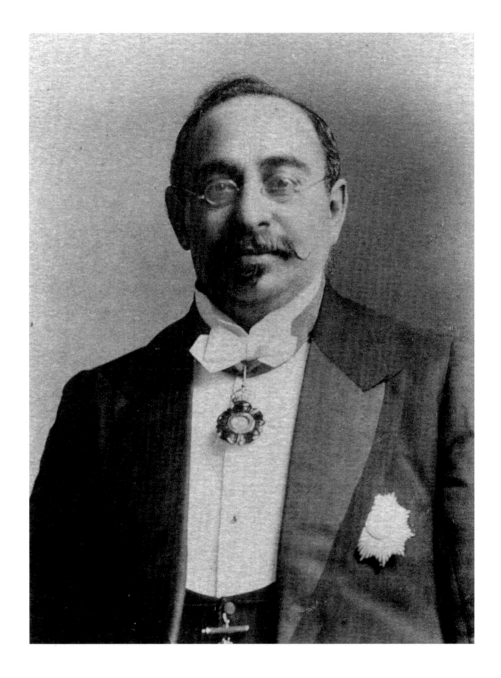

Mancherjee Merwanjee Bhownagree was the second Asian MP elected to parliament, standing for the Conservative Party in 1895. (1900)

in 1909 when Sir William Curzon Wyllie, a civil servant notorious for monitoring student activities, was assassinated by Madan Lal Dhingra at the Imperial Institute. Partially sparked by the partition in Bengal in 1905, this murder led to increasingly stringent surveillance policies by the India Office. Keen to stem support for Indian Home Rule fast manifesting itself at the heart of Empire, the British authorities attempted to stamp down on the rising climate of colonial resistance.

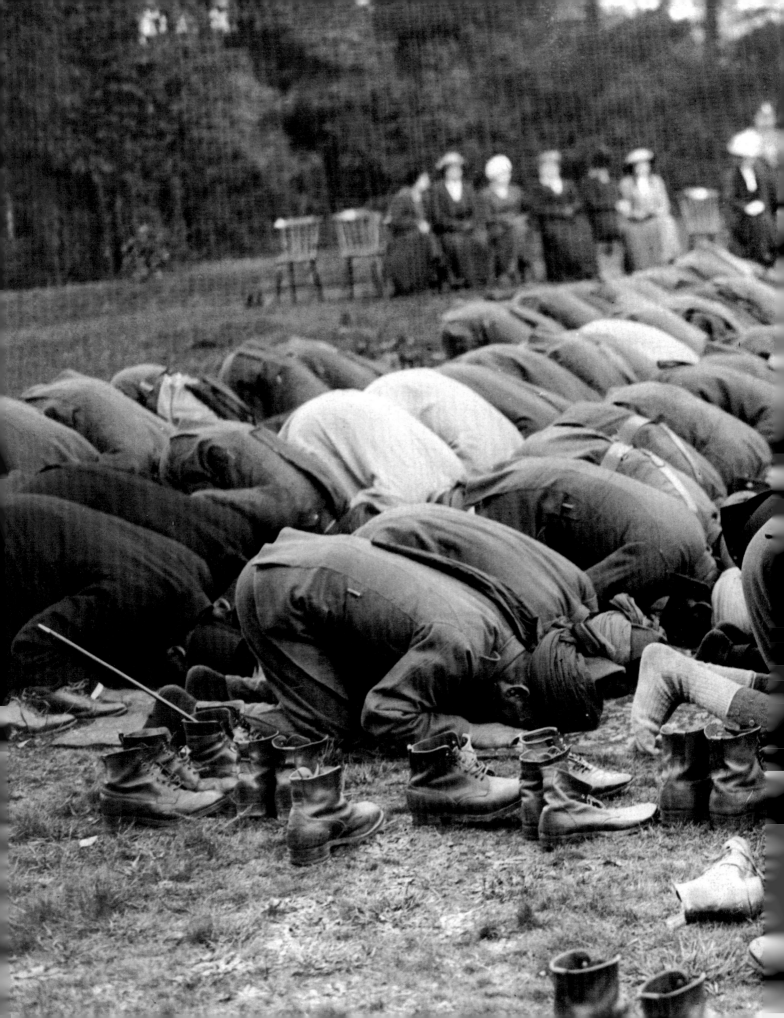

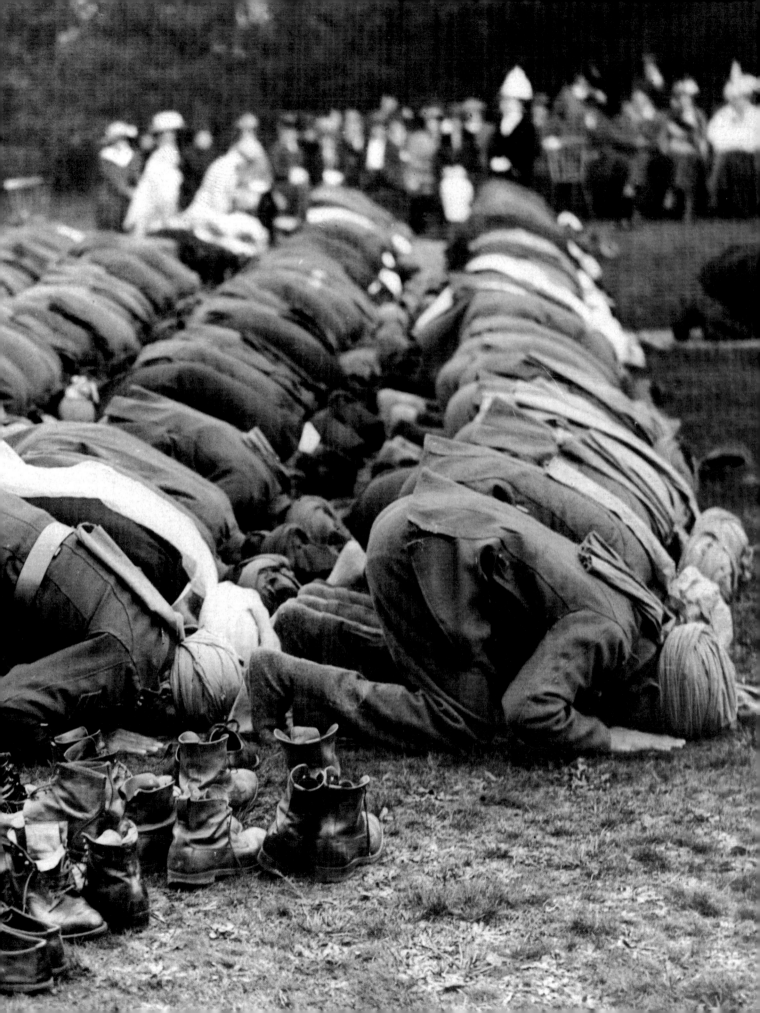

THE ILLUSTRATED LONDON NEWS

REGISTERED AT THE GENERAL POST OFFICE AS A NEWSPAPER.

No. 3664.— VOL. CXXXV.　　　SATURDAY, JULY 10, 1909.　　　With Special 36-Page Supplement: SIXPENCE.
　　　　　　　　　　　　　　　　　　　　　　　　　　　　　　　　The Web of the World

The Copyright of all the Editorial Matter, both Engravings and Letterpress, is Strictly Reserved in Great Britain, the Colonies, Europe, and the United States of America.

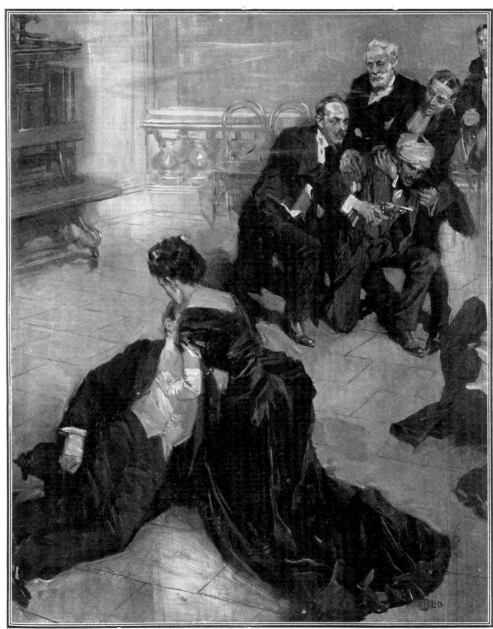

POLITICAL ASSASSINATION IN ENGLAND! THE MURDER OF SIR CURZON WYLLIE - DRAWN FROM MATERIAL SUPPLIED
BY MR. D. W. THORBURN, WHO HELPED TO CAPTURE THE ASSASSIN.

Our drawing was made, as we have noted, from material supplied by Mr. D. W. Thorburn, one of those who witnessed the assassination and helped to hold the murderer until the arrival of
the police, and may be taken as representing accurately the scene the moment after the crime, when Lady Wyllie was bending over the body of her husband and the assassin was in the hands
of his captors. The crime takes the greater significance when it is remembered how rare is political assassination in this country. At the inquest a verdict of Wilful Murder was returned
against Madar Lal Dhingra, "25, a native of the Punjaub, described as an engineering student."—[DRAWN BY OUR SPECIAL ARTIST, CYRUS CUNEO.]

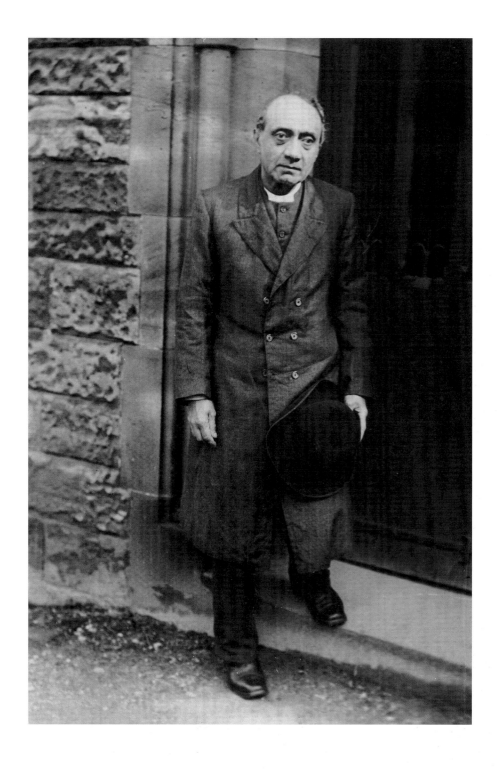

Shapurji Edalji was Vicar of Great Wyrley, Staffordshire. A converted Parsee, his wife was from Scotland and the family experienced much prejudice. (1900)

Facing page: Artist's impression of the assassination of Indian Army officer Curzon Wyllie by student Madan Lal Dhingra, Imperial Institute, London. (1909)

Previous pages: Indian troops serving with the British Army pray outside the Shah Jahan Mosque in Woking, Surrey, during the Muslim festival of Baqrid, or Eid al-Adha. (1916)

While political issues were ever present, some Asians caught the public eye for different reasons, such as the much-publicized case of George Edalji – a dramatic story taken up by contemporary author Julian Barnes in his 2005 novel *Arthur & George*. Vicar of Great Wryley from 1873, George's father, Reverend Shapurji Edalji, was married to an

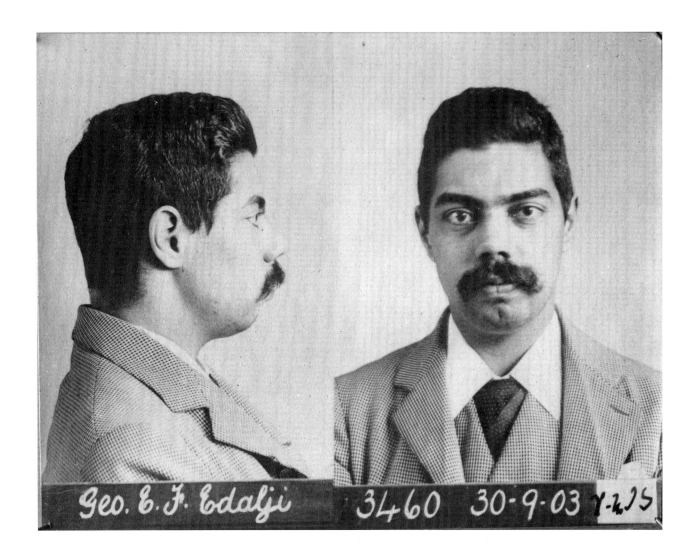

Geo. E. F. Edalji 3460 30-9-03

West Midlands solicitor George Edalji was wrongfully convicted of horse maiming. After a campaign by Arthur Conan Doyle, he was acquitted in 1907. (1903)

Englishwoman, Charlotte Stoneham. After twenty years of living within a small Staffordshire community, their son was wrongly accused of horse maiming and imprisoned. A highly unusual charge, it was most likely racially driven and the culmination of twenty years of sustained abuse by some keen to defame their vicar and his mixed-race offspring. Interestingly, the injustice of Edalji's plight resulted in wide media attention and Arthur Conan Doyle (of Sherlock Holmes fame) pressed hard for his release. After much publicity, over 10,000 signed a petition for retrial as it was clear that this respected young solicitor could not possibly have committed the crime. George was finally freed after three years and his legal case became a trailblazer, eventually prompting moves to establish a criminal court of appeal in Britain.

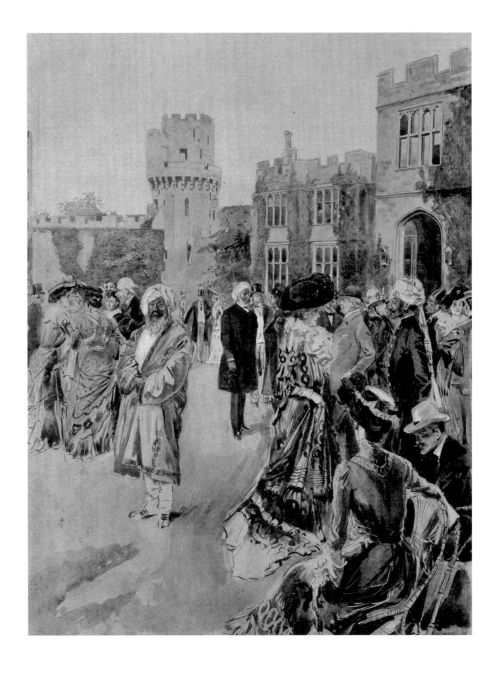

Lord and Lady Warwick's reception for Indian and colonial guests at Edward VII's coronation. Baba Khem Singh Bedi (centre) attended as an official representative of the Punjab. (1902)

At the other end of the spectrum, an early fascination with celebrity culture flagged up the exotic lifestyles of rich Indian princes as they mixed with British royalty at polo and cricket matches, attended country shoots, state balls and parties. Among many notables were the Maharaja of Patiala and Sir Pratab Singh of Jodhpur, whose mid-calf riding breeches famously created a fashion trend. Although the press liked to stress the oriental flamboyancy of these princes, focusing on their appearance, affluence or sporting prowess, some, such as the

The Maharaja of Patiala, Bhupinder Singh, representing the Indian Chamber of Princes, attends a conference. A philanthropist, he funded the first Sikh temple in Shepherd's Bush, West London. (1928)

knighted Maharaja of Patiala, made significant political contributions to the war effort in 1914–1918 as well as future international relations.

Perhaps most significant was the attention lavished on Kumar Ranjitsinhji. A Cambridge student from Trinity, Ranjitsinhji, like many later, became a major British cricket star. Though not the first Asian to play cricket in Britain, he was the first to play for England.

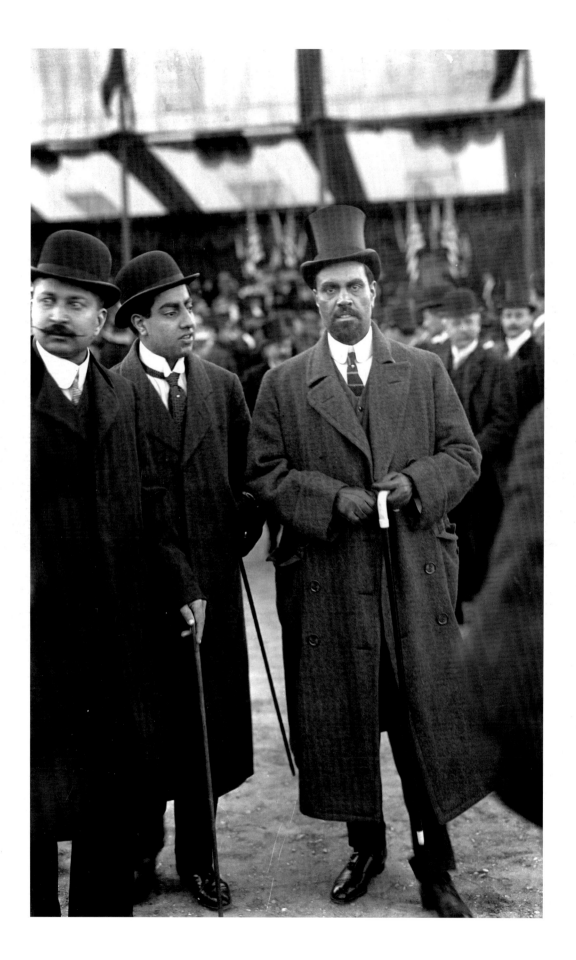

The Maharaja of Kapurthala. Indian royalty travelled extensively to Britain, often staying for long periods of time and owning property there. (1910)

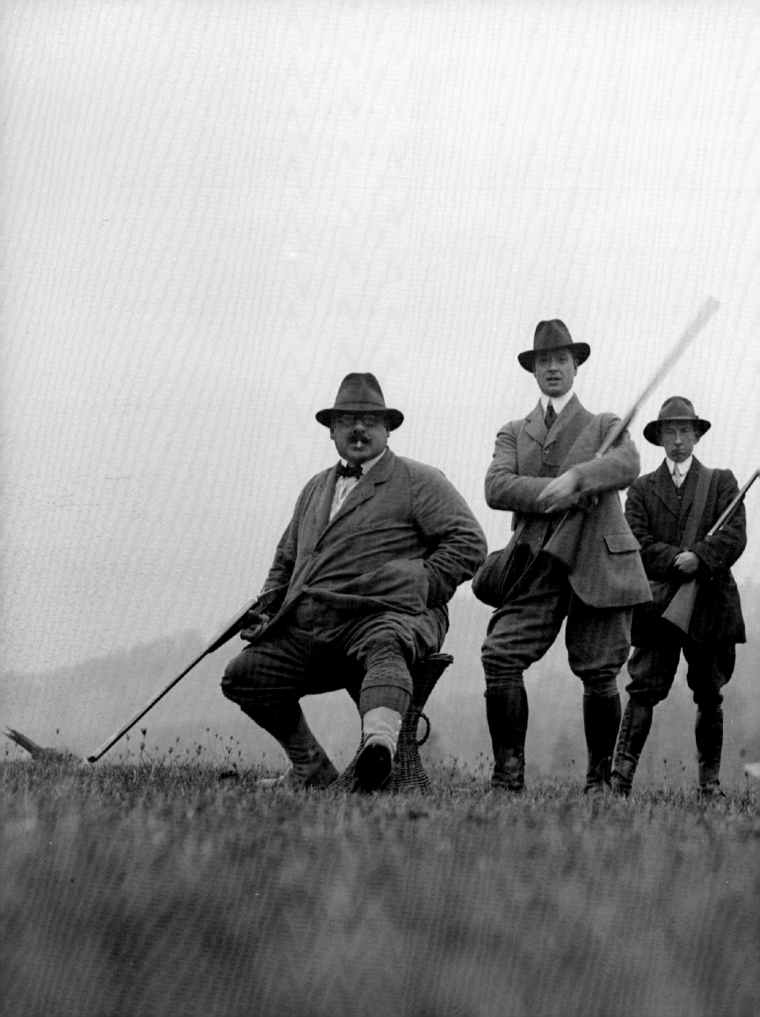

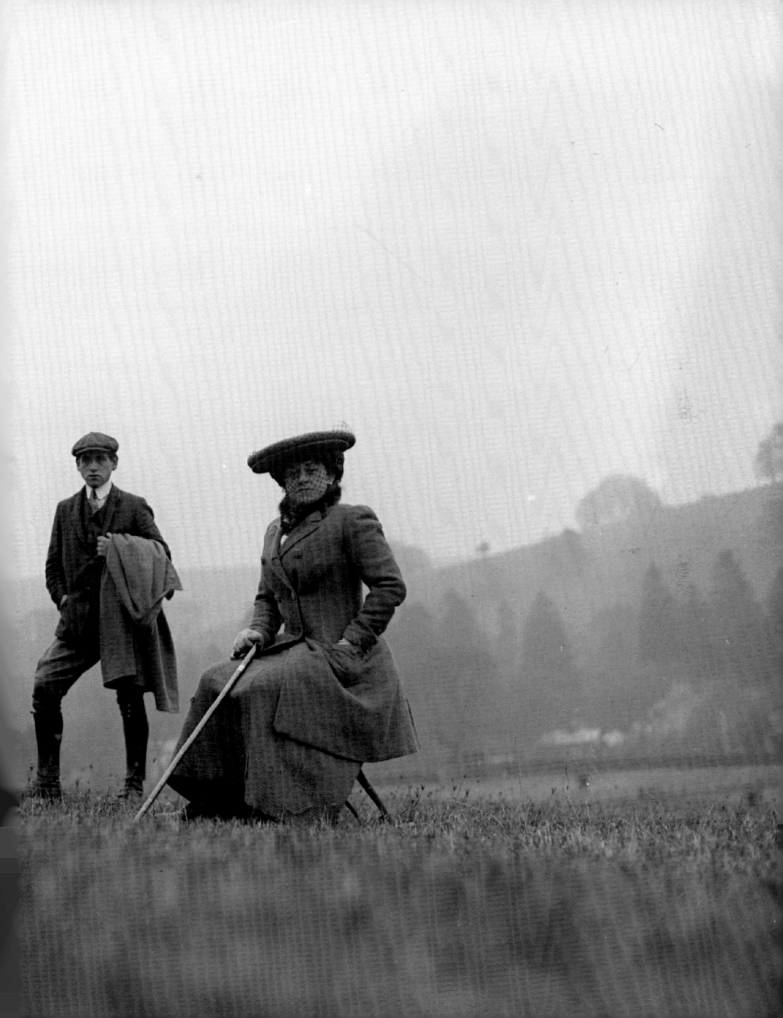

Air travel further improved transport links between Britain and India. Sir Shri Umaid Singhji, the Maharaja of Jodhpur, with his sons at Croydon aerodrome. (1932)

Previous pages: Mrs Henry Coventry and Prince Victor Duleep Singh during a pheasant shoot at Stonor Park, Henley-on-Thames. (1911)

An esteemed member of the Sussex Country Club, his batting success over nine seasons turned him into a legend. The high point was when he 'saved England' in a disastrous match against Australia in 1896. Rather like patriotic support for football today, Ranji (as he came to be known) was celebrated on cigarette cards and inspired rousing cricket songs. Not unlike the Duleep Singh family, Ranji lived the life of a well-heeled British country squire, first in Yorkshire and later in Ireland, where he purchased Ballynahinch Castle. The first in a long tradition of cricketers leading up to players such as Monty Panesar today, his nephew represented England in the 1930s and the Nawab

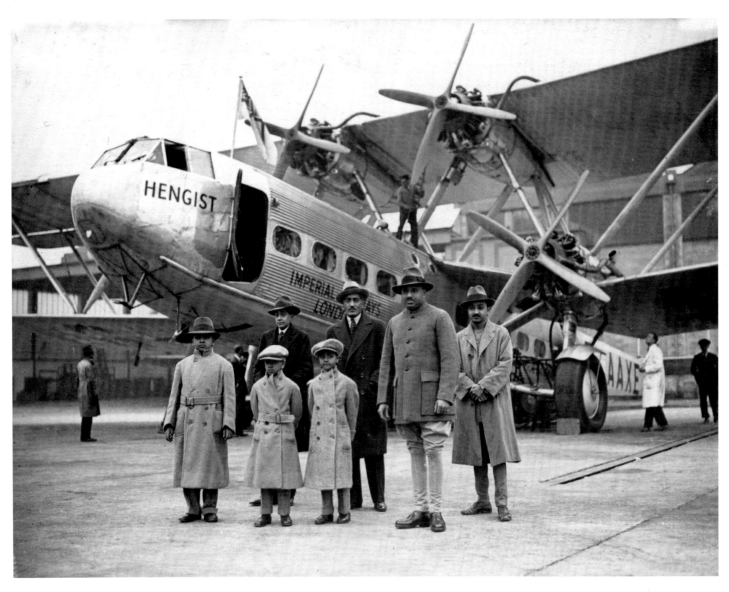

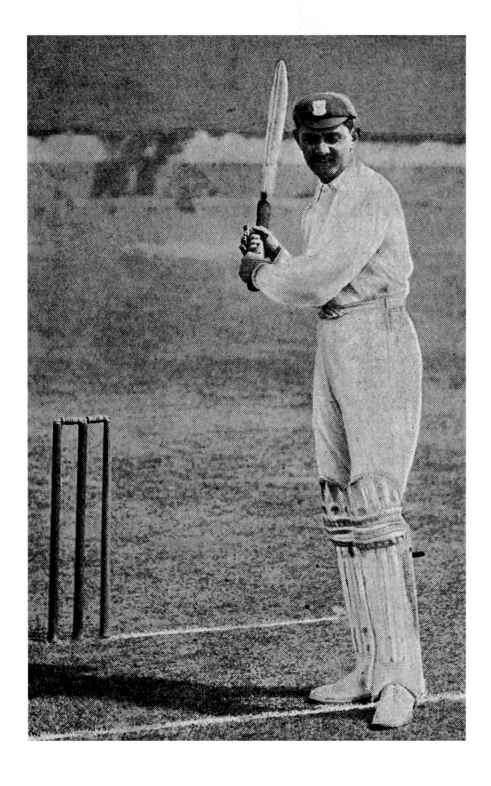

K. S. Ranjitsinhji studied at Trinity College, Cambridge. He played for Sussex and was selected for the England team in 1896. (1896)

of Pataudi, also a prince, followed in the 1940s.

By the turn of the twentieth century, the activities of a wide range of religious, artistic and student associations, both Asian and British-led, began to impact on the fabric of public, domestic and artistic life.

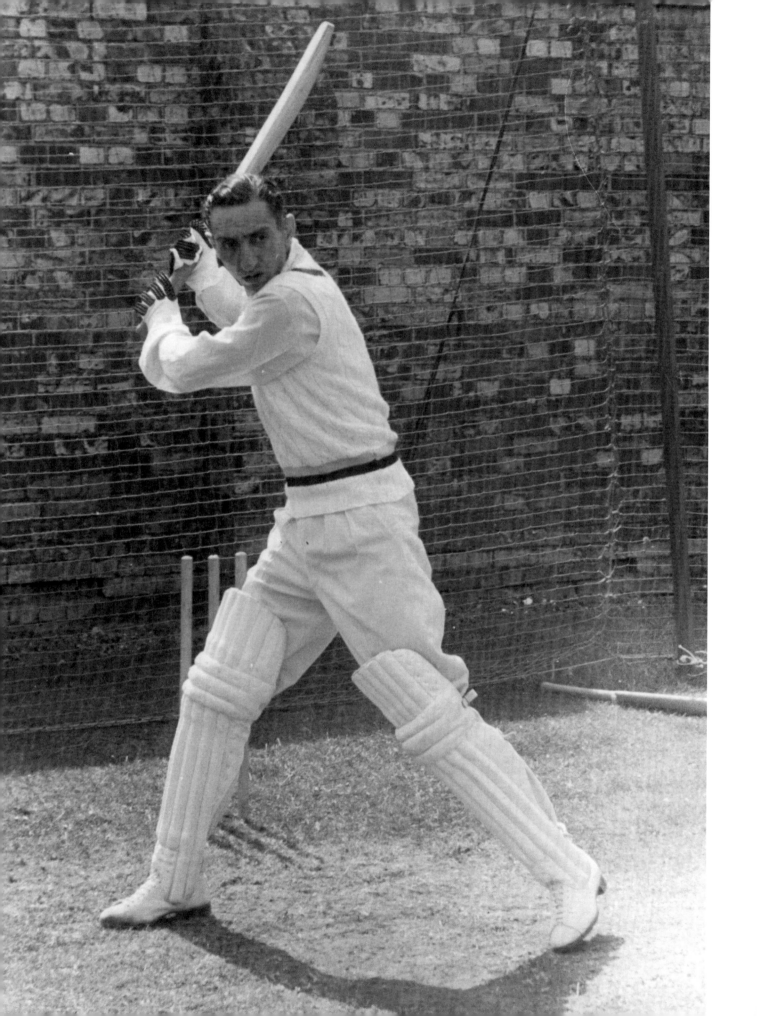

The National Indian Association, a portal for incoming university students, opened branches in several cities. Various other faith-based societies, as well as British-Indian run groups such as the East India Society or Theosophists, spearheaded by Indian Home rule supporter and feminist Annie Besant, were common. Perhaps one of the most notable examples of such cross-cultural interactions was in the arts, where the lifelong friendship between artist William Rothenstein, founder of the India Society in 1910, and poet Rabindranath Tagore, winner of the 1913 Nobel Prize in Literature, sparked a widespread debate on the sometimes blinkered premises of Western cultural,

Annie Besant, President of the Indian National Congress from 1917 to 1923, with fellow theosophist Jiddu Krishnamurti. Adopted by her, he lived in Britain from 1912 to 1921. (1933)

Facing page: Cricketer Iftikhar Ali Khan followed in the footsteps of Ranji, scoring a century against Australia during his test match debut. (1946)

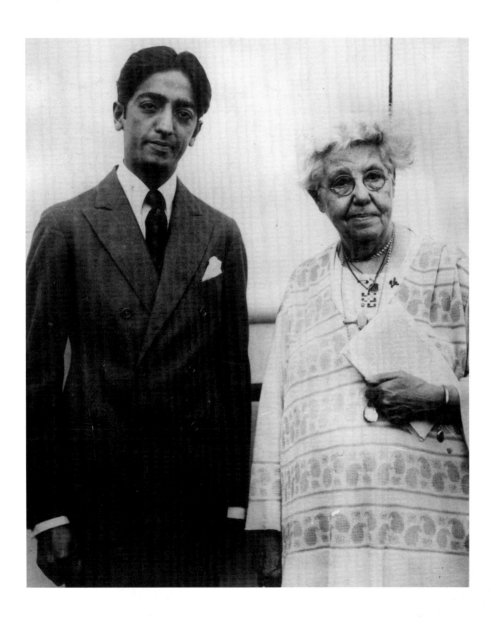

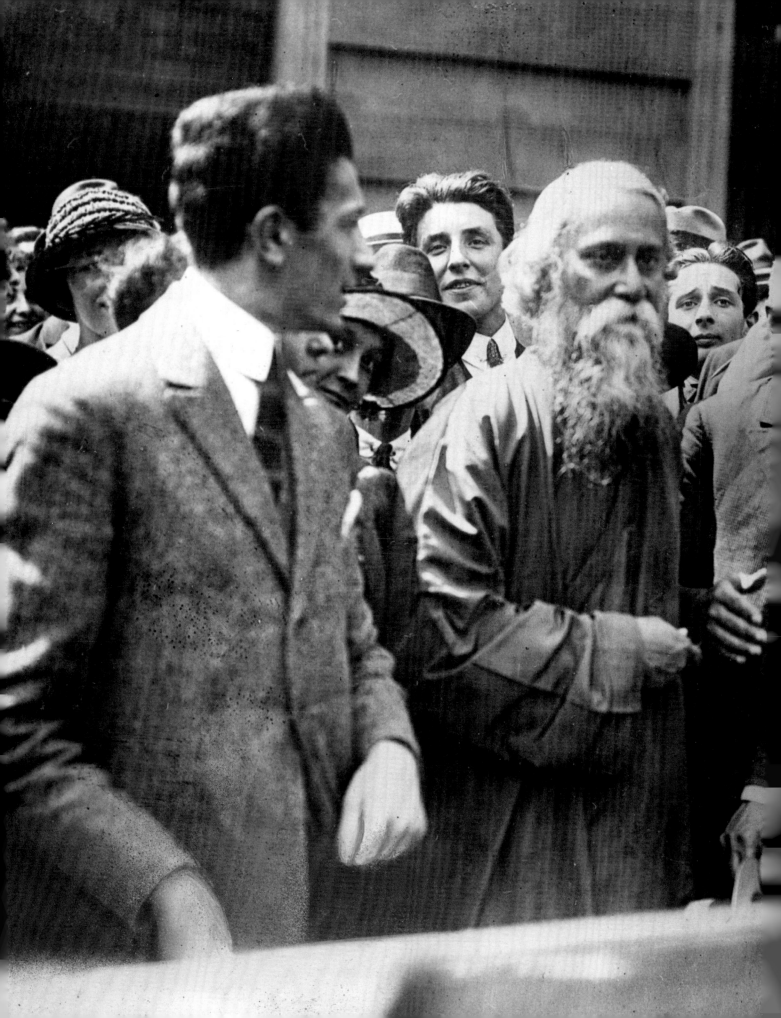

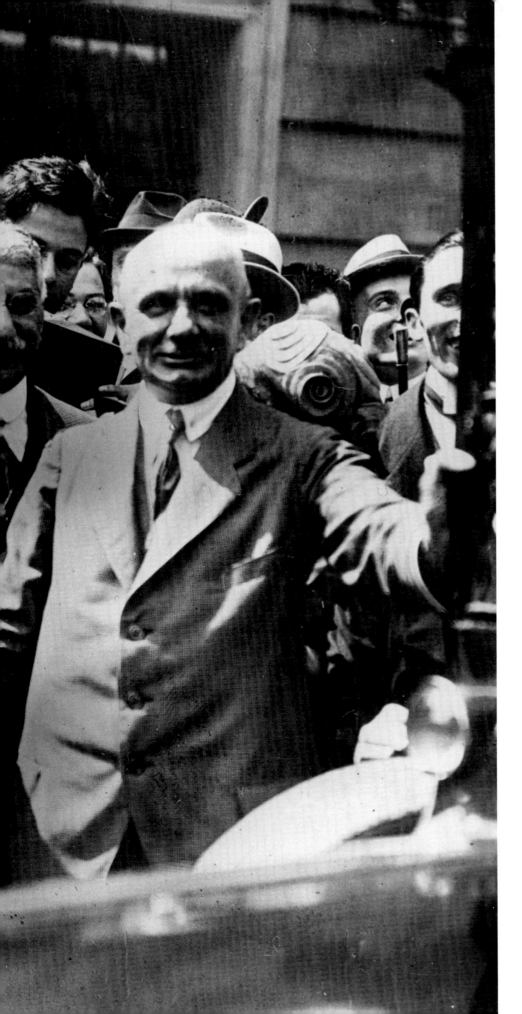

Indian poet and philosopher, Rabindranath Tagore, the first Indian to win the Nobel Prize in Literature in 1913. (1921)

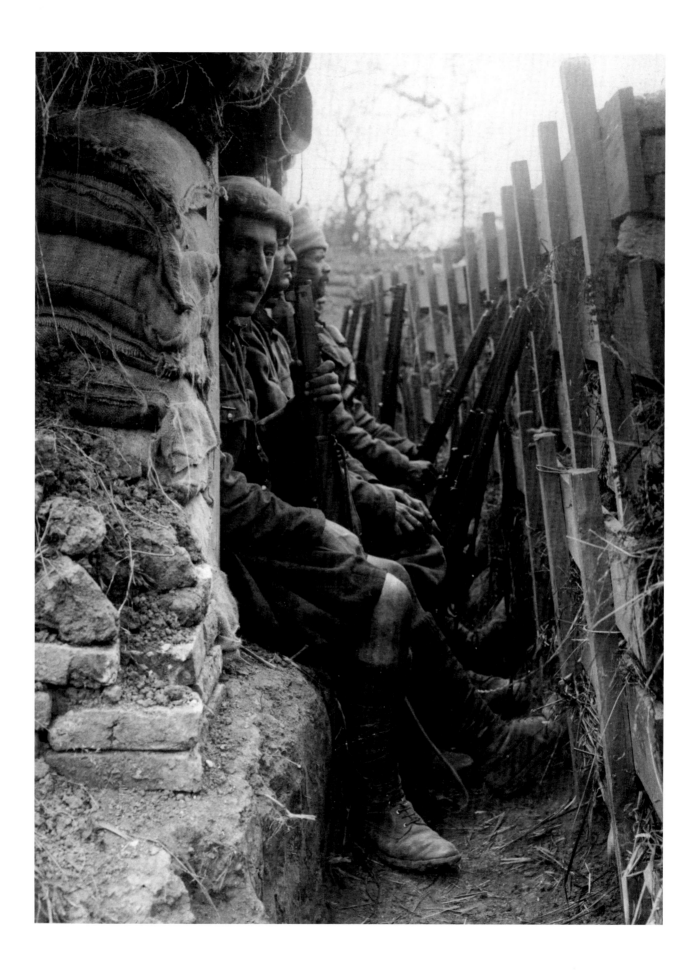

Indian Army and British Army cavalry playing football together in a rare moment of respite. (1915)

Facing page: Men of the Black Watch and Indian Dogra soldiers positioned in a trench on the Western Front. (1915)

spiritual and aesthetic superiority. Impacting on mainstream figures, such as the Irish poet W. B. Yeats, such exchanges stretched across a wide spectrum of the visual, literary and dramatic arts, beginning a process of cross-cultural fusion, now a key dimension of contemporary postcolonial British culture. Moreover, as Britain moved towards the horrors of the Great War, the spiritual breadth of Tagore's humanist vision had such a widespread influence that British war poet Wilfred Owen was found to have died on the Western Front with some lines by Tagore in his coat pocket.

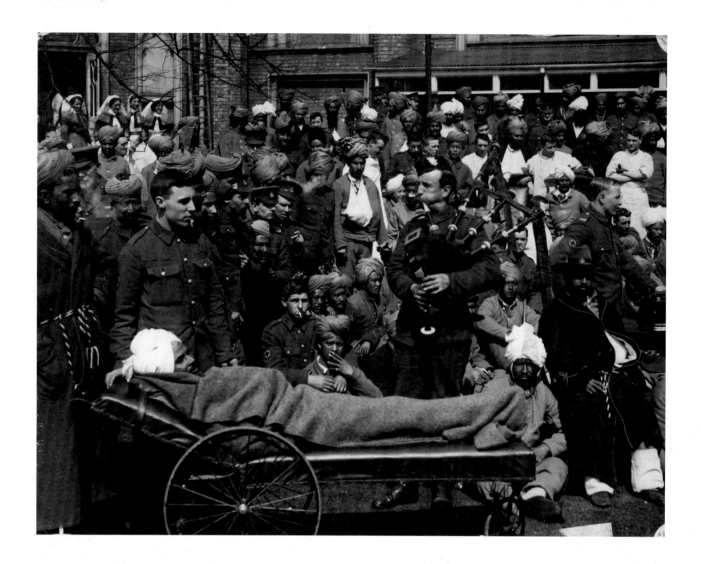

A group of wounded Indian soldiers at the Kitchener Hospital, Brighton, entertained by a bagpiper. (1915)

Facing page: Convalescent Indians in the grounds of Brighton Pavilion Hospital, and others out for their march through the town. (1915)

World War One was a defining moment in Indian-British relations as it was the first time Indians participated in direct combat in Europe. Although this was not originally envisioned, when the British Expeditionary Force was almost decimated in the first two days of war, support from India became essential. Over 1.4 million troops, the largest force outside Britain, participated in all the theatres of the war and 138,000 served on the Western Front, fighting alongside British soldiers in the trenches. Whether in India or Britain, Indians as imperial citizens rallied to the cause, putting King and country before their own political differences and needs. Perceived as an opportunity for India to prove its equality once and for all, some of the political elite developed expectations, later deflated, that participation in the war might help India gain the Dominion status already offered elsewhere

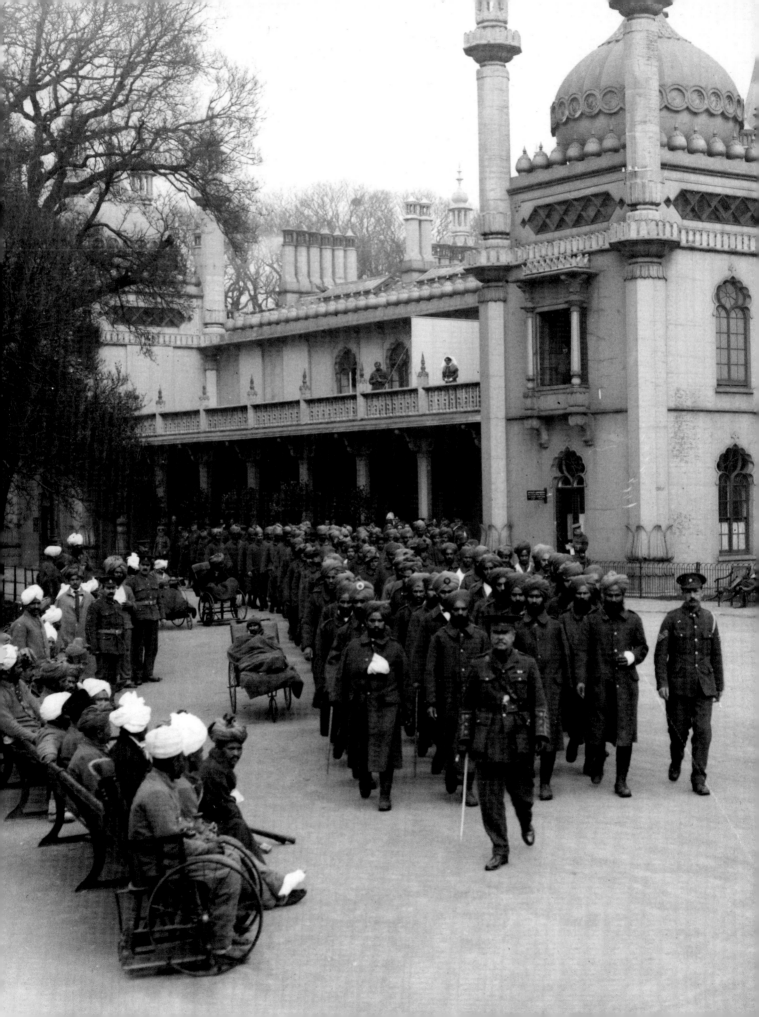

An Indian soldier
in front of the
entrance to the
cemetery for
Muslim soldiers at
Woking. (n.d.)

to Britain's white colonies. The princely states committed resources, troops and large amounts of money to bolster the Treasury. At the same time, political leaders such as Naoroji swallowed their differences and encouraged volunteers to sign up. In Britain, Gandhi encouraged Indian residents to commit wholeheartedly to the wider global needs of the Empire and mobilised an Indian Volunteer Corps. Made up of doctors, nurses and some students who acted as interpreters, the Corps helped to care for the Indian wounded in the special military hospitals set up in towns like Brighton and Bournemouth in the south of England. Yet, although the war was in one sense a leveller which encouraged the British public to recognise the bravery, sacrifices and

substantial losses of the Indian forces, it also pointed to the continuing prevalence of sharp racial divisions and inequalities.

With increasing numbers of casualties and wounded, it became imperative for Britain to publically demonstrate that Indians were going to be on the receiving end of the same medical care as British troops. Bearing this partially propaganda-driven aim in mind, special provision was made to accommodate caste and cultural differences as Indian workers, some from the Strangers' Home, were recruited as cooks, and practices for Muslim burial or Hindu and Sikh cremation

A mixed group of British and Indian soldiers relaxing in a farmyard at Brigade Headquarters. (1915)

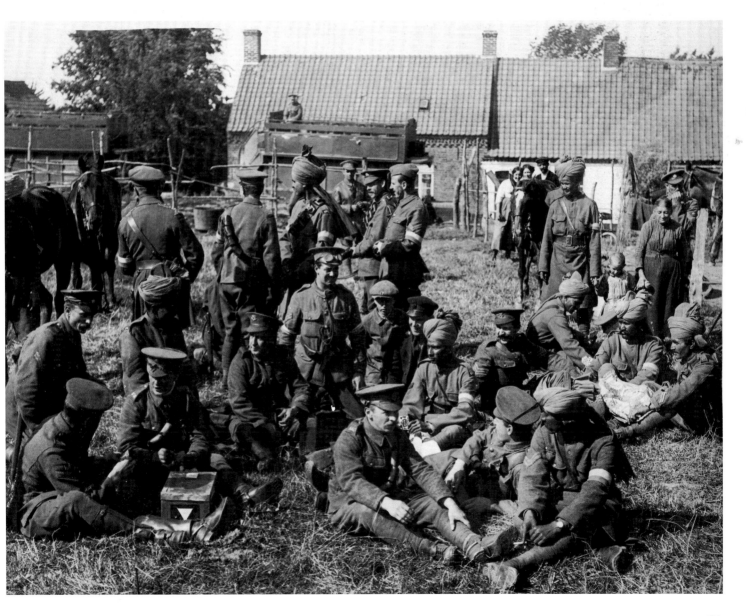

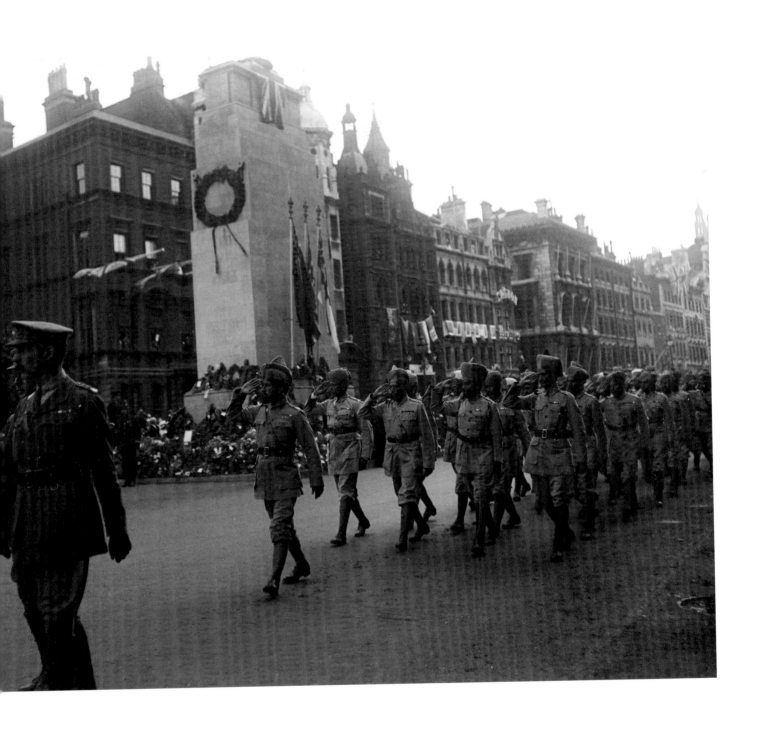

Indian soldiers pass the Cenotaph during the London Peace Day Parade commemorating the signing of the Treaty of Versailles, marking the end of World War One. (1919)

rites were strictly observed. The proximities of surviving conditions in the trenches as well as the large presence of the Indian wounded on British soil should have meant it was difficult to hang on to false racial and cultural stereotypes. Yet strict regulations determining freedom of movement outside the precincts of the hospitals suggested otherwise, a topic addressed in some of the letters soldiers sent home,

which depicted conditions not dissimilar to those of imprisonment. Perhaps most shocking was the resurgence of bigotry regarding the potential contact of these sepoys with English women. Anxieties about racial degeneracy and mixed relations quickly resurfaced with the consequence that, if British nurses were allowed to work in such hospitals at all, it was only in a supervisory capacity.

Although grand narratives of World War One frequently highlight the conditions British soldiers endured on the nation's behalf, such accounts still remain surrounded by absences which fail to include the vital contributions made by Britain's imperial subjects. Though some initiatives are now belatedly beginning to redress such inadequate commemoration (most recently with the inauguration of the Commonwealth Memorial Gates in 2002), major gaps in the story remain, even where there is a wide range of visual evidence readily available in national archives.

The first two decades of the twentieth century had witnessed a sizeable growth in Britain's Asian population, although numbers declined after the war boom. As large sectors of the male British population were signed up, urgent labour needs meant that many lascar seamen, previously targeted for repatriation, found lucrative employment onshore in London, Sheffield, Liverpool and Glasgow. Others, often artisans or mechanical engineers from Bombay and the Punjab, were invited to Britain to work in the munitions or shipbuilding industries. In addition, companies such as Tate & Lyle, the sugar producer, ignored previous legislation which had restricted the rights of the Asian maritime workforce, making the most of the opportunity to supplement their production lines with this readily available and cheap source of labour.

Perhaps not surprisingly, this situation changed dramatically after 1918, when the government reverted to its pre-war policies of debarring Britain's Asian imperial subjects from their rights. In addition, returning British soldiers began to agitate against the

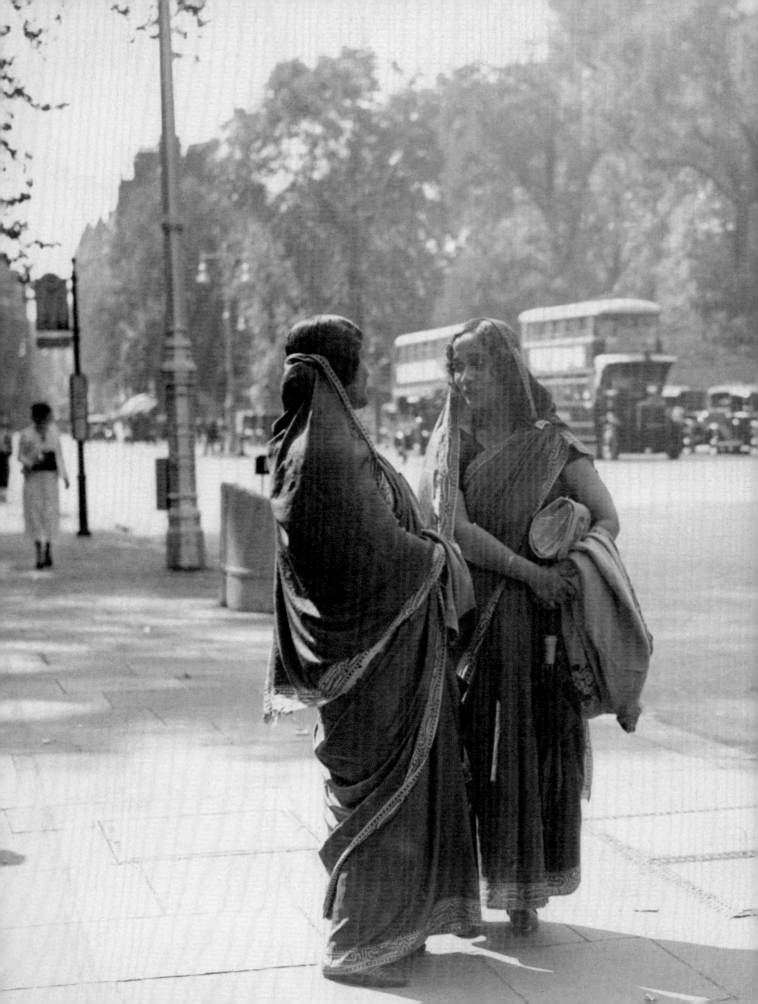

Women standing at a bus stop opposite London's Hyde Park. (1935)

Following page: A group of Sikh men standing outside Hyde Park Corner Underground station. (1935)

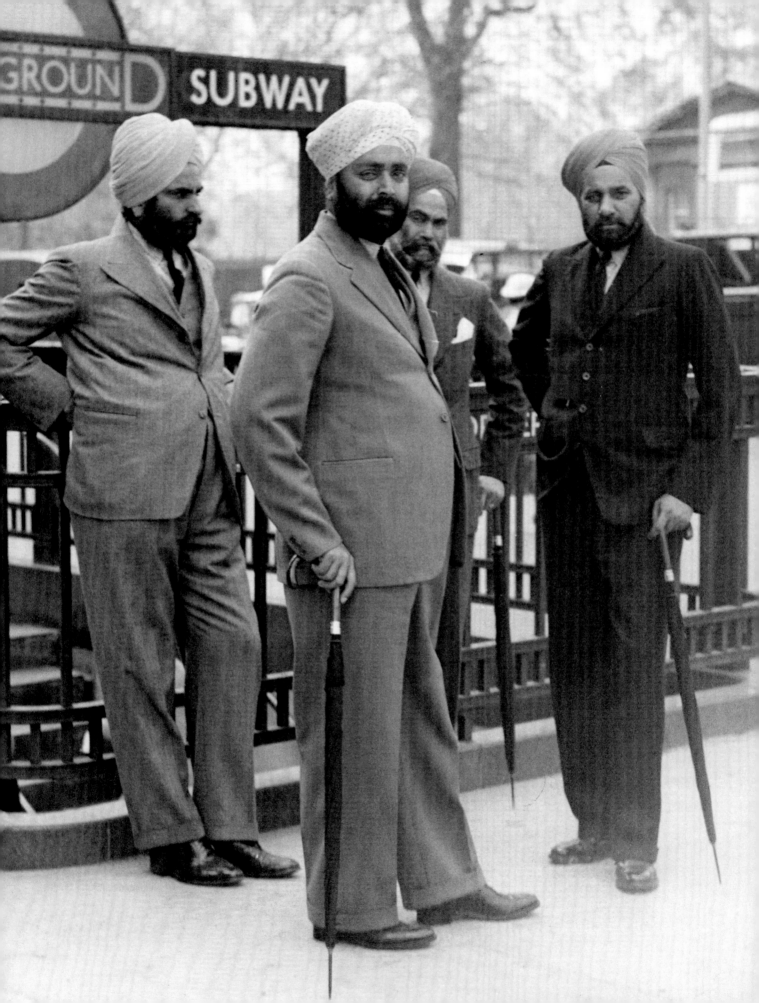

perceived usurpation of their jobs. As tension mounted, the 1919 Aliens Act provoked widespread riots across the country, unifying the discontent felt by black, Asian, Chinese and Malay seamen, many of whom had served loyally on naval vessels during the war. The Coloured Alien Seamen Order, which followed six years later and remained in force until 1942, sparked further resistance, exacerbating an already volatile situation by requesting that all 'aliens' prove their nationality with official identity documents. The Home Office well knew that these types of documents were seldom issued to such workers and would, therefore, be unlikely to prove rights of residence.

The exclusionary base of such legislation also targeted the growing pedlar population who were familiar figures in English and Scottish towns in the 1920s and 1930s. Often wrongly accused of being illegal lascars in disguise, some were actually demobilised and stayed on. However, the majority came from rural areas of the Punjab, a region

Below left: Sita Devi Devidoss, who, like Cornelia Sorabji, was one of the first female Indian barristers called to the Bar. (1928)

Below right: Dr A. H. Fyzee played at the 41st Wimbledon lawn-tennis championship. (1921)

Following pages: A family by their air-raid shelter at home in Hither Green, South East London. (1917)

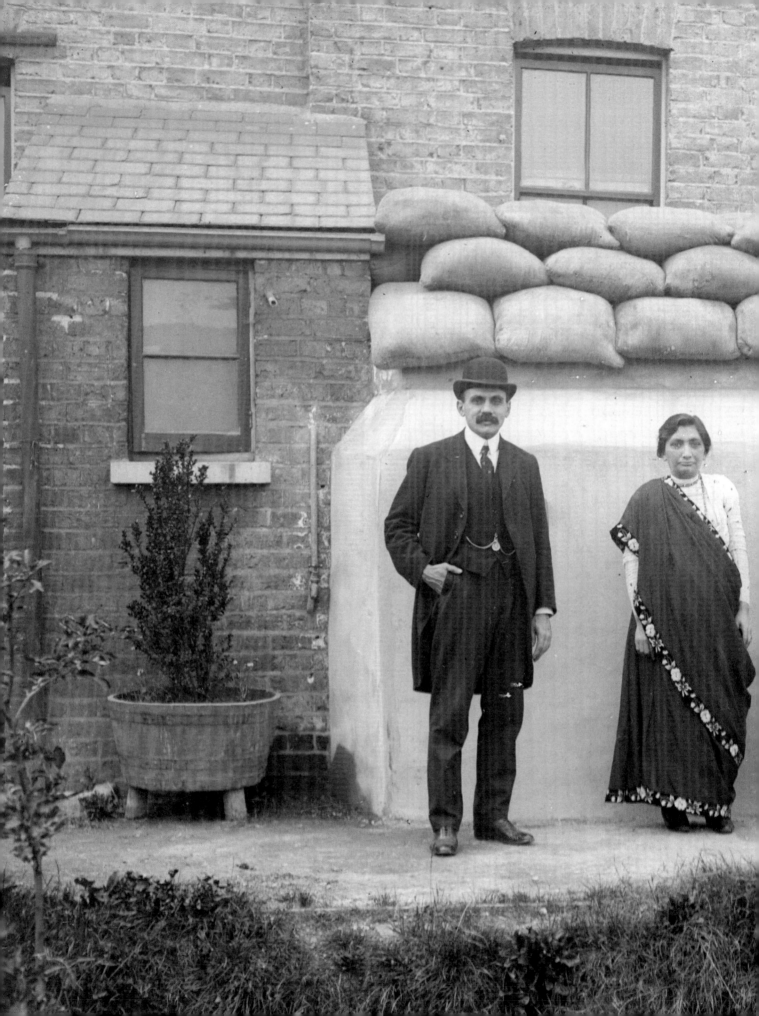

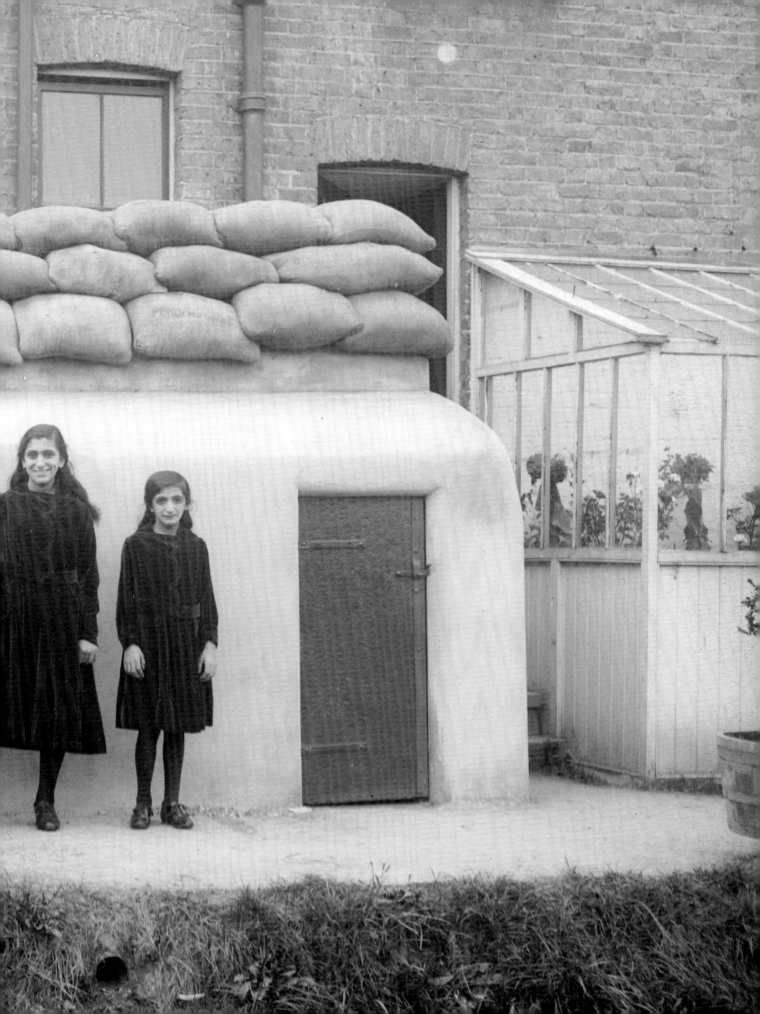

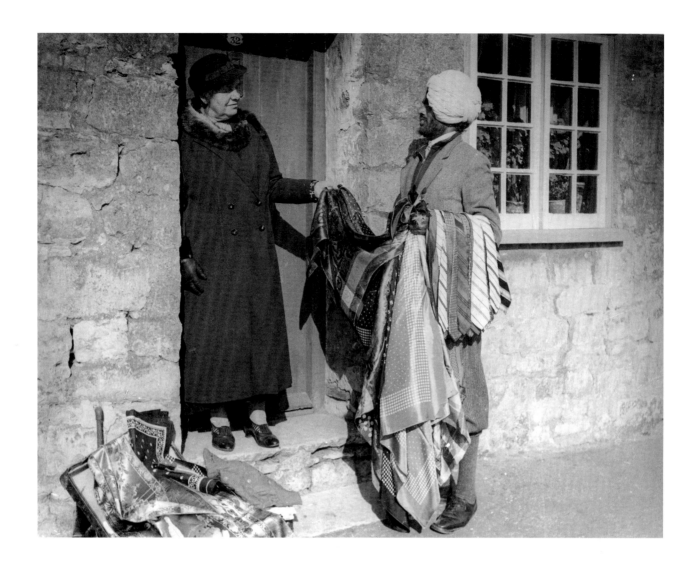

A door-to-door salesman with a selection of wares to sell to British households, a familiar sight in rural Britain. (1930)

already well connected to Britain through army recruitment during the war. As the economy slumped during the 1930s depression, their wares became popular with hard-pressed English housewives. And the cottons, silks and woollen fabrics they carried paved the way for the growth of several Asian-led textile and clothing companies as the century progressed.

Interestingly, but perhaps not surprisingly, official requests for identity documents did not extend to the middle- or upper-class elites. Many had either been issued with special passports detailing their occupational suitability by the Indian government or were simply allowed to remain in Britain without them. To highlight these disparities, the case of Lord Sinha, purported to have become a

member of the House of Lords without a birth certificate, was taken up as a flagship case by the Swaraj League. Although primarily a group of radical Indian nationalists, the League operated with the full support of the British Communist Party. Both anti-colonial and anti-capitalist, the Communist Party had established links with Indian students by the 1930s. Some were perhaps inspired by the example of Rajani Palme Dutt, one of the party's founding members and also an influential voice in the growing British labour movement. Such campaigns also attracted the support of Shapurji Saklatvala, Britain's

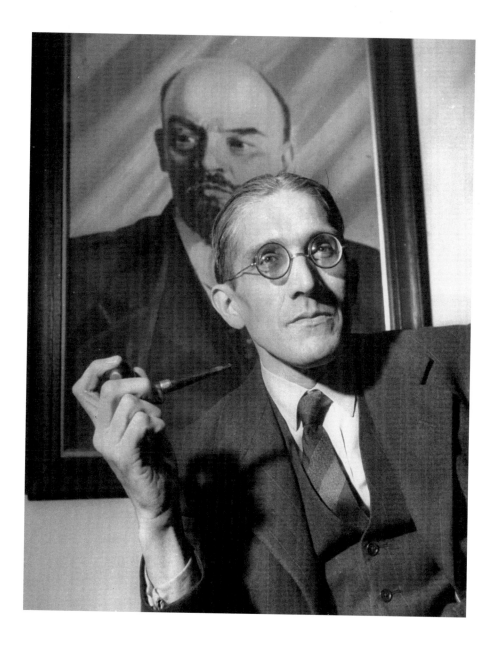

Rajani Palme Dutt, son of a Cambridge-based Bengali doctor, was a leading figure in the British labour movement. With his brother Clemens, he was a founding member of the Communist Party of Great Britain. (1944)

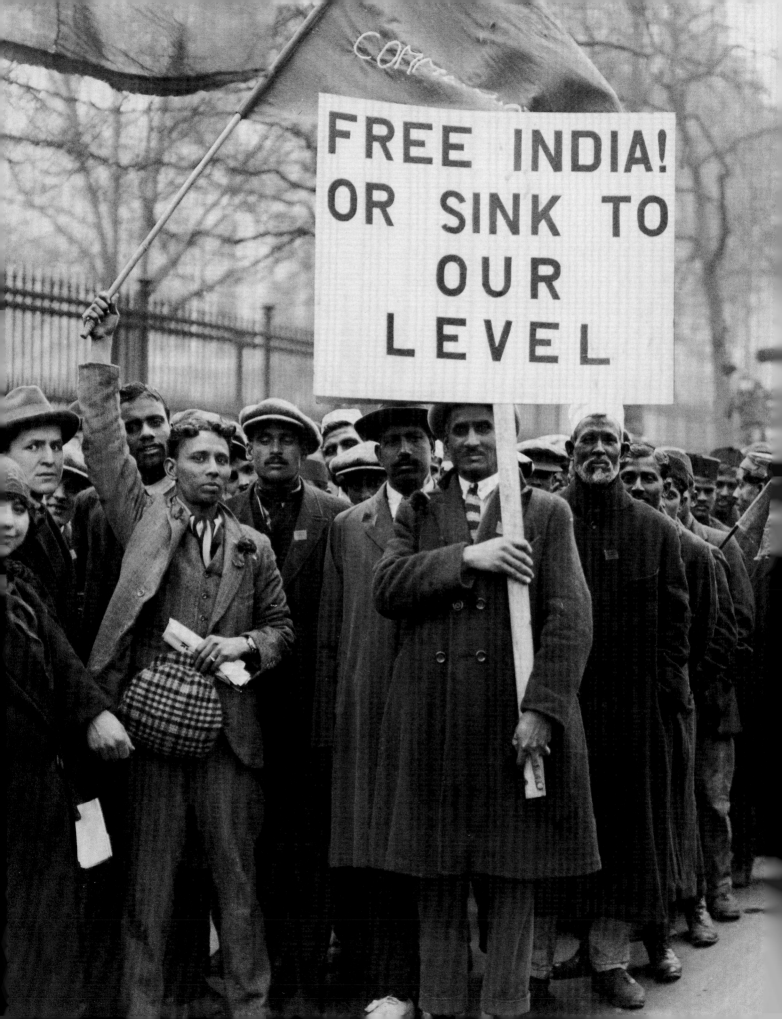

third Asian MP. President of the Seamen's Union and an active trade unionist, Saklatvala, who was a persuasive speaker, was often to be heard denouncing imperial rule and the conditions of the British working classes. MP for Battersea North in 1921, Saklatvala was a friend of Sylvia Pankhurst. He was re-elected between 1924 and 1929.

Increasing awareness of racial and social discrimination

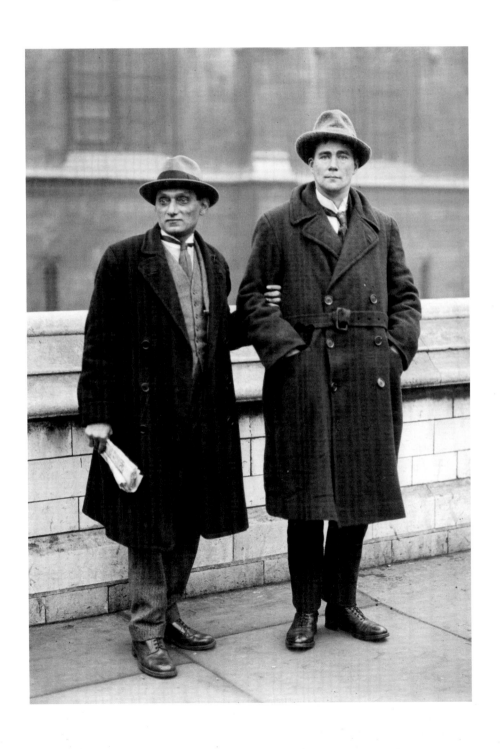

The Communist MP for Battersea, Shapurji Saklatvala (left), at the opening of parliament. With him is the MP for Motherwell, Walter Neubald. (1922)

Facing page: Many South Asians were activists for greater equality and social justice. Here a group protests at a May Day demonstration. (1940s)

Following pages: Shapurji Saklatvala addresses crowds at Speakers' Corner, Hyde Park, calling for the release of the Reichstag Fire suspects in Germany. (1933)

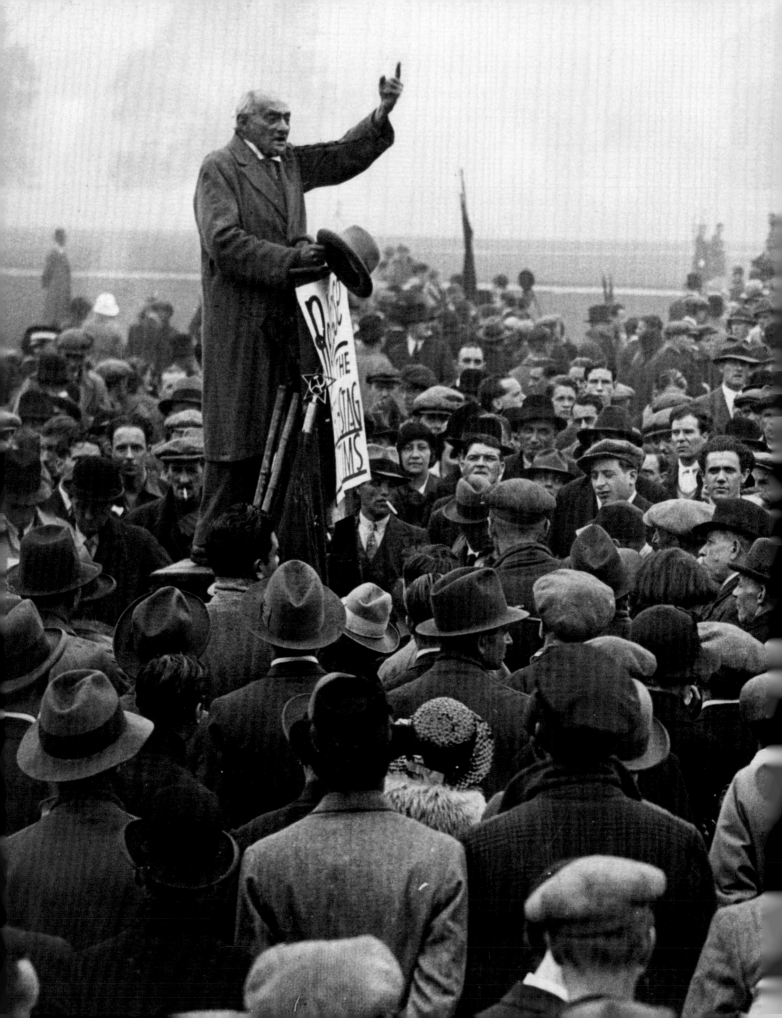

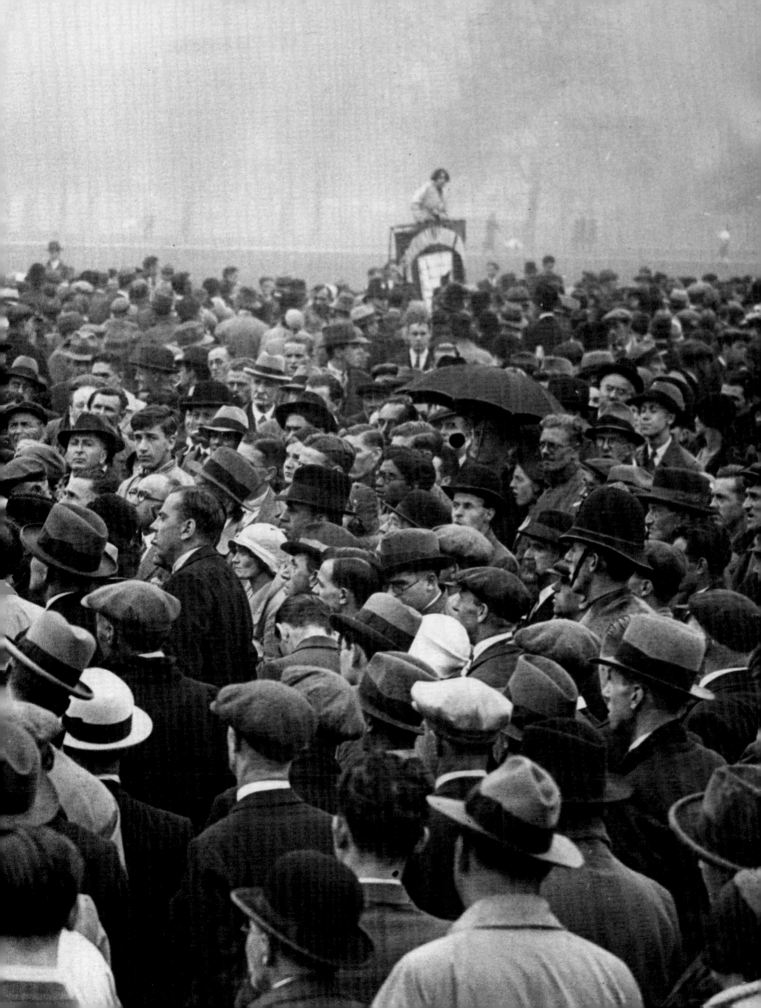

combined with the resurgence of nationalist movements added further fuel to a growing scepticism with the imperial façade of justice and democracy. In addition, the vision of Britain as the epitome of a civilised nation had been significantly undermined by the atrocities encountered at the 'heart of whiteness' during the Great War. As the promise of Dominion status receded from view, events in Amritsar in 1919, provoked by a senior British military officer ordering fire on 379 innocent Indian civilians, added to the growing sense of injustice and betrayal among Asians in Britain. The political reverberations of the Jallianwala Bagh massacre were significant and marked a watershed moment, polarising future political relations. The much-feted British celebrity and Nobel Laureate Rabindranath Tagore immediately renounced his knighthood and Mohandas Gandhi, fast gaining international recognition as the iconic 'Mahatma' and leader of the freedom movement, garnered mass support during his civil disobedience campaigns. Clad in white *khadi*, he returned to London in 1931 as representative for the Indian National Congress at the second Round Table Conference. Attracting a great deal of coverage in the British press, Gandhi's provocative dress statement provoked

Mahatma Gandhi arriving in Folkestone with poet and activist Sarojini Naidu and P. Pattani for the second Round Table Conference. (1931)

Facing page: Gandhi leaving a meeting at Friends House, Euston Road, London, with India League Secretary, V. K. Krishna Menon (left), and other delegates. (1931)

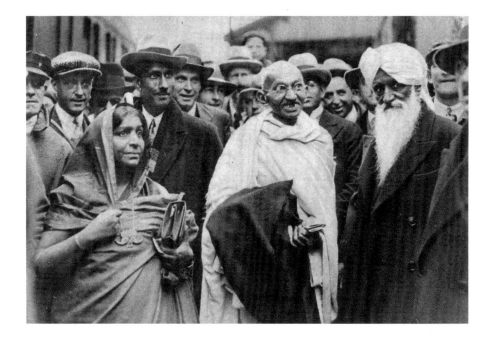

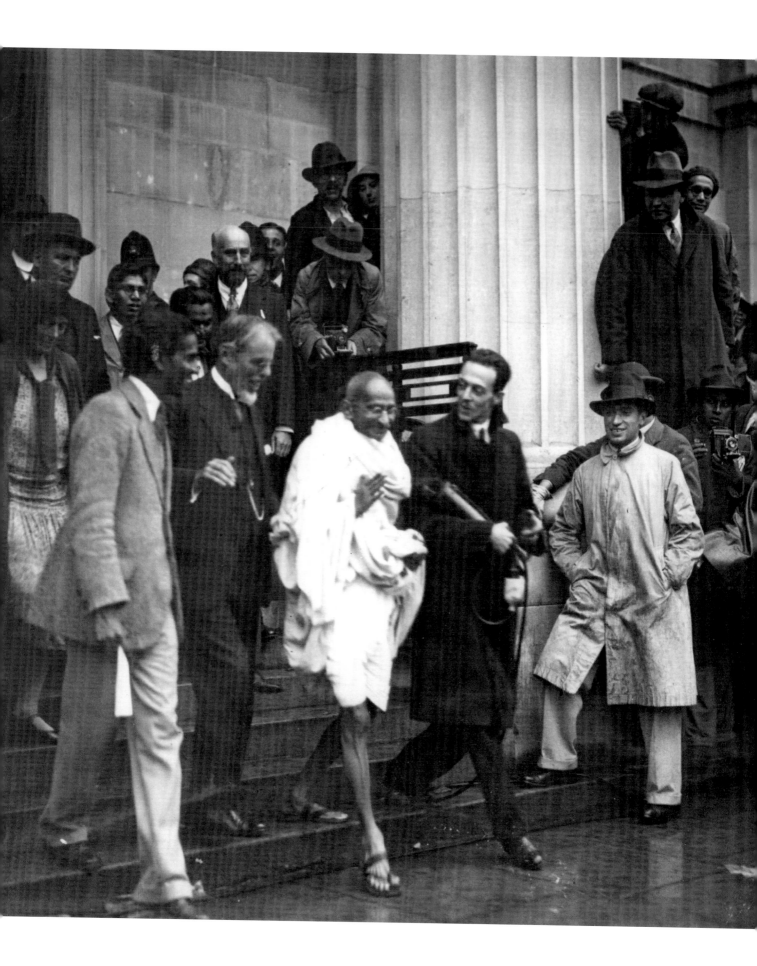

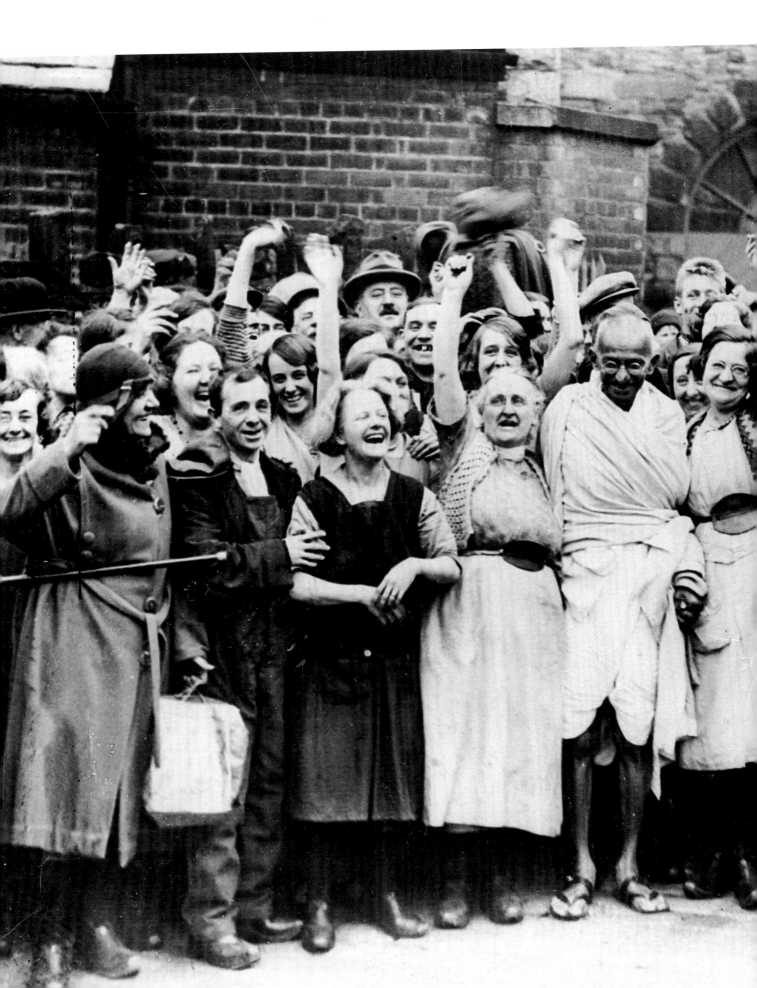

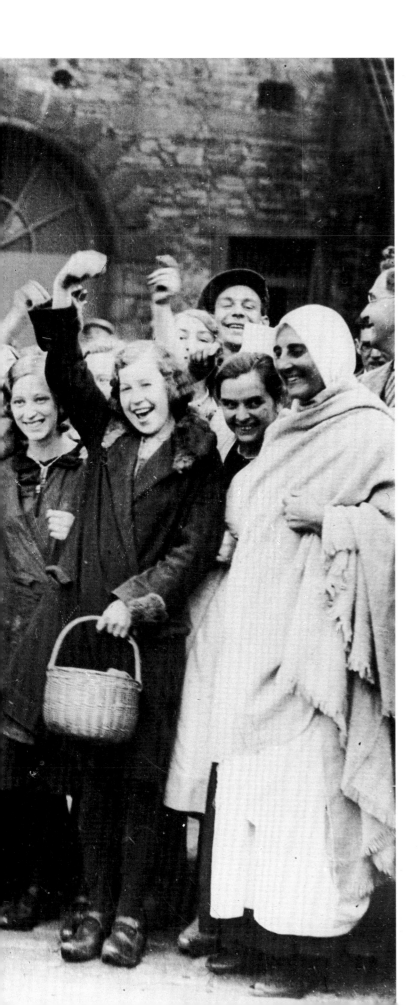

On his visit to Darwen, Lancashire, Gandhi is greeted by a crowd of female textile workers. (1931)

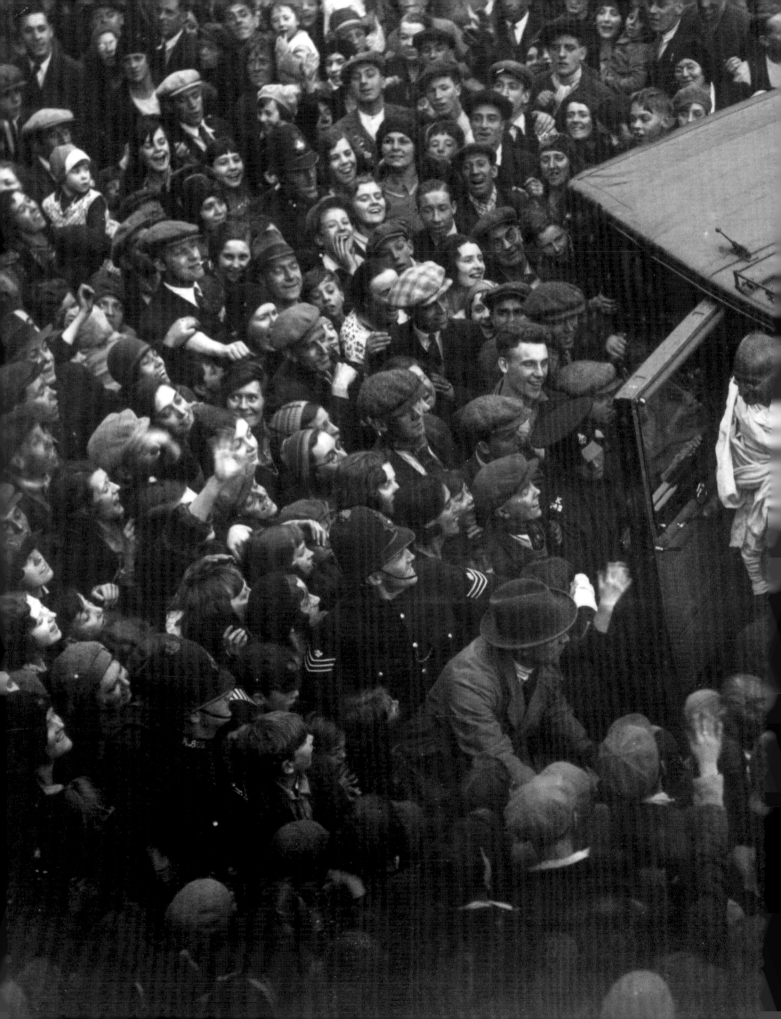

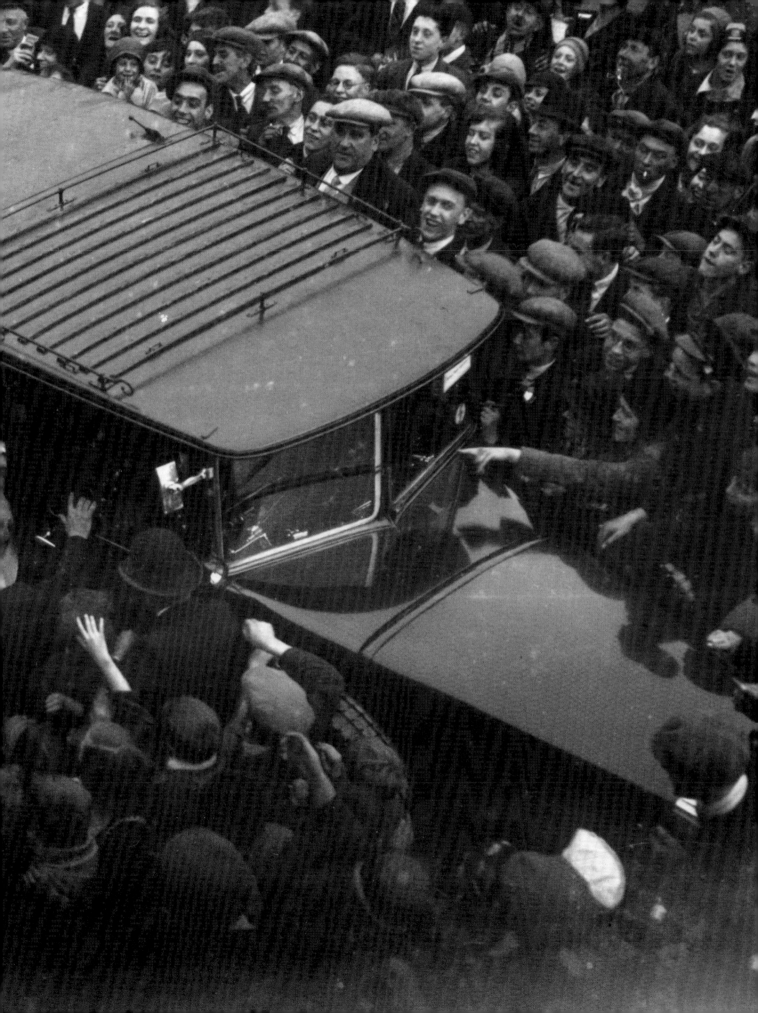

Jawaharlal Nehru addresses a demonstration in Trafalgar Square, London, in support of the Spanish Republican cause. (1938)

Facing page: India League Secretary and St Pancras Councillor, V. K. Krishna Menon was a passionate activist for Indian Independence and social justice in the 1930s and '40s. (1941)

Previous pages: While in London, Gandhi was regularly mobbed by large crowds, here in Canning Town. (1931)

much debate and admiration as his symbolic status and policies of non-violence began to stir the support and imagination of the British Left and the working classes.

Part of the political struggle to achieve freedom from colonial rule was conducted on British soil. Though the periodic arrivals of previously imprisoned Congress Party members, such as Jawaharlal Nehru, later the first Prime Minister of independent India, are well covered in the archives, there is curiously less about the activism of prominent radicals such as Krishna Menon, who led the British-based India League. Elected Labour Councillor for St Pancras, a position he held for thirteen years, Menon was well known for improving social welfare among his Camden constituents. Resigning in 1947 to take up the role as India's first High Commissioner in Britain, a plaque now commemorates his contributions to the borough. A talented

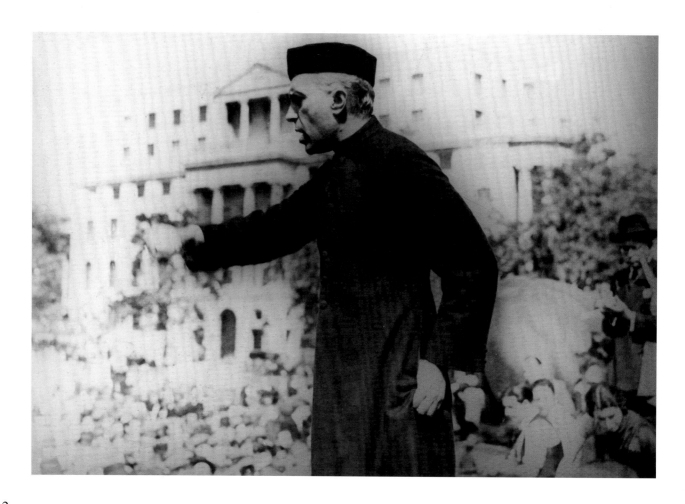

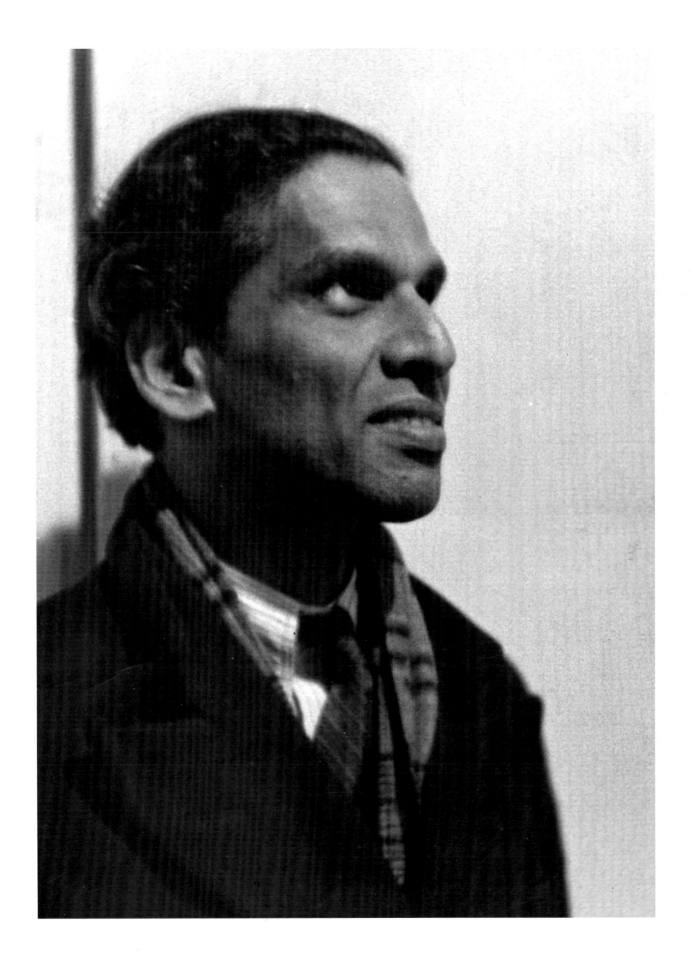

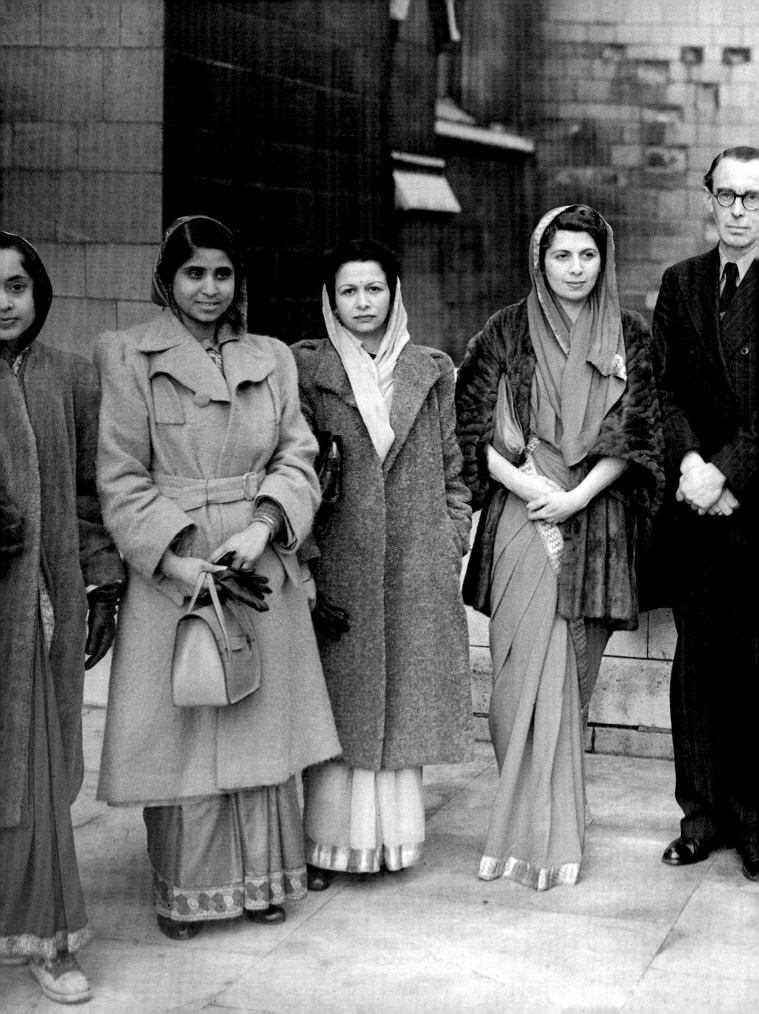

A group of women
lobby Labour MP
Reginald Sorensen
for Gandhi's release.
(1943)

Uday Shankar, former student of Fine Art, poses for William Rothenstein, Principal of the Royal College of Art in the 1920s, during the tour of Shankar's dance troupe. (1934)

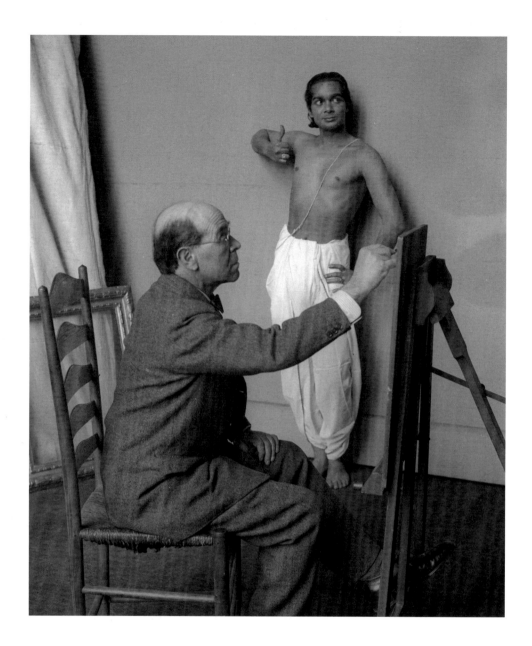

polymath, Menon's vision for a local mobile library service encouraged reading; he also launched the Camden Arts Festival, which continues today. A vocal public intellectual and political campaigner, he was also a meticulous editor. Well-connected in the publishing world, he acted as Nehru's literary agent and was keen to promote the works of key thinkers such as Sigmund Freud, H. G. Wells and George Bernard Shaw by making them available to the public at large. As general editor for the non-fiction Pelican series which he co-founded with Allen Lane, he made sure these paperbacks were cheap and had a wide circulation.

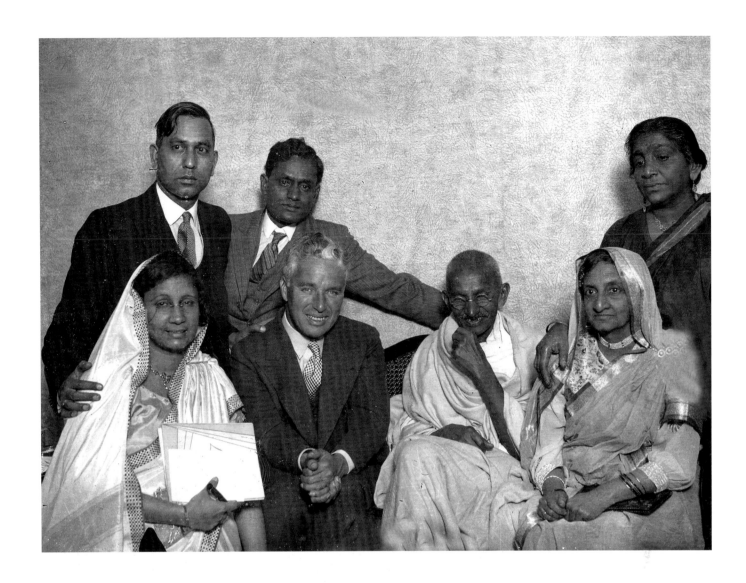

The India League was only one of many pressure groups active at the time, but it was certainly the most influential. Not only did its lobbies operate at different levels, influencing politicians and ordinary workers, but its membership was predominantly English. From the mid-1930s to 1947, Menon tirelessly toured the country, delivering public lectures and distributing pamphlets countering government propaganda. Setting wider global concerns such as the developing fascist threat in Europe alongside the Indian freedom struggle, Menon, with others including the writer Mulk Raj Anand, heightened awareness of the ongoing hypocrisies of imperial rule. The League galvanised a wide spectrum of high-profile support from across the British Left, including Bertrand Russell (chair from 1932 to 1939), Julius Silverman,

East End doctor C. L. Katial set up this meeting at his home between actor Charlie Chaplin and Mahatma Gandhi with his family and fellow campaigner, Sarojini Naidu. (1931)

Britain's acute shortage of doctors led to an increased recruitment drive in India and Pakistan. Since the 1948 launch of the NHS and the mid-1960s, 18,000 doctors were recruited from the subcontinent alone. (1967)

Facing page: Avabai Wadia was a lawyer and activist in the family planning movement. She lived in Britain in the 1930s and was the first Ceylonese woman to be called to the Bar. (1946)

Michael Foot and Ellen Wilkinson. Encouraged by Menon's interests in the arts, numerous concerts, plays and dance events were staged across the country, partly with the aim of demythologising narrow notions of Eastern traditions. Perhaps one of the most exciting performers was Uday Shankar, an outstanding dancer and one-time student of William Rothenstein, at the Royal College of Art.

Life between the wars extended well beyond the platforms

Two unemployed people are served a free meal at Veeraswamy's restaurant in Regent Street, London. (1939)

Facing page: The President of the Sikh community serving his guests. (1938)

of radical political groups. On a daily level, the harsh realities of the 'colour bar' continued to operate, a situation highlighted in a vehement debate by D. F. Karaka, journalist and first Indian president of the Oxford Union. Despite such deplorable hurdles, committed professionals such as Dr Chunilal Katial worked hard to provide adequate health services for all during the depression years, establishing a model later developed nationwide by the National Health Service. Appointed Britain's first Asian mayor, Katial was not

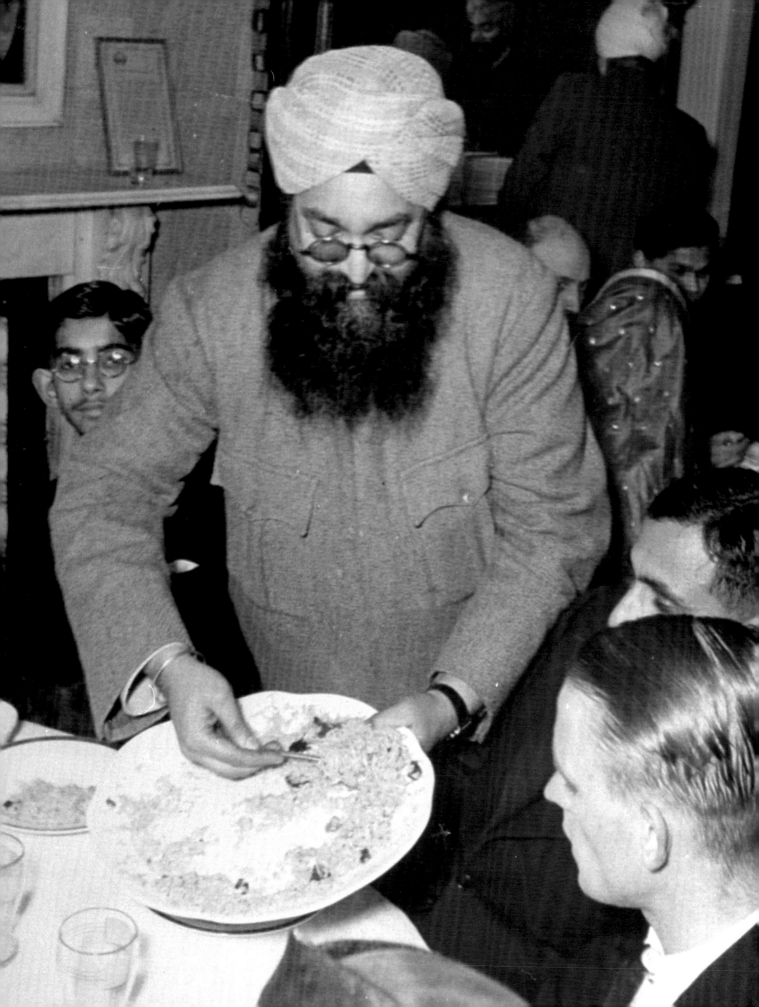

A mixed congregation at the Bhupinder Singh Dharamsala, Britain's first gurdwara at 79 Sinclair Road, Shepherd's Bush. Many Britons with Raj connections joined the Sikh community in weekly prayers. (1938)

alone in his efforts. As statistics from the Indian Medical Association, founded in the 1930s, make plain, there were already 1,000 doctors practising in the UK by the mid-1940s. This support remains crucial to National Health provision today as at least 17 per cent of GPs and 20 per cent of hospital specialists are of Asian heritage.

From another perspective, female barristers such as Avabai Wadia gained a significant reputation through her campaigns with women's groups and her international efforts with the League of Nations. A number of Indian restaurants and food shops also opened during the interwar period, both catering to the needs of a growing Asian population, but also attracting a large British clientele. Precursors to the many restaurants which now operate on most high streets, they

set a culinary trend which is now a key feature of British everyday life as Foreign Secretary Robin Cook was to famously comment in 2001, when he nominated 'chicken tikka masala' the 'British national dish'. In addition, while the visibility of gurdwaras, temples and mosques is seen to be a recent feature of Britain's changing cultural landscape, numerous clubs and societies, such as the Indian Social Club or the Jamiat-ul-Muslimin (Muslim Association) had already begun to cater for the varied needs of their particular religious communities. And though it is not commonly acknowledged, mixed-race marriages and friendships were not at all unusual, despite the fact they were often frowned upon by some people who still held on to fears of miscegenation in wider society.

The Shah Jahan Mosque, Woking, Britain's first purpose-built mosque, attracted a diverse community of Muslims resident in Britain, here celebrating Eid al-Adha. (1937)

Above: An English woman in Hampstead with friends after her marriage to an Indian engineering student from Imperial College, London. (1939)

Below: The same couple on holiday in Wales. (1930s)

Operating at a perhaps more elite level, the artistic networks of writers such as Mulk Raj Anand or Meary James Tambimuttu, founding editor of *Poetry London*, began to create publishing platforms, establishing formative connections across the arts and intellectual life. Some of these groups, which made inroads into the exclusive modernist culture of Bloomsbury, held meetings at West End restaurants, such as Shafi's, whose staff were often drawn, as today, from the Sylheti (Bangladeshi) community. At the same time and with quite different political effects, British film celebrities such as 'Sabu', orphan child star of *Elephant Boy*, or actress Merle Oberon, also impacted on British popular culture.

Mulk Raj Anand with his daughter Sushila from his first marriage to actress Kathleen van Gelder. (1930s)

Above: Meary James Tambimuttu was a writer, critic, editor and publisher. Prominent in 1930s Bloomsbury, he founded the magazine *Poetry London*. It profiled writers Stephen Spender and artists Henry Moore and Barbara Hepworth. (1968)

Below: Shafi's Indian restaurant in Gerrard Street, London, was established in 1920. It was a popular meeting place for Indian students, providing a 'home away from home'. (1955)

Facing page: The artist Francis Newton Souza, founding member of the Progressive Artists Group, gained much recognition in Britain. He also published in *Encounter*, a journal edited by poet Stephen Spender. (1955)

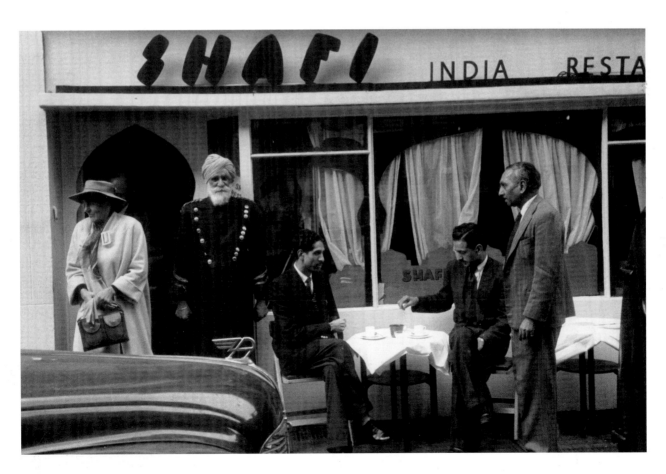

Movie star Merle Oberon sits for Gerald Brockhurst. She hid her South Asian roots to pursue a successful film career and transcend the colour bar in Britain and America. (1937)

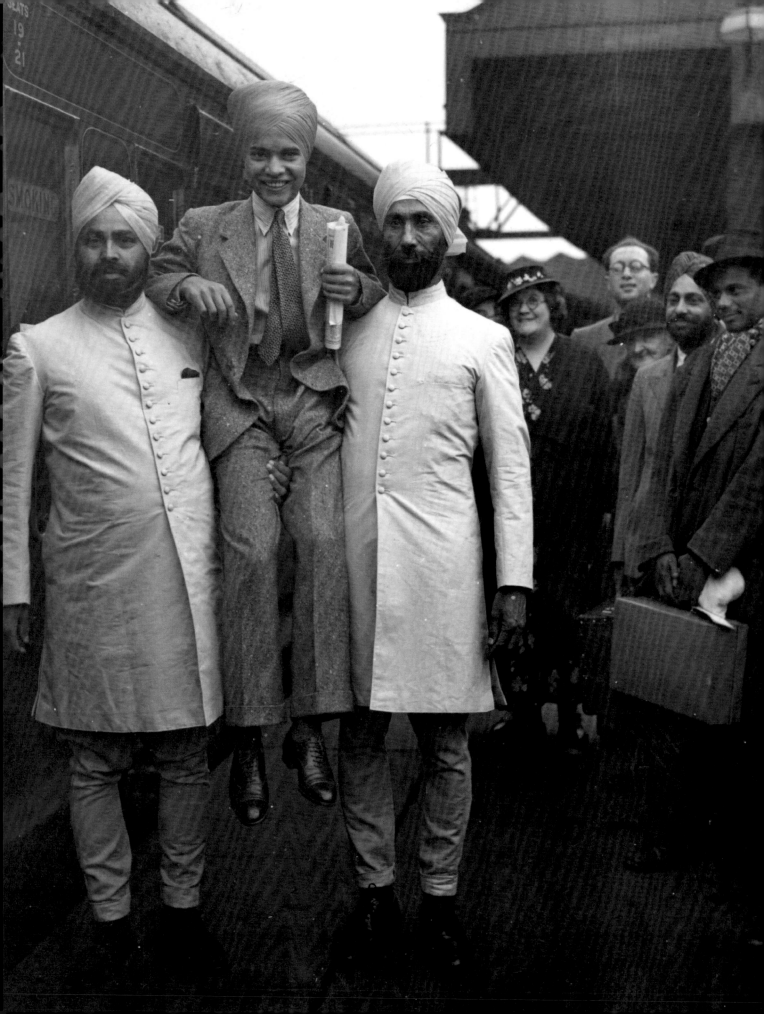

The outbreak of World War Two significantly affected a large number of the Britain-based population who, despite their loyalties to the freedom movement and a conflictual relationship with Britain, were keen to offer support. As in World War One, India supplied the largest colonial force of 2.5 million and its global involvement ensured Britain's success in defeating Hitler and the Axis powers. The war mobilised support from all the colonies, though once again the heroism of black and Asian servicemen and women seldom appeared in recycled victory myths of the British nation standing alone in its 'finest hour'. The battle at Dunkirk, for instance, involved several hundred who defended a nation where their own citizenship rights were often contested. Similarly, little is known about the recruits to the Royal Air Force, many of whom flew in the Battle of Britain, or those seamen who made up a quarter of the entire Merchant Marine. Such absences also surround the forgotten bravery of the Special Operations Executive secret agent Noor Inayat Khan, who was arrested by the Gestapo and executed in 1944. Posthumously awarded the George Cross, the first bust to mark this woman's bravery was only erected in 2012.

Contributions 'at home' were also evident across all levels of society. As the need for essential wartime resources developed, labour was directed to factories in Bradford, Leeds and Coventry. In the area of civil defence, many Asian doctors, nurses and students worked for the Indian Ambulance Unit. Others, including prominent opponents of Empire, such as Krishna Menon, took up positions as air raid precaution wardens. Several Asian women along with white volunteers made clothing to provide Indian food parcels for prisoners of war, an effort co-ordinated by the Indian Comforts Fund. At the same time, the Bevin Trainee scheme encouraged young apprentices to come to Britain to develop skills to supplement the much-needed supplies provided by the Indian munitions factories and engineering industries.

Facing page: Sabu, the first international Indian film star, leaves Waterloo for the premiere of his latest film, *The Drum*. (1938)

Following pages: Indian animal transport companies evacuated at Dunkirk and were subsequently stationed in Britain until 1943. (1940)

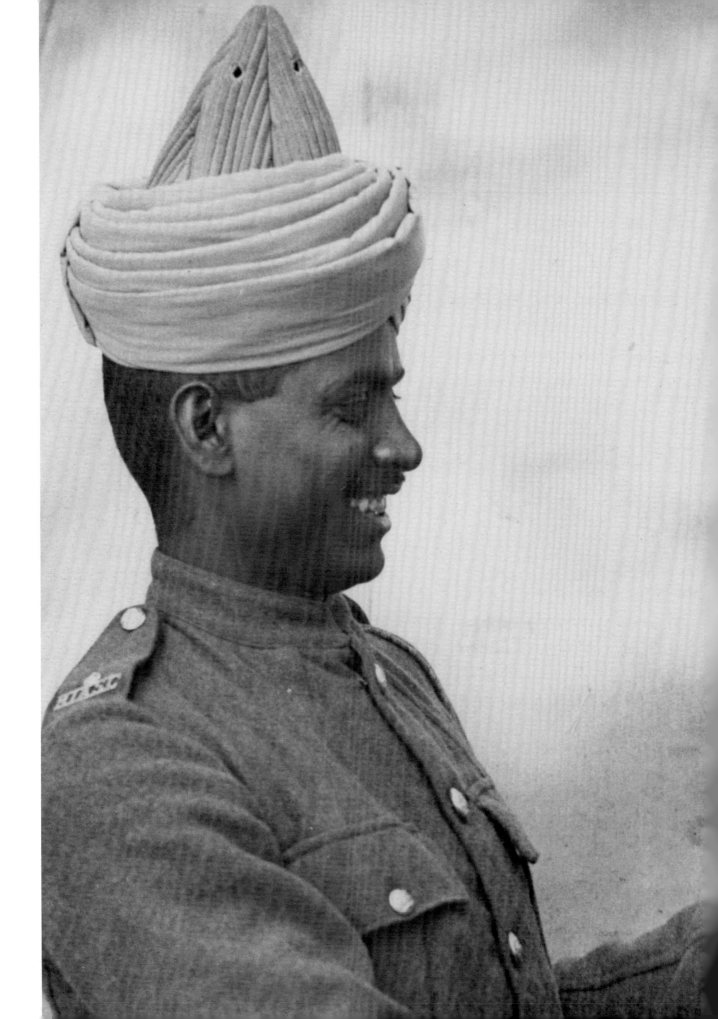

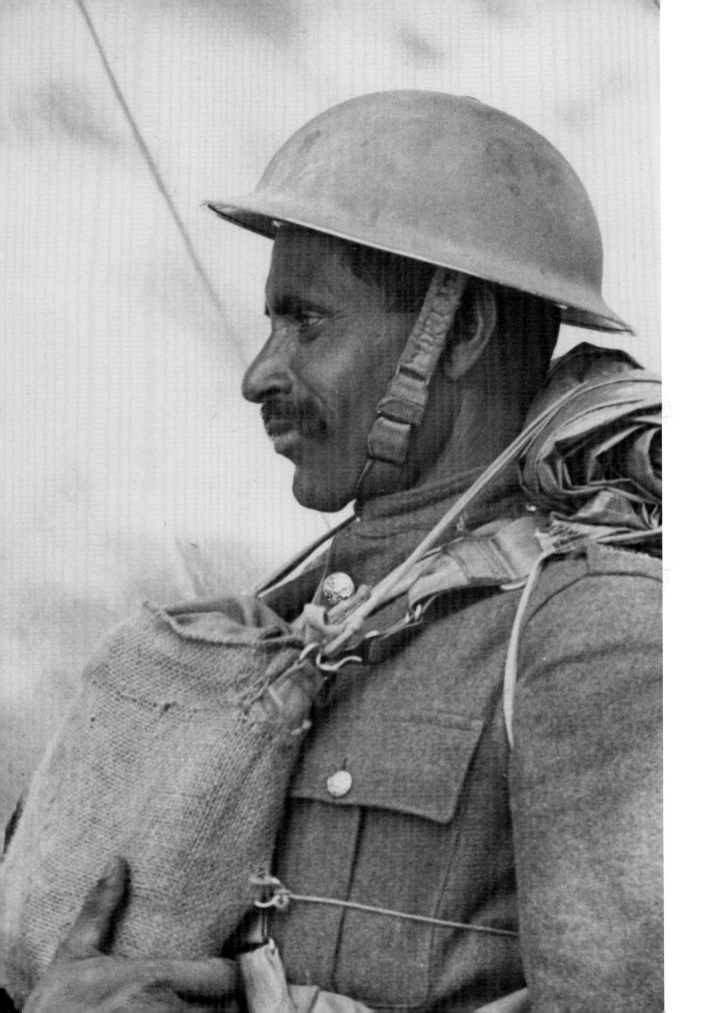

Above: Havildar
Madho Singh,
Major P. W. Weeler
(Dorchester), Major
M. W. S. Hoch
(Hampstead) and
Captain M. B. Elatau
(Highbury) (l. to
r.), British officers
of a Sikh battalion
wearing turban, beard
and same uniform as
their men. (1945)

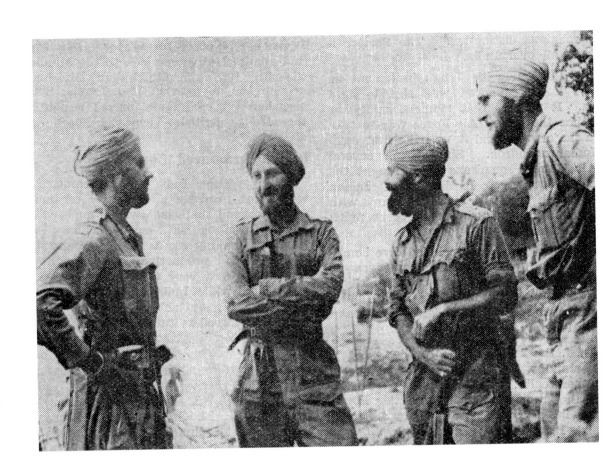

Below: Pilots selected
by the Government
of India joined the
RAF to alleviate a
shortage of pilots after
the Battle of Britain.
(1942)

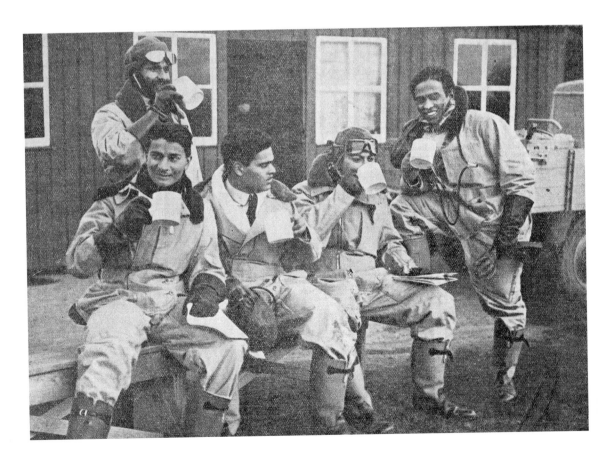

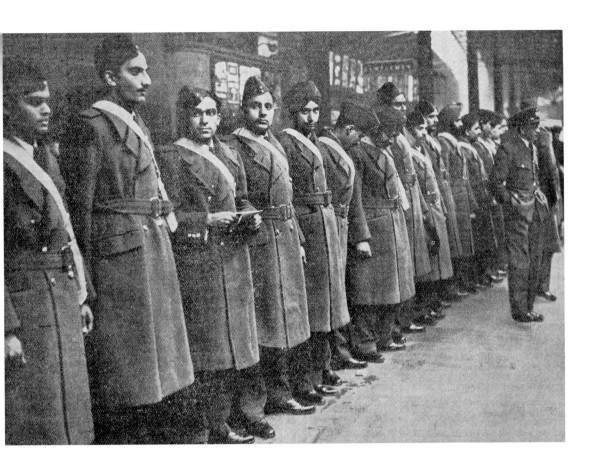

Above: A group of Indian pilots, including Squadron Leader Mahinder Singh Pujji, on arrival in London. He flew Hurricanes over the English Channel and was awarded the Distinguished Flying Cross. (1940)

Below: English and Indian pilots at the controls of their multi-engine bomber. (1942)

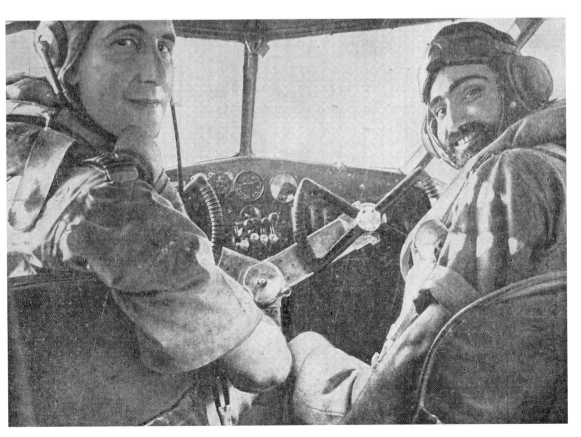

Asian along with Czech, French, Caribbean and Australian pilots flew many missions across the Channel in fighter and bomber planes. (1941)

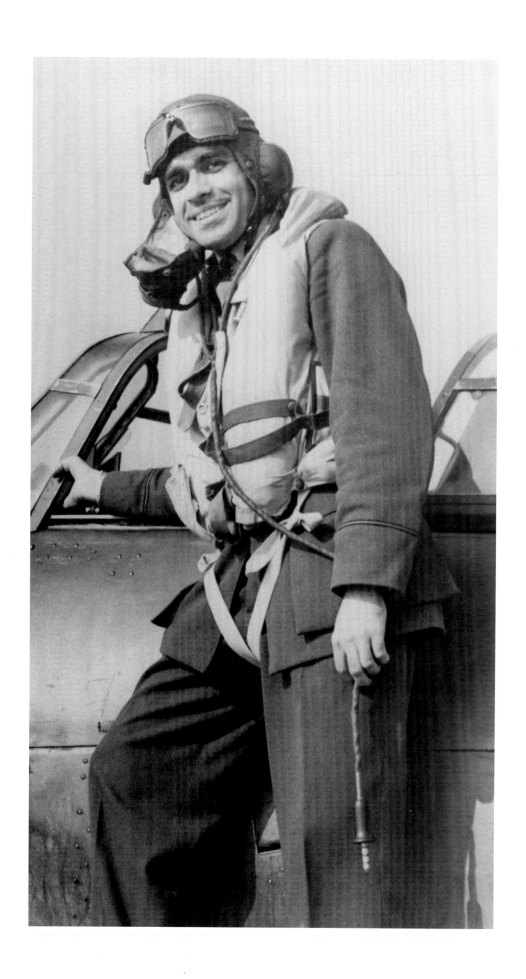

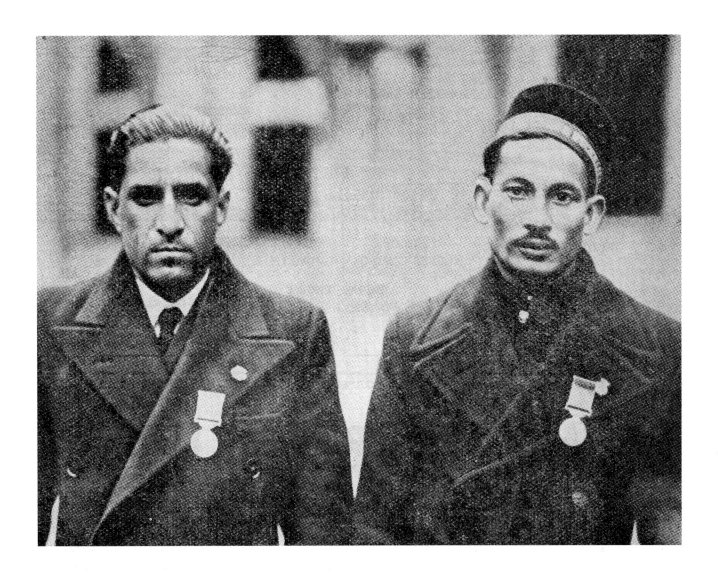

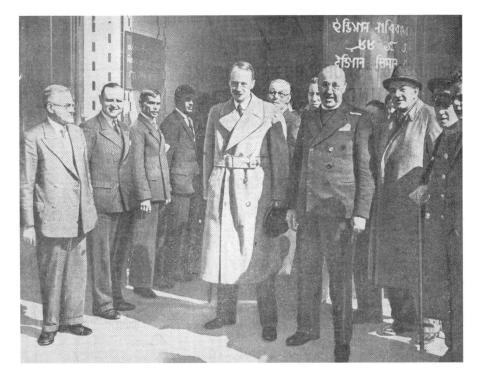

Above: Merchant Seamen Ana Mian and Mohamed Ismail after receiving the Medal of the British Empire at Buckingham Palace. (1942)

Below: A new club for lascar seamen was opened in Liverpool in 1942. (1942)

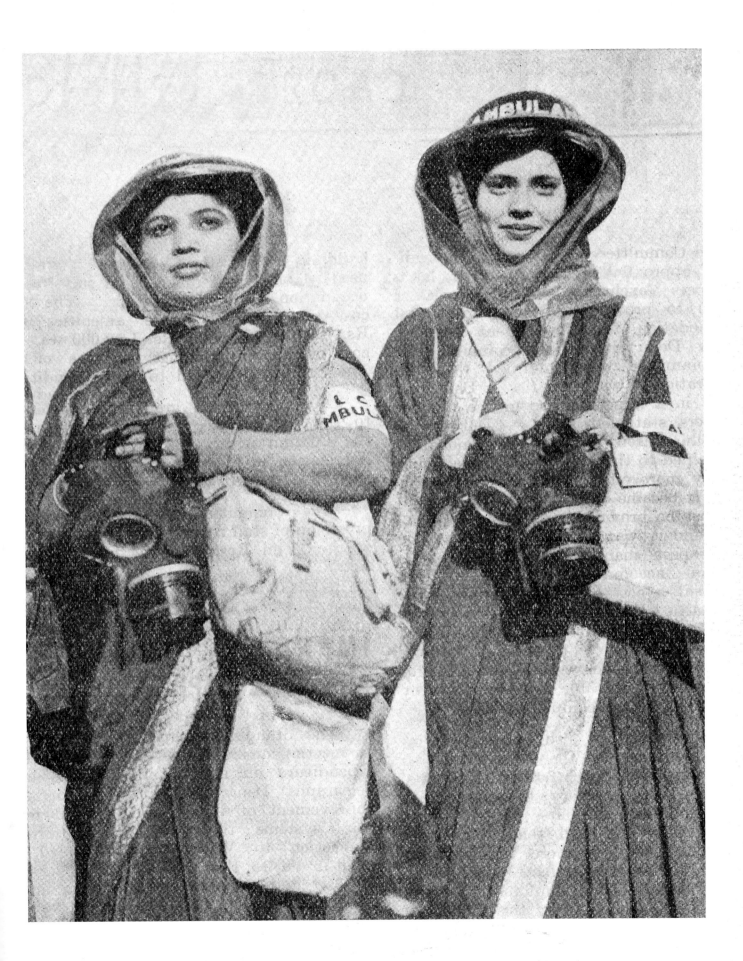

Udham Singh after his arrest for shooting the former Governor of the Punjab, Michael O'Dwyer. Singh was found guilty and sentenced to death. (1940)

Previous pages: Left: Craftsman P. S. Birdi repairing a damaged wooden aircraft propeller at a workshop in the West Country during World War Two. (1943)

Right: Doraj Ross initiated an Ambulance Service with personnel drawn from London's South Asian residents, recruiting some 100 volunteers, including doctors and barristers. (1941)

All colonial citizens resident in Britain for two years were liable for conscription. Many were willing recruits, but the conditions they faced were often contentious, fuelling divisive issues of allegiance, identity and class. Those reluctant to support the war of an imperialist nation were seen as potential security threats; others, due to their class, were delegated to the Indian Auxiliary Corps, a British-based unit mainly composed of working-class Muslim seamen and Sikhs.

Wireless operator, Noor Inayat Khan, worked for the Special Operations Executive, charged with sabotaging the Nazi war machine. She was posthumously awarded the Croix de Guerre and the George Cross. (1941)

Growing fears about security came to a head in 1940 when Udham Singh, a revolutionary radical and one time pedlar, assassinated Sir Michael O'Dwyer as a public act of revenge for his support of the 1919 Amritsar massacre. The subversive influence of Subhas Chandra Bose, a Bengali nationalist hero, whose anti-imperialist stance was encouraging disaffection, further exacerbated these concerns. As Bose, an impressive speaker, became a persuasive anti-British voice in German propaganda broadcasts, the BBC swiftly stepped up the output of its Eastern Service programmes to counter this. Led by Zulfikar Bokhari (later Head of Pakistan Radio) and George Orwell (Talks Producer), these broadcasts, often translated, engaged a wide range of distinguished participants from across the Indian and British intelligentsia. Several Asians, both men and women, were also

Labour politician and editor of the *Daily Herald* George Lansbury greets nationalist leader, Subhas Chandra Bose, who later led the Indian National Army. (1938)

Auxiliary Ambulance Volunteers undergo a gas mask drill at their station, St Pancras. (1939)

Facing page:
Above: British and Asian ladies, one of many knitting parties of the Indian Comforts Fund, making clothing for Indian troops and seamen. (1944)

Below: Packing station at India House, Aldwych, of the Indian Comforts Fund. The charity was next of kin for all Indian Prisoners of War in Europe. (1939-45)

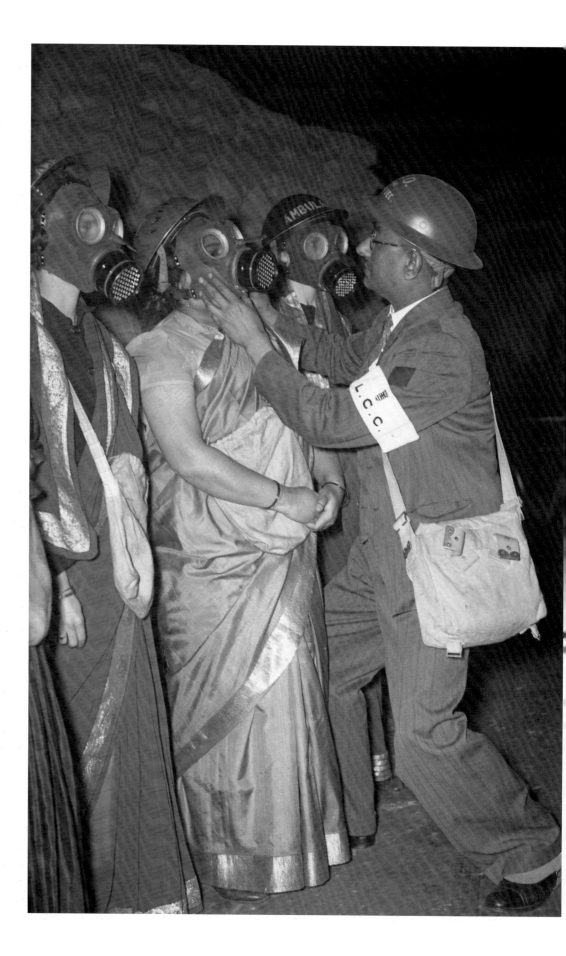

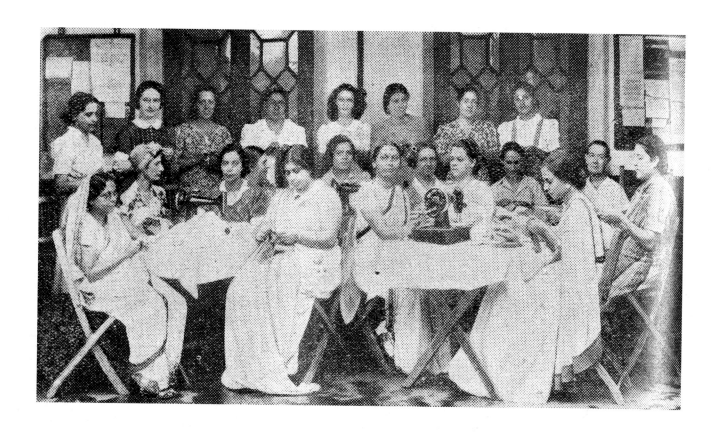

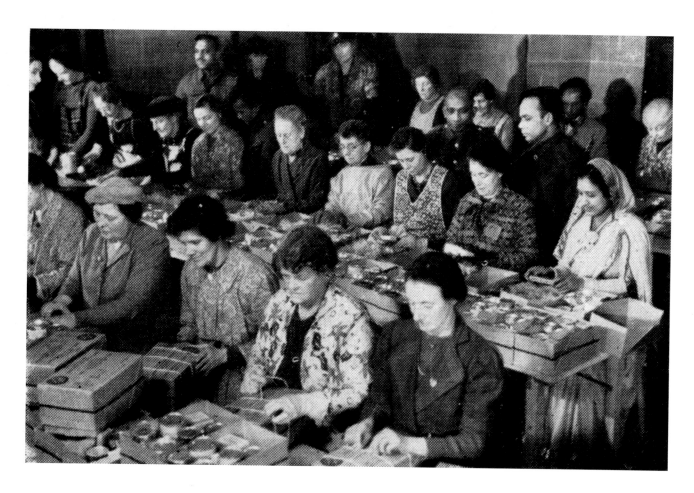

Above: Women pack food parcels in the store room of India House for Indian Prisoners of War. (1943)

Below: Mrs Mukerji serves refreshments to troops at India House, Aldwych, during a leave visit to London. (1940)

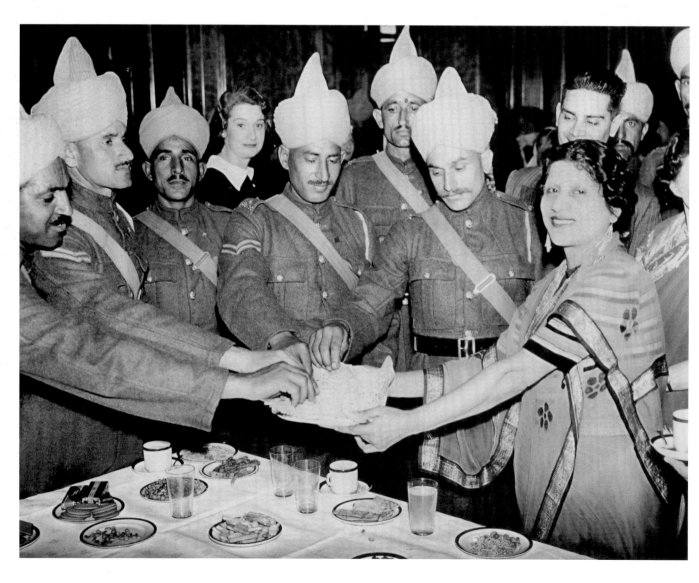

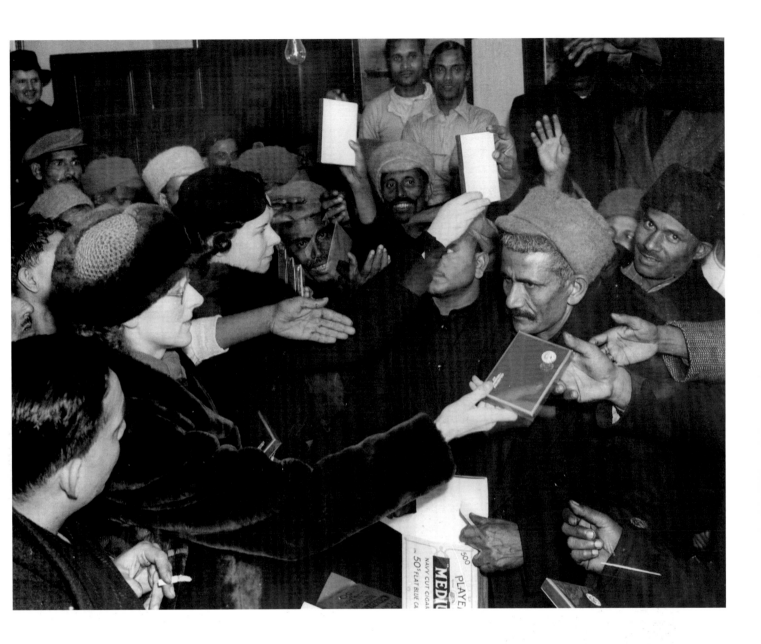

employed as permanent staff working as translators and presenters. However, with the launch of the Quit India campaign in 1942, some of these, such as writer Mulk Raj Anand, became increasingly torn by dual allegiances. Importantly, these programmes, originally devised as part of the war propaganda machine, provided a unique public platform for cross-cultural contact and exchange, setting in motion a pattern which would ultimately become integral to Britain's postcolonial culture as the century progressed.

Following World War Two and the coming of Independence,

Indian lascar sailors in the merchant marine helped keep Britain's supply lines open. This group rescued from the prison ship *Altmark* receive gifts in Liverpool. (1940)

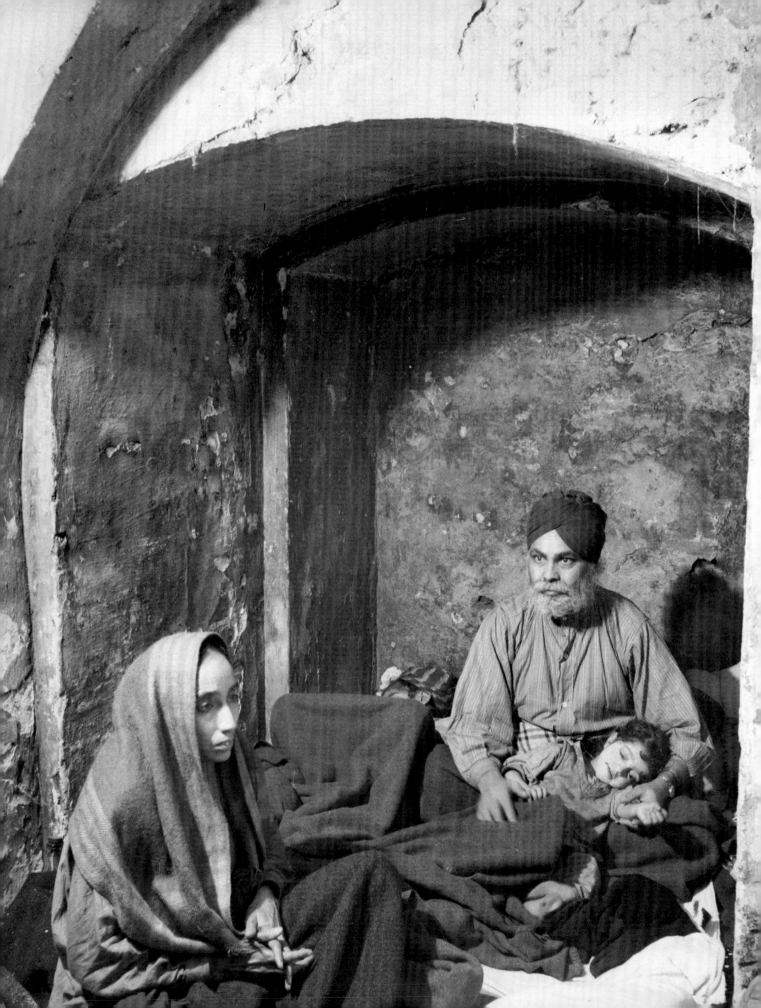

Above: Minister for Labour, Ernest Bevin, welcomes the first group of trainees soon after their arrival in England. (1941)

Below: Bevin trainees from India and British girl apprentices together in a machine shop at a training centre in Britain. (1942)

Facing page: Many Asians lived in London's East End. Here a family is sheltering in an alcove of the crypt of Christ Church, Spitalfields, during the Blitz. (1940)

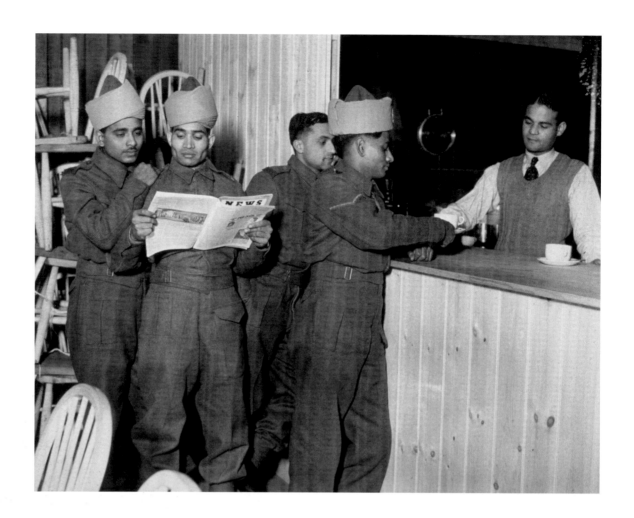

Above: Indians resident in Britain joined the Indian Auxiliary Military Pioneer Corps. (1940)

Below: A nurse serves the morning milk ration to injured servicemen at Lynhales Auxiliary Hospital, Herefordshire. The hospital was staffed with Indian doctors and British nurses. (1941)

Facing page: Indian soldiers in Britain drinking tea from a mobile canteen outside the Shah Jahan Mosque, Woking, Surrey, which became an important gathering place for prayer and festivals. (1941)

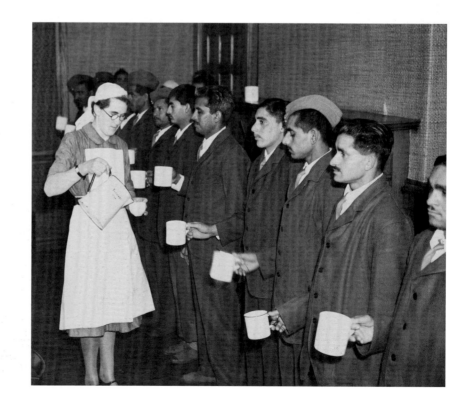

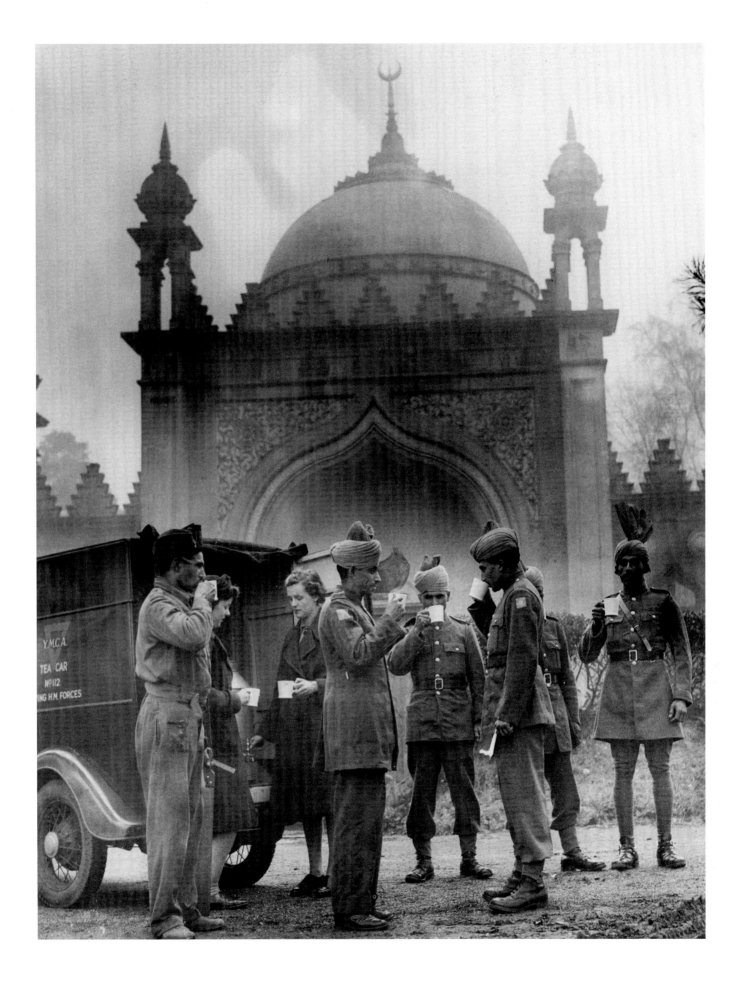

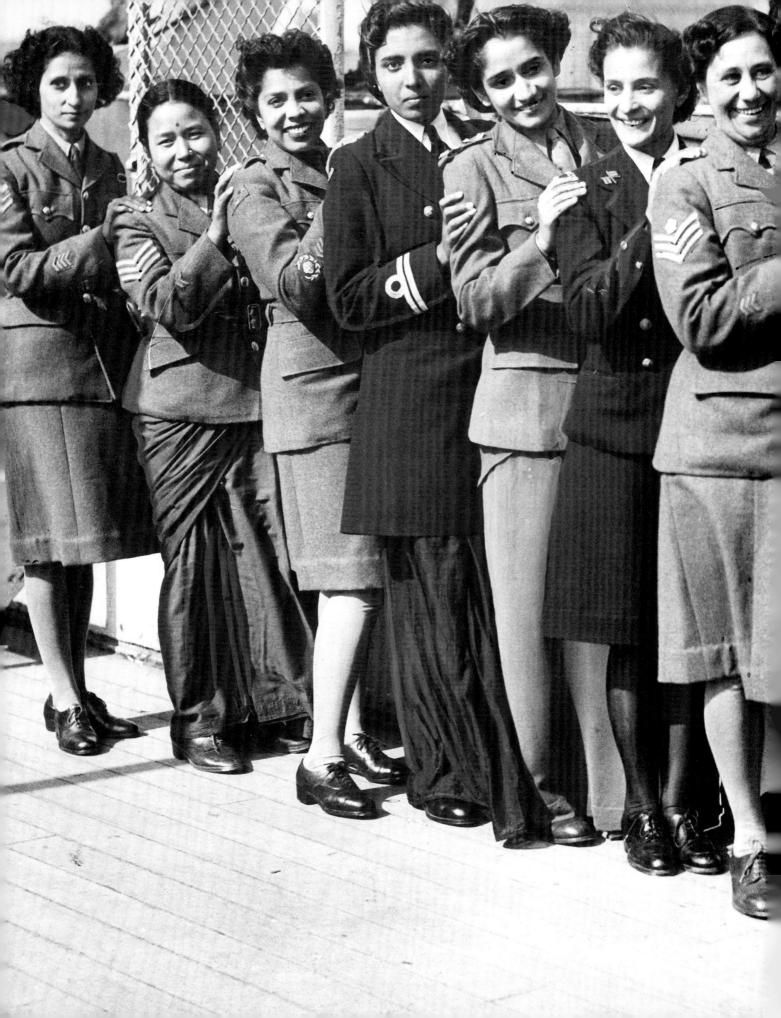

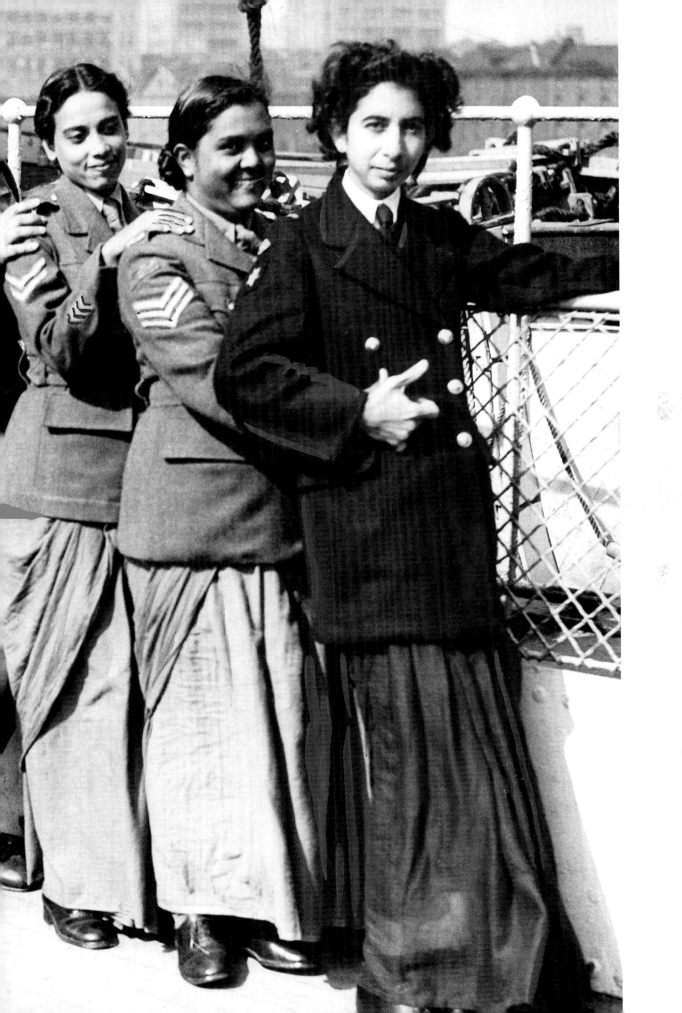

Zulfiqar Ali Bokhari was producer for the BBC's Eastern Service's Indian section. With George Orwell he assembled a team of writers and intellectuals, including Mulk Raj Anand, composer Narayana Menon and editor M. J. Tambimuttu. (1940)

Facing page: Queen Elizabeth, the Queen Mother, meets repatriated Indian Prisoners of War from Europe at a Garden Party at Buckingham Palace. (1945)

Previous pages: Much propaganda focussed on Indian servicewomen's contributions to the war effort. (1946)

several who had been resident in Britain during the years of Empire returned to become citizens of the newly formed nations of India and Pakistan. But many remained. The writer and BBC Urdu translator Attia Hosain, for instance, arrived just prior to Independence and Partition but decided to stay for political reasons. Others, like the family of W. C. Bonnerjee, the nineteenth-century Indian nationalist, had by then established long-term social and educational connections. A considerable number of others had intermarried and they and their

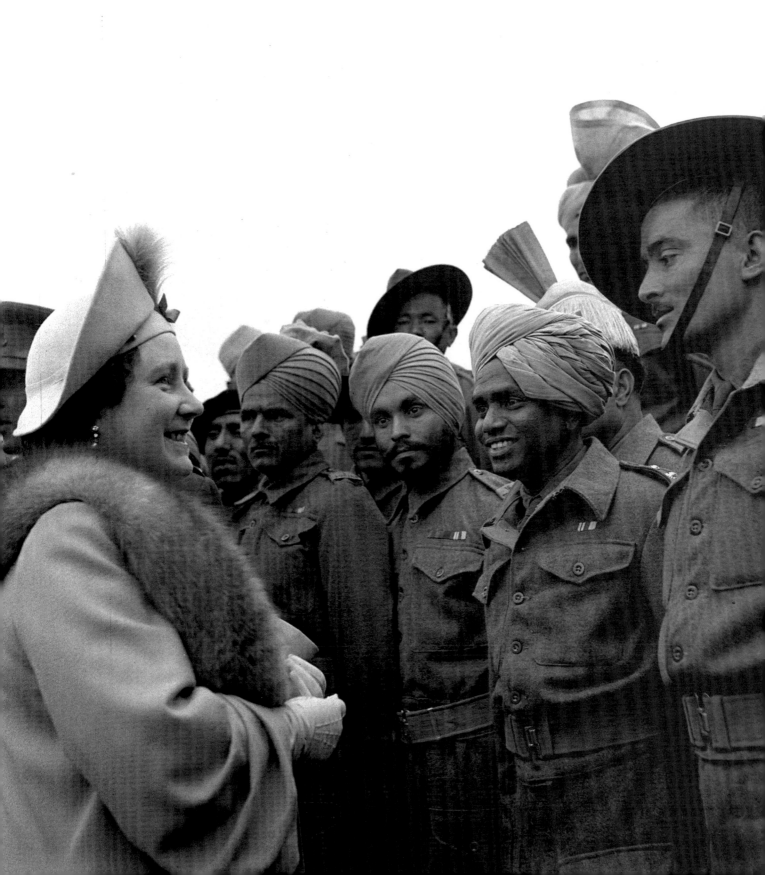

Mulk Raj Anand, novelist and art critic, arrived in London as a student. He networked with the Bloomsbury group and later worked with George Orwell at the BBC. (1930s)

Facing page: Broadcaster and novelist Attia Hosain with her editor, Cecil Day Lewis, who published her novel *Sunlight on a Broken Column*. (1960s)

descendants put down permanent roots, whether working as doctors and nurses bolstering a fledgling National Health Service, or as lawyers, businessmen and teachers. It was clear too that the working-class populations, established in the Midlands and northern cities

during the war, continued to be an integral part of the workforce in British industries. In addition, many grocery and textile shops and restaurants set up during the interwar years continued to thrive.

We are often told that the larger-scale migrations which took

Womesh Chandra Bonnerjee with family and friends. He settled in Croydon in 1902 where he embarked on a political career and served as Privy Council lawyer. (1905)

place post-1950 constituted the *beginnings* of Asian Britain. Rather like misplaced attempts to mark the inaugural moment of black British settlement by the 1948 docking of HMS *Windrush* at Tilbury, the realities of individual lives and factors determining migration are far more complicated. As with the East African descendants of the indentured labour system, histories during the colonial period were closely intertwined. Thus several post-war Caribbean migrants, like Nobel Prize winner, V. S. Naipaul, sometimes referred to as East Indians, are also of Asian descent. Such attempts to create a definitive moment when Britain became host to a 'new immigrant' population not only divorce the multicultural present from its continuities with a long colonial past but, more worryingly, empty out the textured

Hemangini Bonnerjee in her garden in Croydon wearing Victorian dress. Her children grew up in England and descendants still live here today. (1905)

Shapurji Saklatvala and his English wife, Sarah Marsh, posing in their garden in North London. (1930s)

Facing page: Muhammad Ali Jinnah at home in Hampstead in the early 1930s when he practised as a barrister at the Inner Temple. (1930s)

histories of what is a far more complex reality. As the chapter of Empire closed, these regularly cited myths of 'arrival' became increasingly prevalent in re-inventions of the nation's island story. It was almost as if a curtain had fallen, hiding everything that had ever been known.

To be sure, the period after the war marked significant changes. India was the first British colony to gain its independence. The moment was also symbolic in marking the onset of a wider and irreversible process of decolonisation, which led in turn to the concurrent and

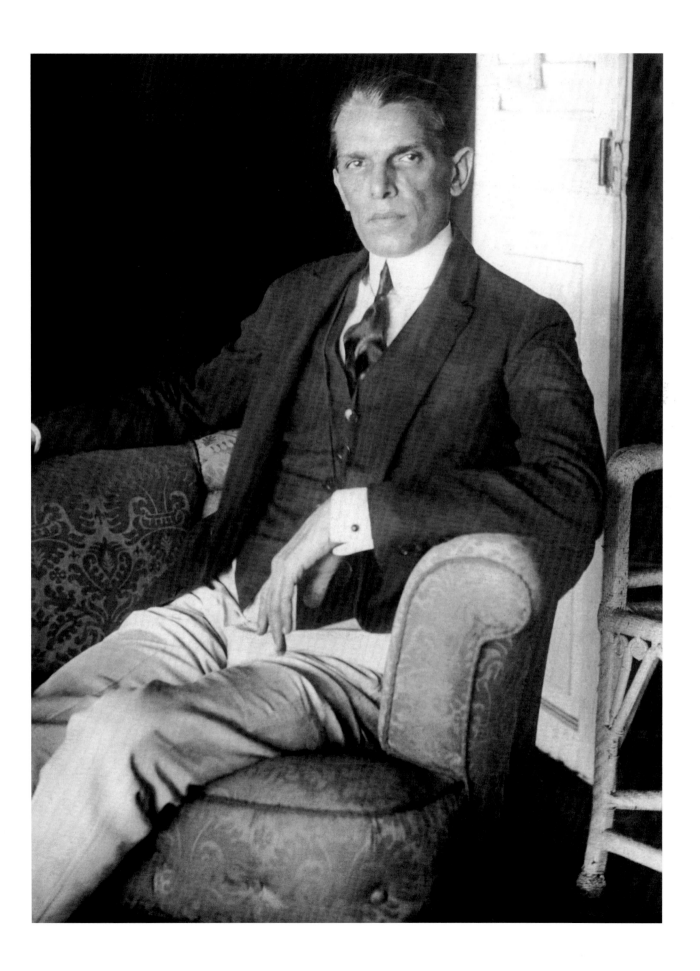

Above: A group of
English and Indian
students from
Imperial College,
London, at leisure in
Barnes. (1936)

Below: A march by
Muslim protesters
from the East End
to India House
demonstrating
against H. G. Wells'
representation of
Islam in *A Short
History of the World*.
(1938)

urgent need for Britain to redefine itself. The negative descriptors of original captions depicting early post-war 'arrivants' from the subcontinent certainly highlighted this, as they reveal the need for a quick change in the nation's angle of vision. No longer preoccupied with the wealth of exotic maharajas, we are introduced instead to lines of homeless migrants apparently seeking to sponge off Britain's now limited resources. In other words, as a new volume and version of the nation's history was opened to ease the pain of the Empire's decline, the many images once used to bolster pride in Britain's imperial riches at the height of its global power were literally removed from sight.

The 1948 Nationality Act had offered full citizenship and an 'open door' policy to all its new Commonwealth citizens. Many were

Jawaharlal Nehru on a visit to London to see his daughter Indira, studying at the University of Oxford. (1938)

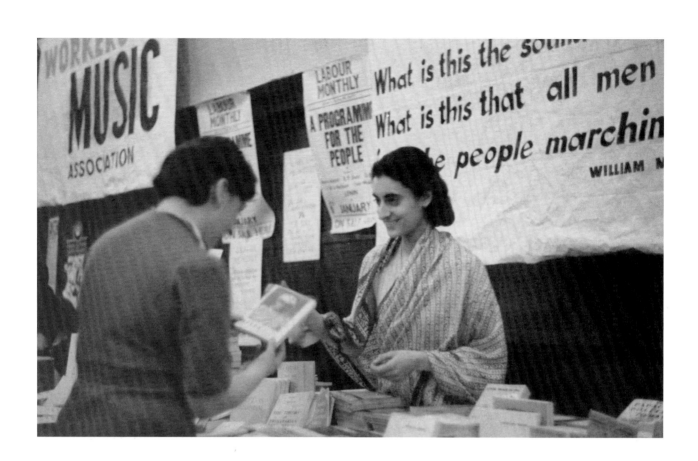

Indira Nehru (later Gandhi) sells her father Jawaharlal Nehru's autobiography at an anti-war and anti-imperialist convention at the Royal Hotel, London. (1941)

lured to the 'mother country', answering calls for labour and to seek improved living conditions. Yet, while the now independent countries of India and Pakistan were ostensibly equal partners in the recently formed Commonwealth family, there was no longer much wealth to share. Communal violence and religious conflict the previous year, prompted by the enforced division of Bengal and the Punjab, led to a bloody genocide. One of the most violent refugee movements in twentieth-century history, Partition was followed by mass migrations of over 15 million and widespread social and economic hardship. The assassination of Gandhi, just six months after Independence, growing political tensions, lack of employment and poor income levels led many to answer Britain's calls for support to rebuild a war-torn nation.

There is certainly no doubt that the first three decades after the war witnessed a substantial increase in Asian migration to Britain, a movement that resulted in widespread settlement on a completely different scale. Census statistics suggest the Asian population rose

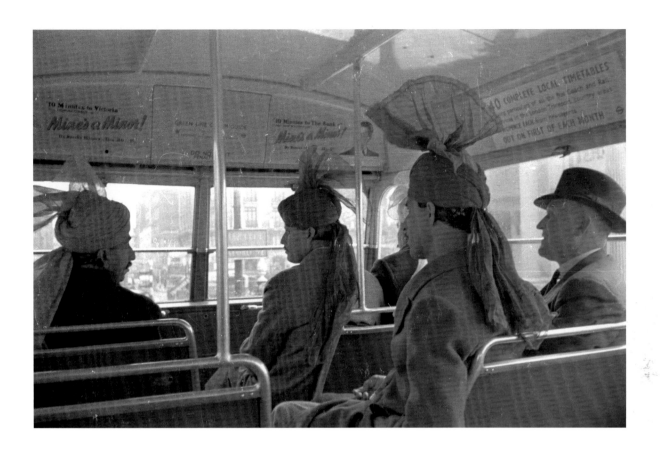

from 43,000 in 1951 to over a million in 1981. The composition of the incoming population was different too as a far larger proportion consisted of unskilled male workers from India, Pakistan and East Pakistan (Bangladesh 1971), uprooted by the turmoil of Partition. The harsh expulsion policies in the newly independent nations of Uganda and Kenya resulted in a second major wave of settlement in the late 1960s and early 1970s as around 29,000 East African families sought refuge in Britain. Although most held British passports and had originally settled in Africa as 'middlemen' due to colonial policy, the British government worked hard at preventing their entry.

As we have seen, many of Britain's early Asian population initially settled in port cities. However, post-war needs significantly changed this pattern. Incoming workers thus moved to places where labour was most urgently required and often where existing kinship or regional connections existed. These included the textile industries in northern cities such as Bradford and Leeds as well as the metal foundries in the

Four orderly officers sightseeing on the top deck of a London bus. Every year four Indian Army officers were chosen as the King's special bodyguard. (1939)

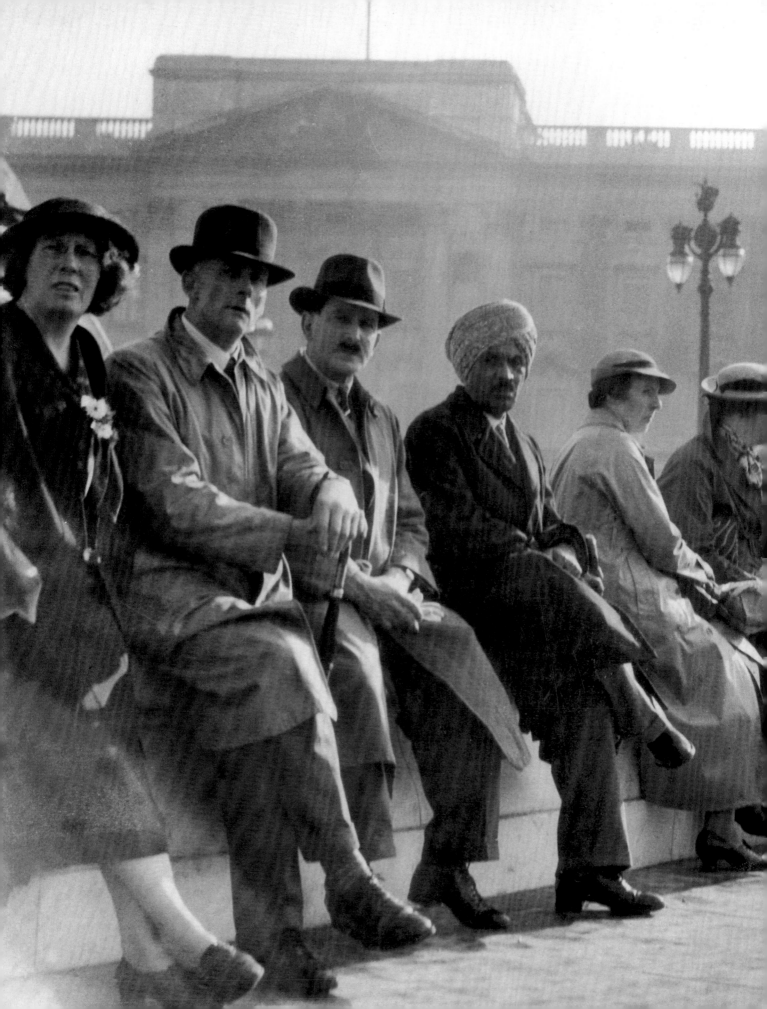

Spectators at the Victoria Memorial in London wait to see the coronation procession of King George VI. (1937)

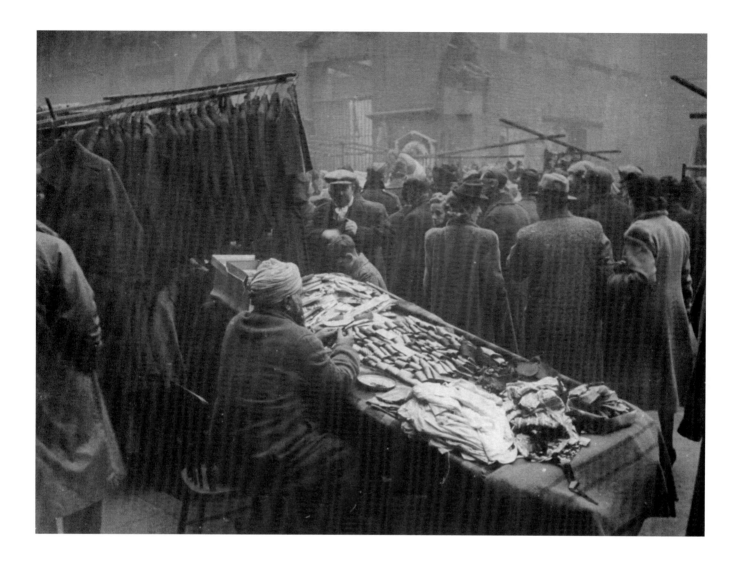

A trader at Petticoat
Lane Market
selling ties and
haberdashery.
(1944)

Midlands. Many responded to advertised vacancies in the public services, working for London Transport or the National Health Service. Others participated in supporting the wider infrastructure, settling in eastern counties of England and providing labour for the car manufacturing industry; others lived in Southall and Hounslow, offering services as cleaners and caterers at London's Heathrow Airport. The later Ugandan or Kenyan groups first migrated to areas such as Leicester or Wembley where they attempted, often unsuccessfully, to resume the status of past professions; due to the unequal opportunities they encountered, most subsequently had to shift gear and develop new businesses. The success story of Laxmishankar Patak is a case in point. A 1950s migrant from Kenya, he built up a small food business from

Above: Nurses Izzat Esmail and Zera Fazal at Hillingdon Hospital, Uxbridge, demonstrating a medical trolley at a nursing exhibition. (1959)

Below: V. S. Naipaul, a Caribbean novelist of Asian heritage, was educated at Oxford University and worked for the BBC's 'Caribbean Voices' programme in the 1950s. He won the Booker and Nobel prizes. (1968)

A group of women, recently arrived from Calcutta. Many answered the call to work as nurses in the newly created NHS. (1957)

Following pages:
Left: Children playing by a canal in the dockland area of Cardiff, known as Tiger Bay. The local population included Arab, Asian, Somali, West African, Caribbean and Greek families. (1950)

Right: Café owner, Mrs Khan of Tiger Bay, Cardiff. Born in Cardiff, Khan moved to Rawalpindi in the North-West Frontier Province of British India, before returning to Britain after Partition. (1950)

Prime Minister David Cameron visiting East End Foods, a popular supplier of Indian foodstuffs. Originally founded by the Wouhra brothers in 1972, the company is based in the West Midlands. (2010)

1956. Patak, along with East End Foods, is now one of the most popular ethnic brands in British supermarkets. Over time, the emergence of a large middle class resulted in movement away from original areas of settlement. However, it was primarily economic factors which first determined where people chose to live, a pattern still evident among communities in areas with the most significant Asian presences today.

It is not possible to fully detail the many complex stories surrounding specific community histories of post-war settlement. What follows, therefore, are some snapshots which provide a variety of illuminating visual reference points documenting how

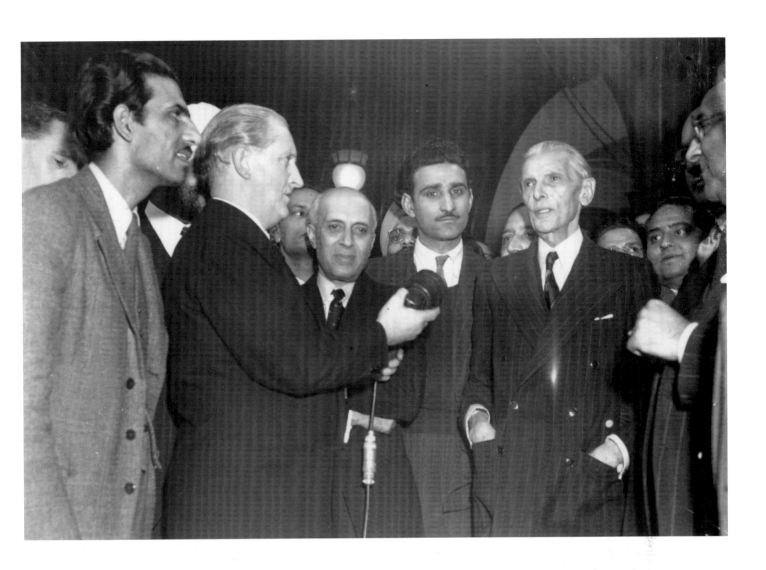

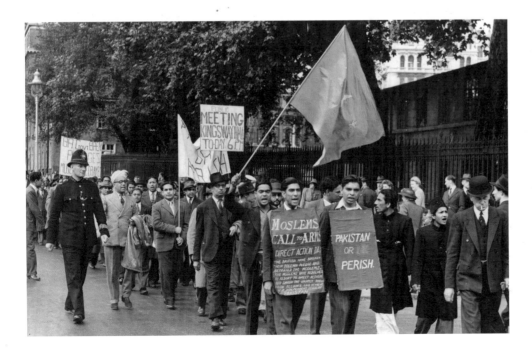

Above: Politicians Muhammad Ali Jinnah (right) and Jawaharlal Nehru (left) at India House, London, for talks on the future of India and the creation of Pakistan. (1946)

Below: After the failed Cabinet Mission of 1946, members of the All India Muslim League demonstrate in London, in solidarity with a general strike by Muslim Leaguers in India. (1946)

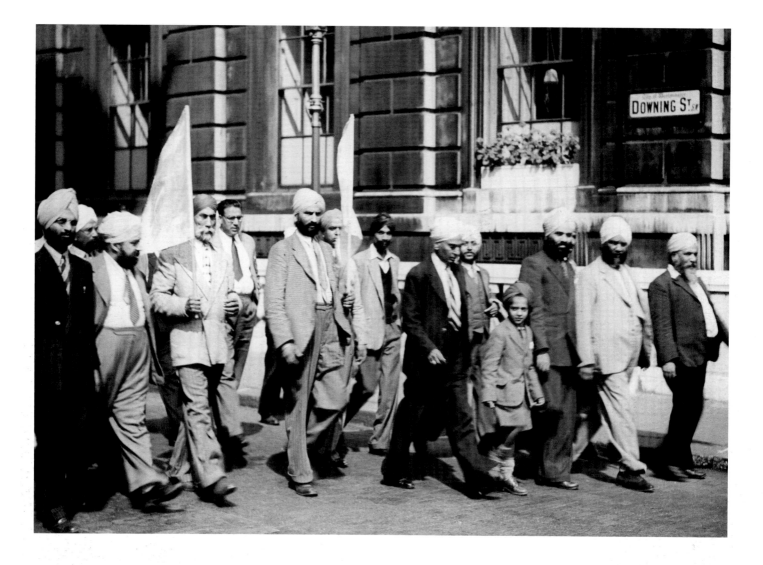

Above: A delegation of Sikhs led by Diwan Singh and Rawel Singh present a petition to Downing Street for the alteration of the Punjab Dividing Line. (1947)

Below: On 15 August 1947, during a ceremony at Lancaster House, London, a civil commission of Pakistanis present the country's new flag. (1947)

Facing page: To mark the historic ceremonies which took place in India during the handing over of power, the new flag of India was hoisted at India House, Aldwych. (1947)

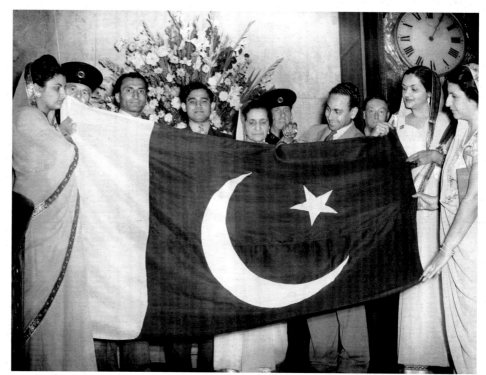

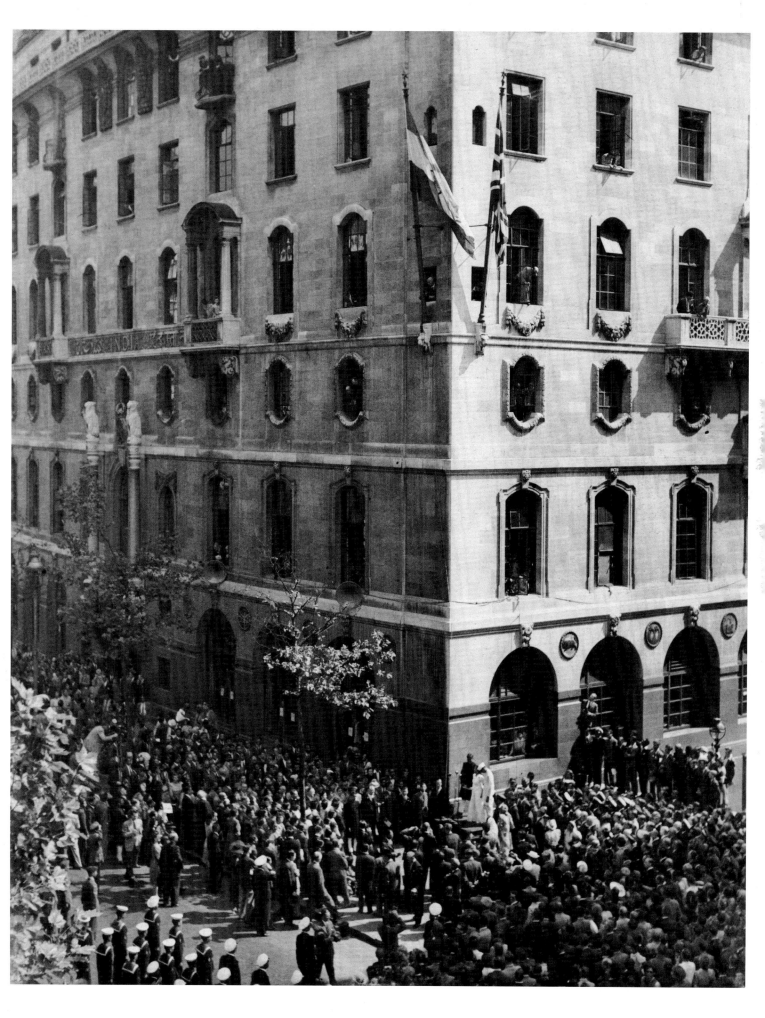

Protests against discrimination in Independence celebrations, India House, London. (1952)

Facing page: Young women reading the news of the assassination of Mahatma Gandhi outside India House, Aldwych. (1948)

Previous pages: In the 1950s, Bradford attracted migrant workers from India and Pakistan to work in the many textile businesses located there. (1950)

Asians cautiously negotiated their lives in a Britain that remained stubbornly reluctant to acknowledge the longevity of their presence, their contributions or their rights to full citizenship. Though from very different regional, class, linguistic and religious backgrounds, the progressive reduction of complex Asian identities along what were often bluntly undifferentiated lines of race and class eventually led to the formation of strategic political alliances, a process evident in much journalistic coverage of the many anti-racist rallies and campaigns of the 1970s. These alliances garnered grassroots support across national and local groups, engaging organisations such as the Indian and Pakistani Worker's Associations and the Black Alliance, a pattern that continued until the mid-1980s. Global movements such as the resistance to apartheid in South Africa, the African-American Civil Rights movement and the civil wars in Nigeria and Bangladesh

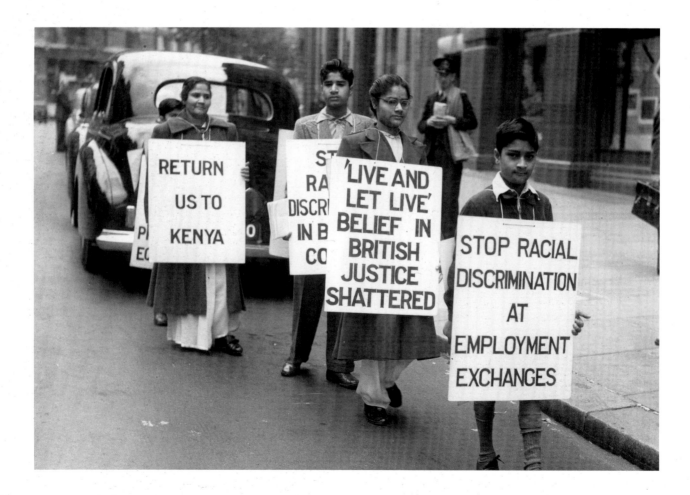

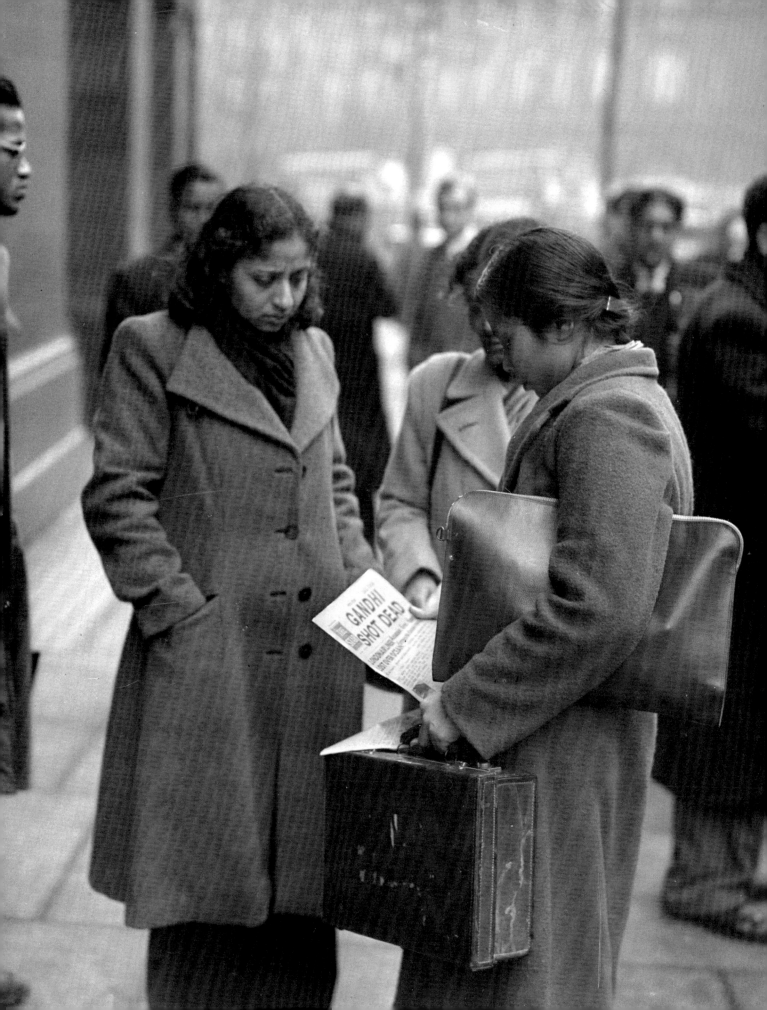

A woman and her pet poodle accompany two men on a round at a golf course. (1955)

Previous pages: Asian-run grocery stores have become a common feature of local communities in Britain. (1955)

Following pages: A London street scene. (1955)

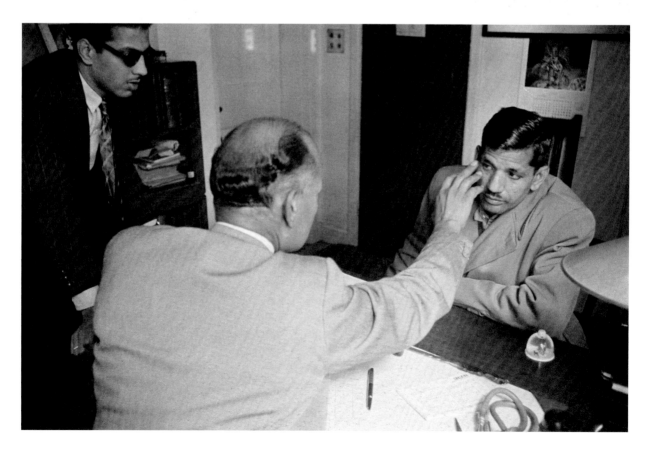

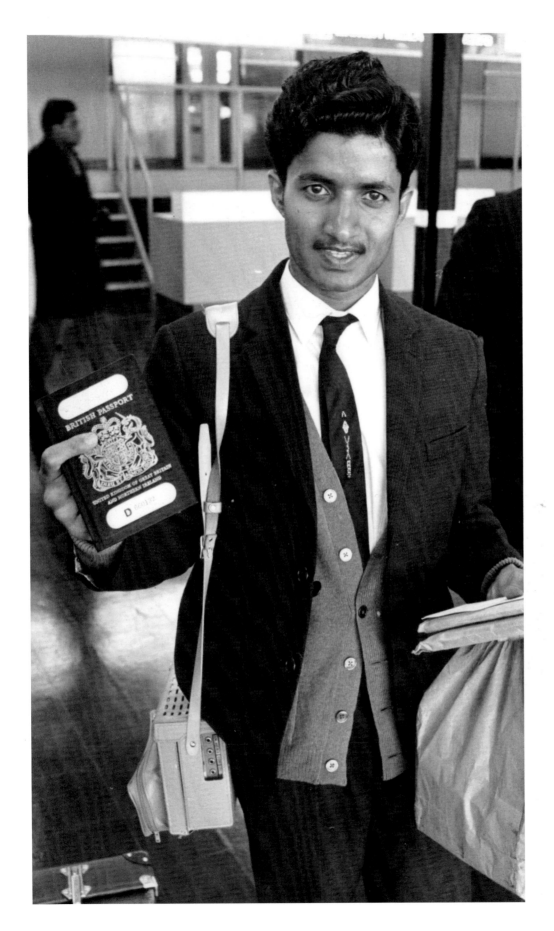

Francis Quadras holds up his British passport on arrival at Luton Airport from Kenya. He arrived in Britain just before the passing of the British Government's Emergency Bill. (1968)

Facing page
Above: Men at work in a textile shop in London. (1955)

Below: A doctor in the fledgling NHS examines a patient. (1955)

A bus driver and bus conductor, two of many jobs Asians took up. (1967)

Following pages: A mixed-race family moving into their new home. (1967)

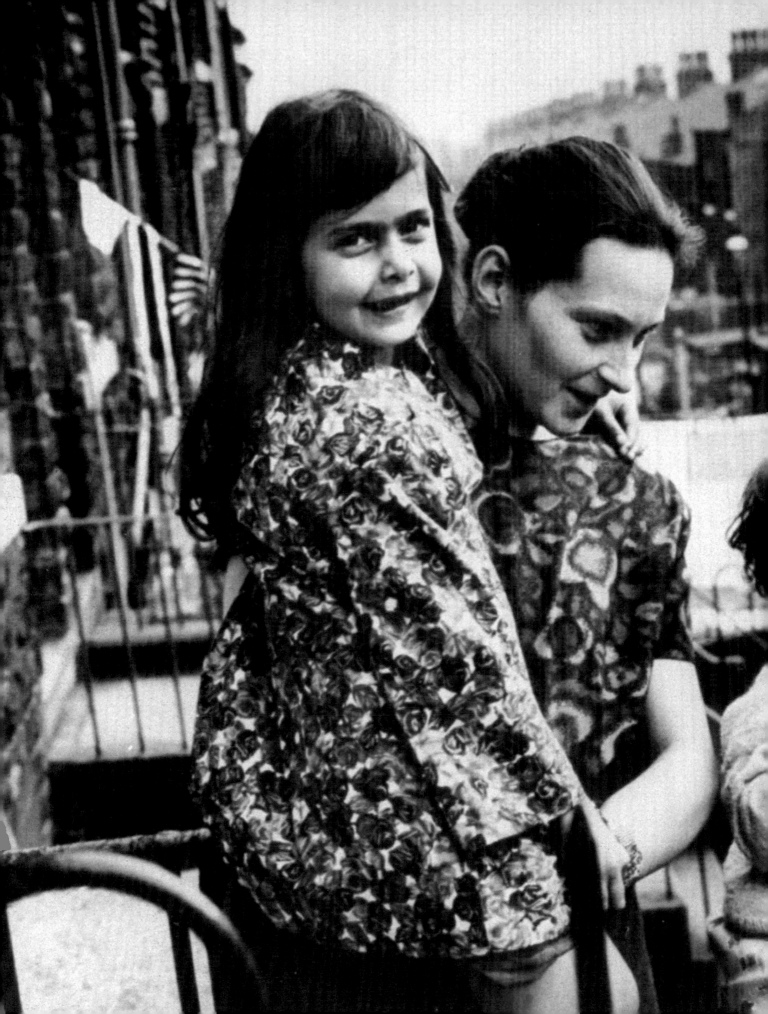

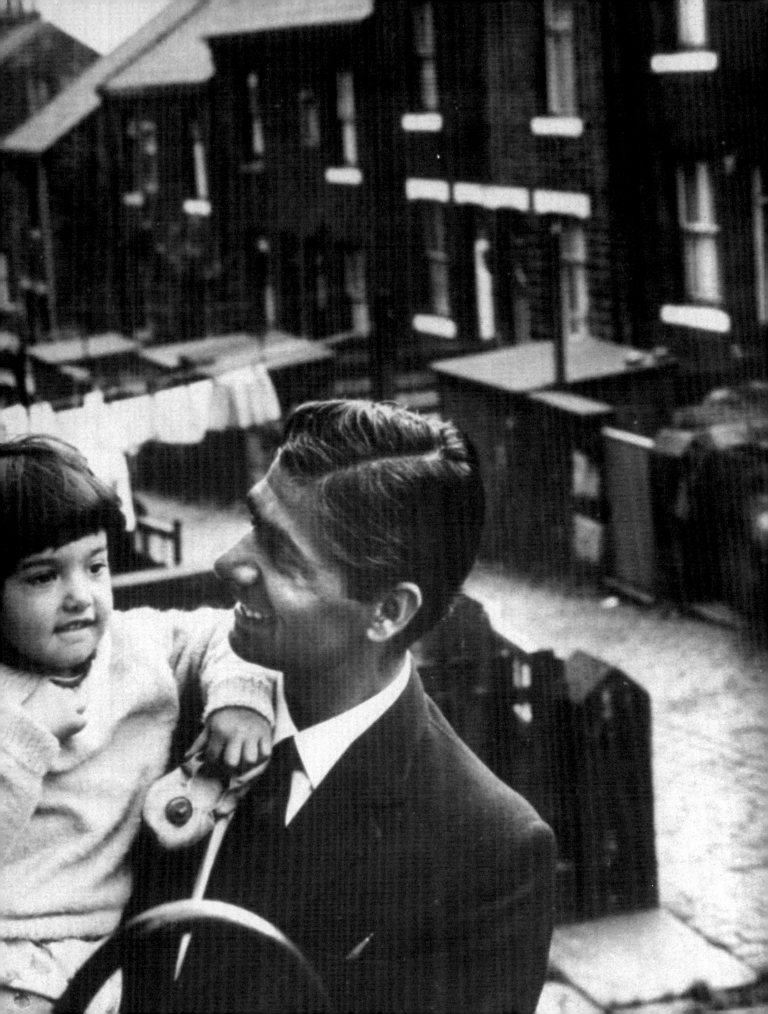

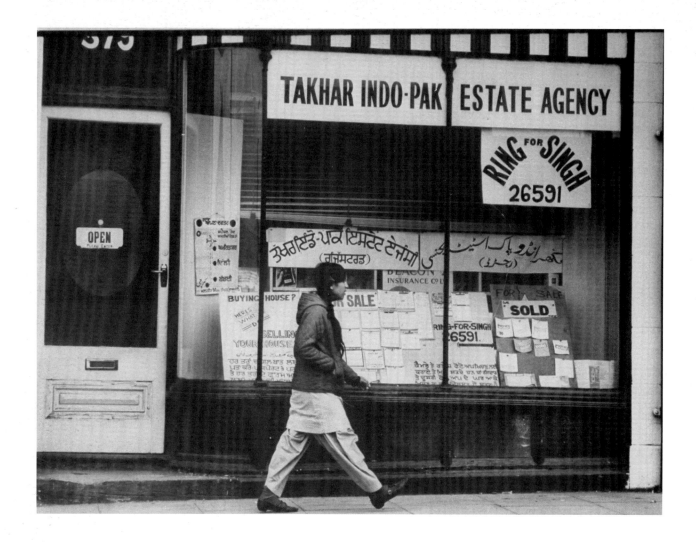

An estate agent in Southall with signs in Punjabi and Urdu. Many had to overcome discrimination from vendors and mortgage lenders. (1967)

Following pages: Asian workers found employment in northern steel works, such as Repton Foundry near Bradford. (1967)

added further agency to these struggles. While these alliances were expedient in creating necessary solidarities – a process that led to the use of 'black' as a strategic political label in the turbulent decades of the 1970s and 1980s – they also significantly diminished the diversity of different cultural and political histories. As Britain's non-white populations were simply lumped together as a body of non-distinctive ethnic minorities, they became united simply by the colour of their skin.

The fact that Asians, like Britain's black citizens, have transformed the face of British national life is no longer a question that can sensibly be contested. We now live, so we are told, in an era of twenty-first-century cultural diversity, a world in which the equal rights of all are officially protected by anti-racist and equal opportunities legislation.

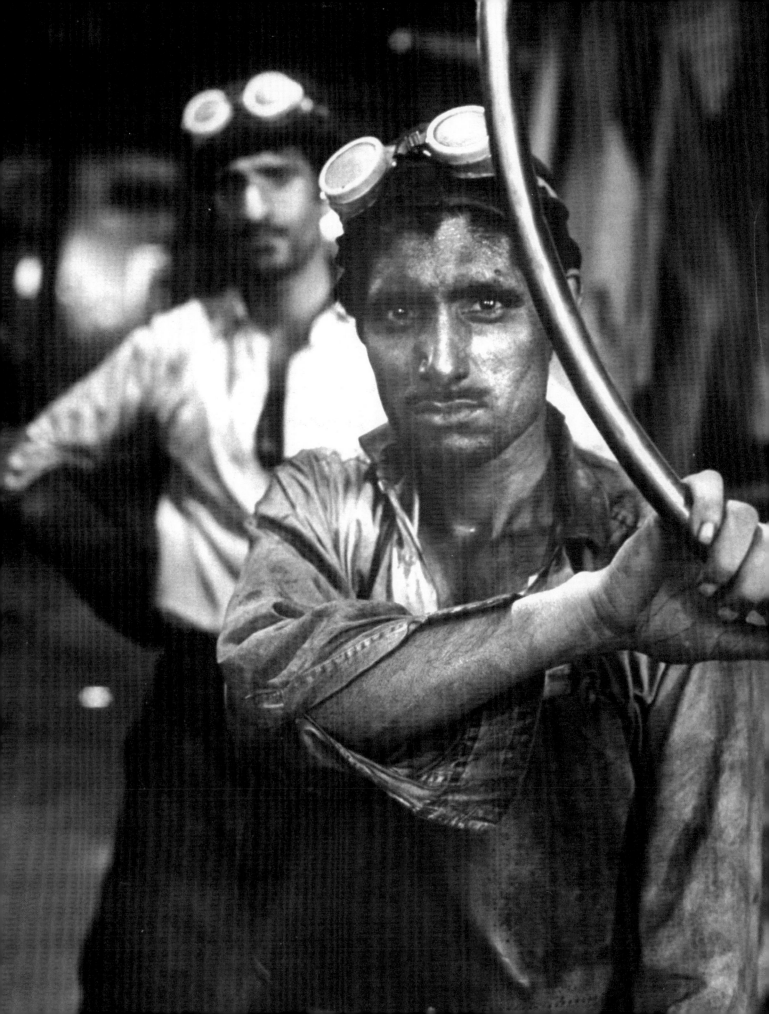

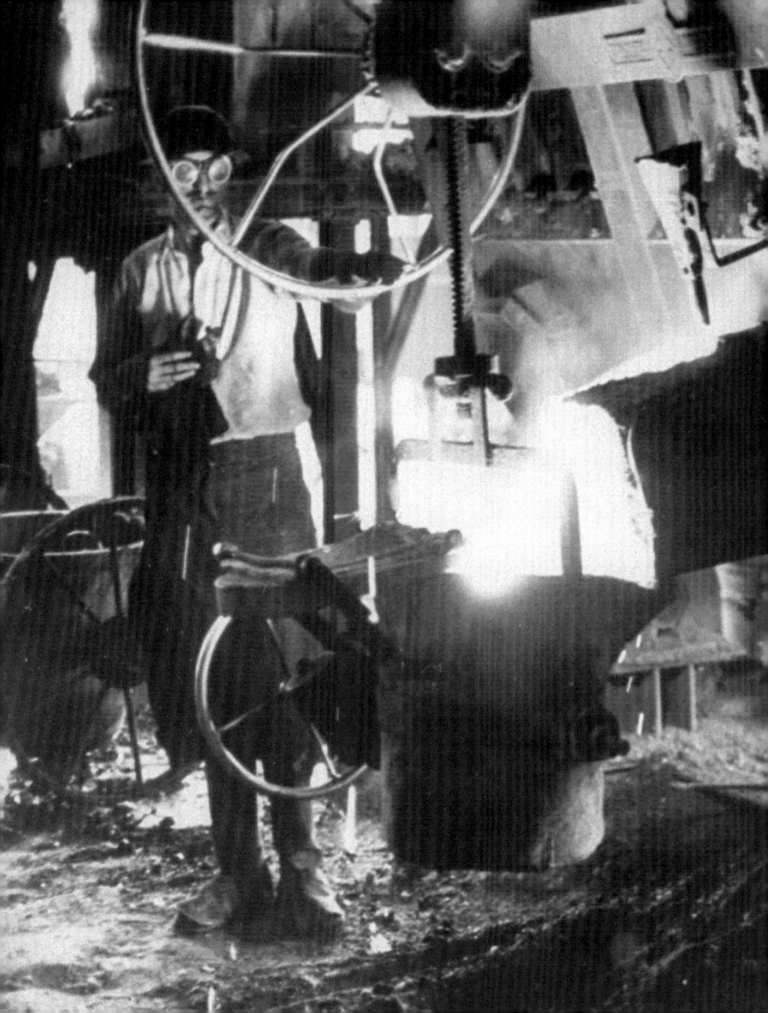

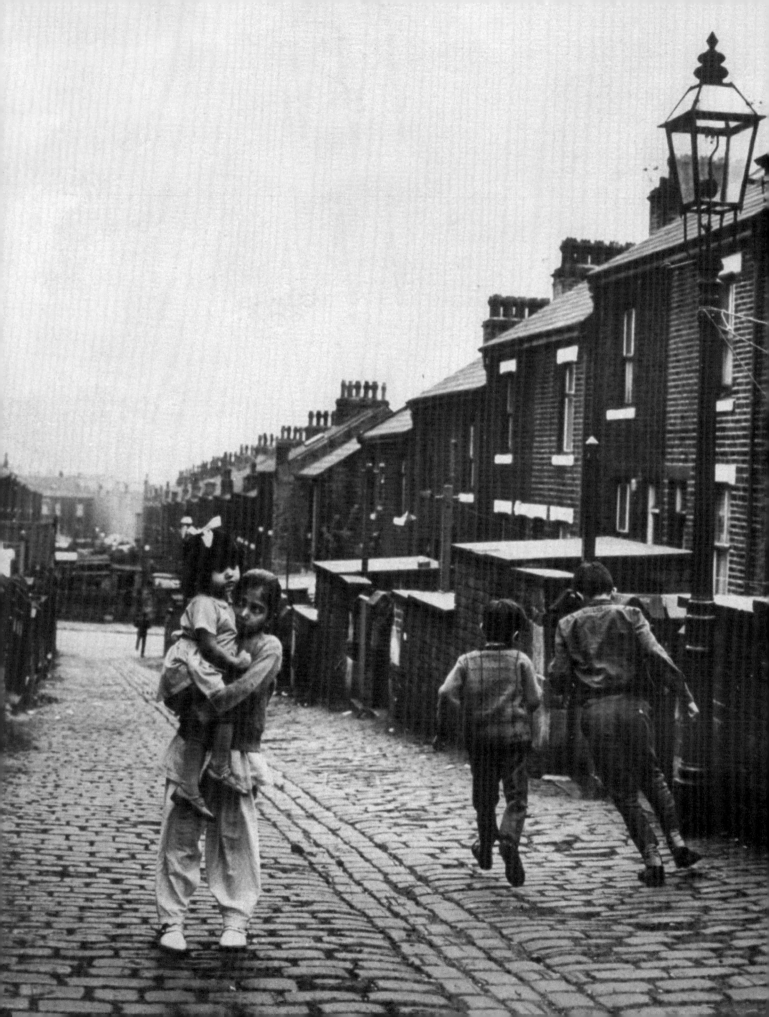

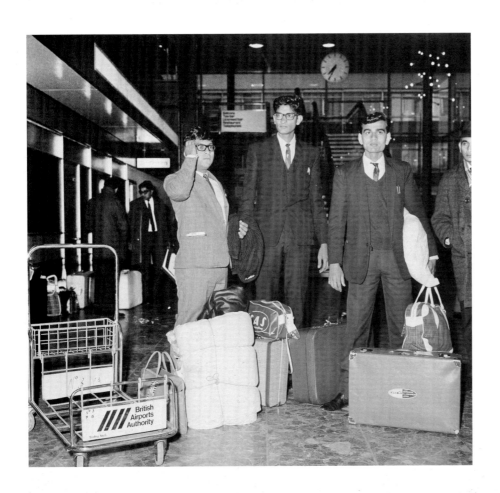

Above: A group of newly arrived migrants at London Airport (now Heathrow). (1968)

Below: Asians arrive at London Airport having been forced to flee Kenya due to the Africanisation policy of its government. (1968)

Facing page: A row of terraced houses in industrial towns like Bradford, where many Asians settled. (1967)

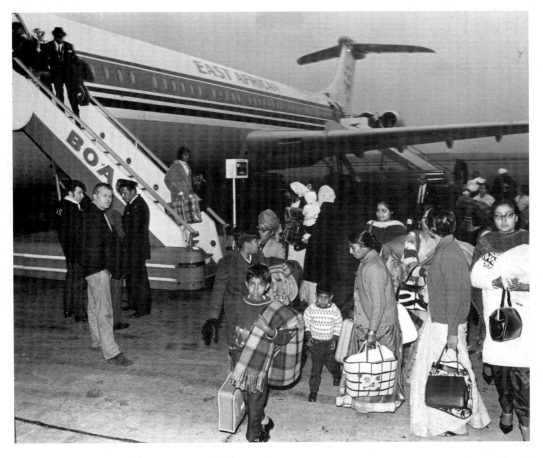

A group from East Africa at London Airport. (1968)

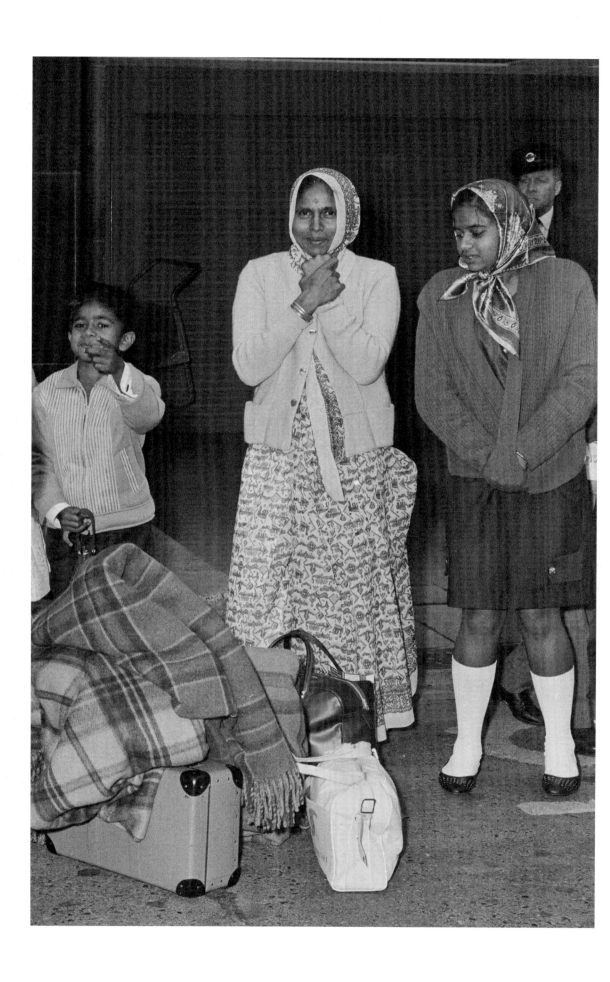

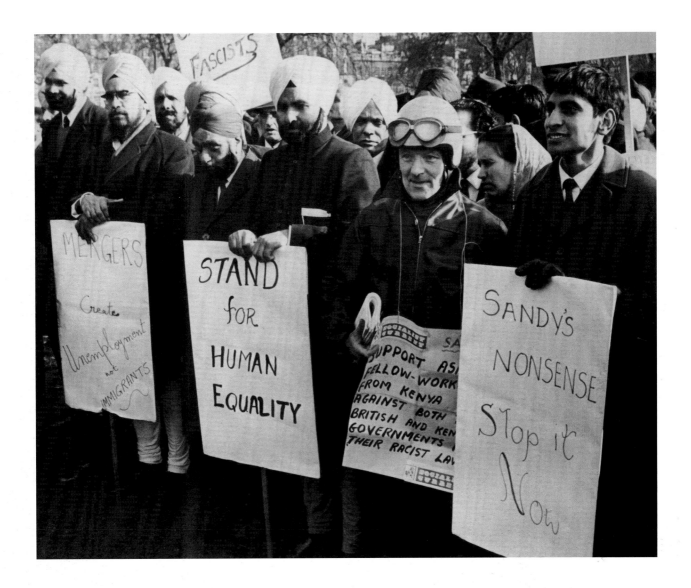

Thus during the 2012 Olympics, the UK was proud to showcase its 'rainbow' society as a model for all who attended. Yet the struggle has been, and continues to be, a far more complex one. Class and racial inequalities in many deprived working-class areas, whether in Bradford or the East End of London, still prevent significant social mobility, causing disaffection among many second- and third-generation British-born Asians unable to attain the glittering rewards promised by today's consumerist culture. Although much progress has been made, a xenophobic rhetoric of exclusion still lurks beneath the surface, a voice which regularly erupts among right-wing nationalist groups and continues to permeate the discourse of present-day anti-

A protest in Hyde Park against new immigration legislation, organised by the National Council for Civil Liberties and the Joint Council for the Welfare of Immigrants, among others. (1968)

terror legislation and immigration and asylum laws.

When thinking about images from the more troubled decades that precede today's more celebratory view of cultural diversity, it is worth remembering the political background that determined their framing. For, behind the scenes of the apparently liberal directives of successive Race Relations initiatives, optimistically launched from 1965 onwards to protect human rights, promote 'integration' and outlaw racial injustices, the legislation of two decades of increasingly discriminatory immigration acts simultaneously restricted the rights of Britain's non-white Commonwealth subjects. Such moves, endorsed by both Tory and Labour governments, not only provided the legitimacy to regard Britain's Asian and black populations as 'second-class citizens', but practically sanctioned the unequal conditions they continued to face in employment, education and housing.

As the need for cheap labour began to diminish in the 1960s, the Conservative government of the day stepped up its immigration controls to prevent automatic rights of entry. When rumours of the 1962 Immigration Act began to circulate, the numbers seeking to 'beat the ban' inevitably increased. The double standards of such cross-party government policies came to a head in 1968 when Labour, fearful of a further influx from East Africa, rushed an emergency bill through parliament in three days. It was a move which basically rendered the British passports of these East African migrants meaningless.

The fact that immigration control was fast becoming a polite euphemism for the 'Colour Bar' was already obvious in the 1964 general election when Peter Griffiths, a successful Conservative candidate from Smethwick (Birmingham), shockingly used the slogan 'If you want a nigger for your neighbour, vote Labour' to woo his constituency. Though such overt racism was publically denounced by Harold Wilson, the leader of the incoming Labour Party, and not condoned by many Conservatives, this deplorable rhetoric was to raise its head again in Birmingham four years later during Enoch Powell's

A mass protest in London's
Hyde Park against new
immigration legislation.
(1971)

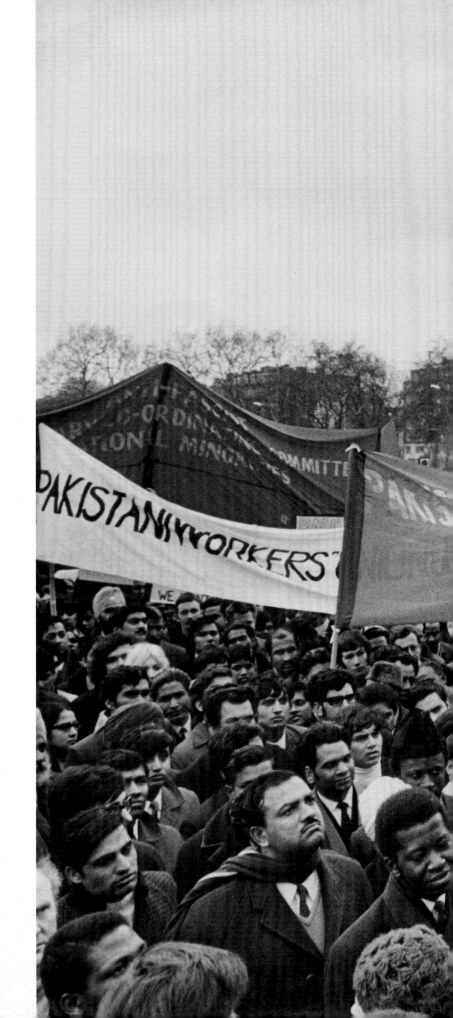

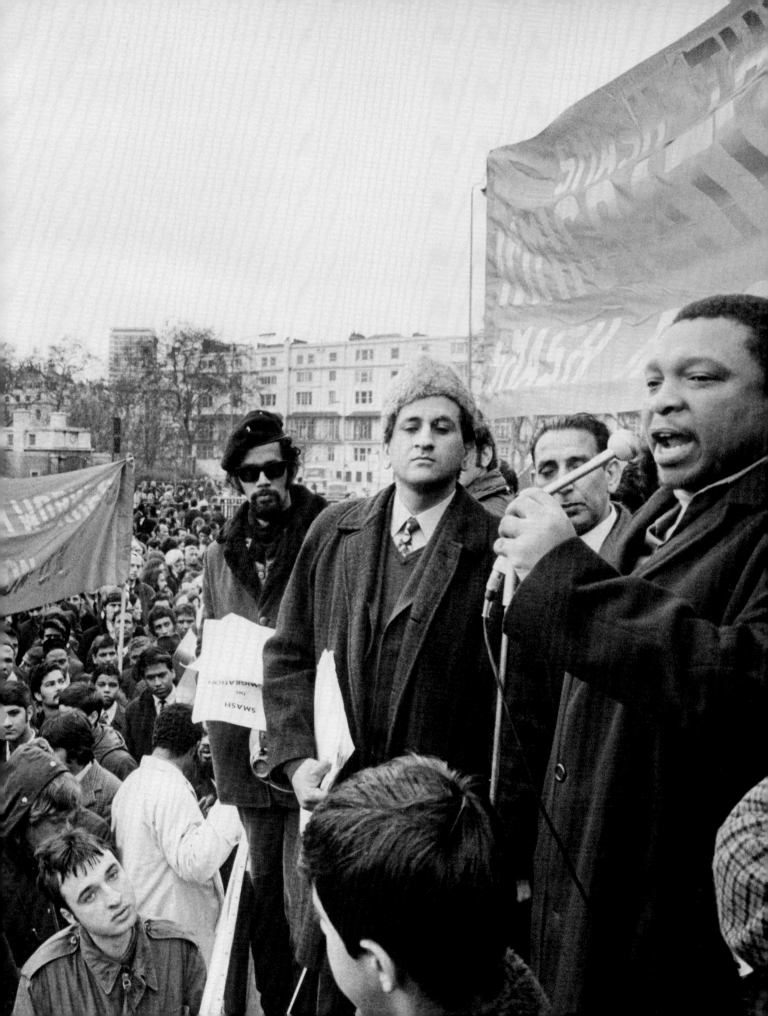

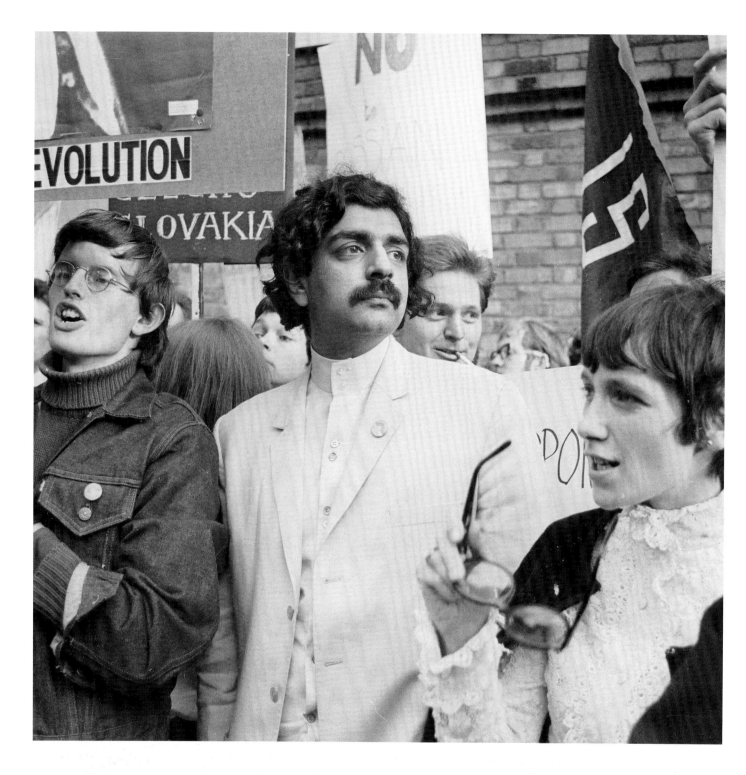

Campaigner, activist and intellectual Tariq Ali was elected president of the Oxford Union in 1965 and campaigned against the Vietnam War, leading student protests. (1968)

Facing page: Dr Narinder Singh Kapany (co-inventor with Dr H. H. Hopkins) adjusts a machine that aligns glass fibres into a fibre optic bundle at Imperial College, London. (1955)

Poor housing conditions and squalor were of major concern to activists, here in Brick Lane, London. (1979)

Gilbert Greenwood, formerly a colonel in the British Indian Army (far left), and Zahid Kashmiri (far right), fluent Urdu speakers, explain a gas converter set to a family outside their home in Hounslow. (1979)

infamously rabble-rousing 'Rivers of Blood' speech. As Powell stirred up xenophobic hostility towards the strangers 'flooding' Britain's shores, his words provided the sanction for physical assaults on black and Asian communities across the country. Although Labour attempted to calm the widespread outrage caused by stepping up policies to improve race relations, it nevertheless continued to appease its predominantly white electorate on the increasingly explosive issue of immigration. Further legislation endorsing the now common pattern of racially determined controls followed in the 1970s, reinforcing the common perception that Britain's so-called 'ethnic minorities' were 'a problem' and did not belong. As Margaret Thatcher, soon to be Prime Minister, put it – in slightly more polite terms than Enoch Powell's inflammatory 1968 speech – the continuous influx of people from

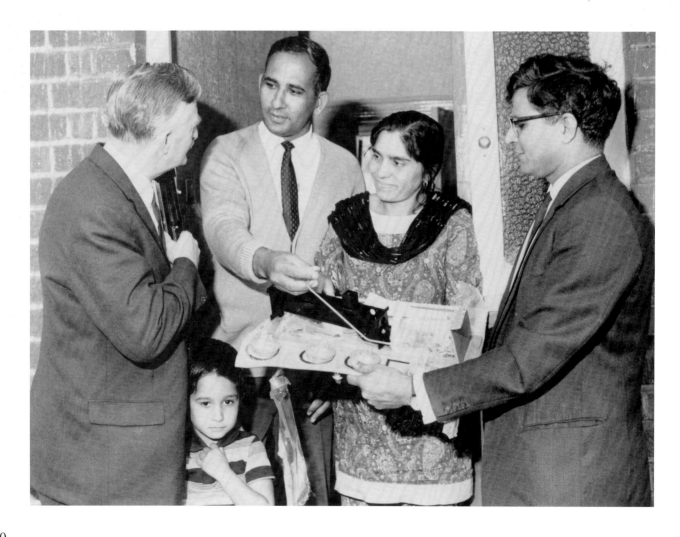

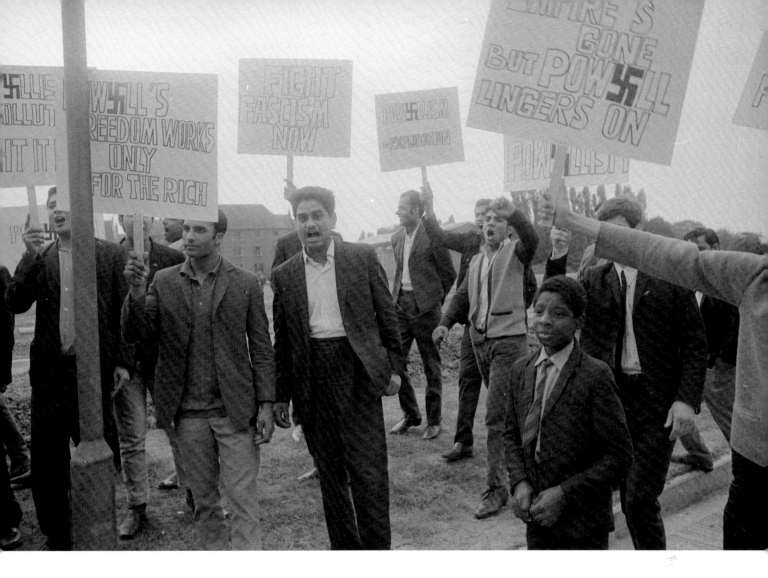

'different cultures' was threatening to completely swamp the 'British way of life'.

Given this backdrop, it is intriguing that some images deriving from the immediate post-war decades seem to initially reflect a nation cautiously at ease with the lives of its new Asian citizens in their midst. In the late 1940s and 1950s, memories of the war effort and Britain's recent defeat of the fascist Nazi regime in Germany were still fresh in the public consciousness. Perhaps as a consequence, the nation was unable to name or unwilling to identify its own latent prejudices, though they were routinely targeted at Jewish refugees, the Irish, Asians and blacks. Several photos of the 1948 London Olympics suggest, for example, the openness of a welcoming nation celebrating

Enoch Powell's infamous 'Rivers of Blood' speech (1968) had far-reaching consequences and featured in the 1979 election campaign. Anti-racism demonstrators gather in Wolverhampton in protest. (1970)

The wedding of Syeda Nayma Hussain and Mohammed Qaseem Khan at the Islamic Cultural Centre, St John's Wood. The centre was opened by George VI in 1944. (1952)

Facing page: A man and his son queue to pay their last respects to King George VI at Westminster Hall, London. (1952)

the talents of the many who visited. A similarly inclusive perspective is offered by the presence of a patriotic Sikh gentleman among the mourners at the funeral of George VI. Also apparently upbeat was a planned but unpublished *Picture Post* feature focusing on two turbaned young men as they stride down Piccadilly. Like characters from Sam Selvon's classic novel of black immigration, *The Lonely Londoners*, they look as if they own the town, even though the title of the play advertised behind them, *The Outcast*, gives an ironic slant to their confidence.

Photographs from this apparently more tranquil era also yield many images of Asians actively rebuilding the nation, whether as factory hands, Liverpool sailors, doctors or specialist scientists. But there is often a subtext. One illuminating photo story features

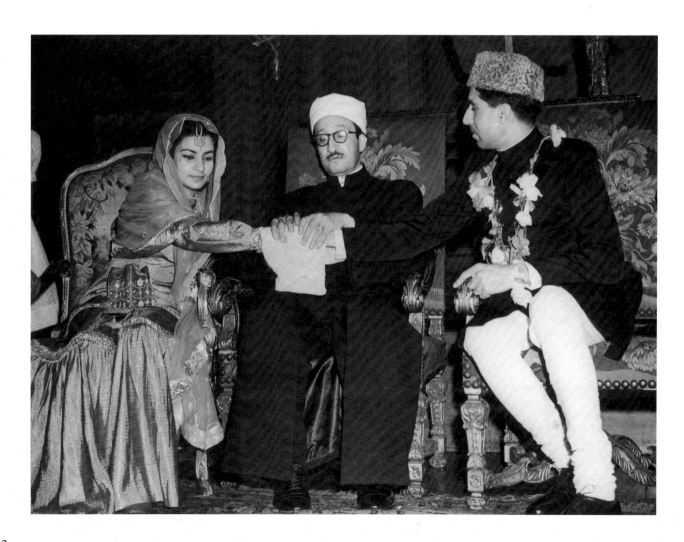

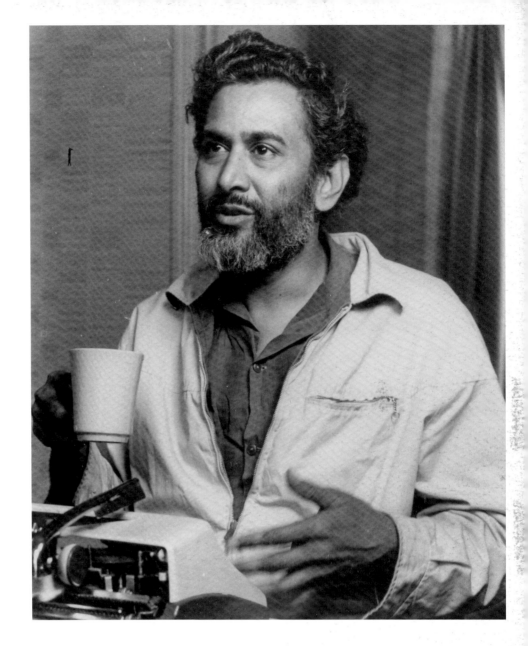

Trinidad-born writer of Asian heritage, Sam Selvon,
poignantly described the migrant experience in his seminal
1956 novel, *The Lonely Londoners*. (1970s)

Facing page: Two men walking down Shaftesbury Avenue
in London's Piccadilly. (1953)

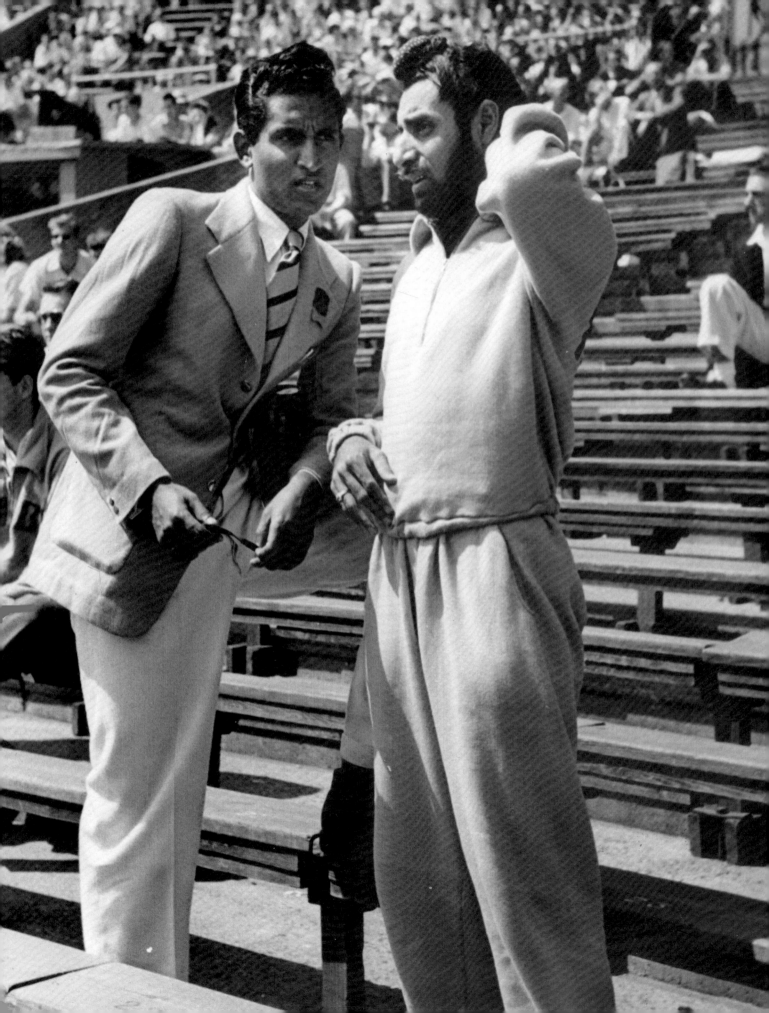

Above: India and Pakistan sent separate teams to the 1948 'austerity' Olympics. The Indian team attacks the Spanish goalmouth during field hockey matches at Chiswick. (1948)

Below: Head waiter Vana, from a West End Indian restaurant, serves food to members of the Indian team during the London Olympics. (1948)

Facing page: Two spectators at the Olympics at Wembley Stadium. (1948)

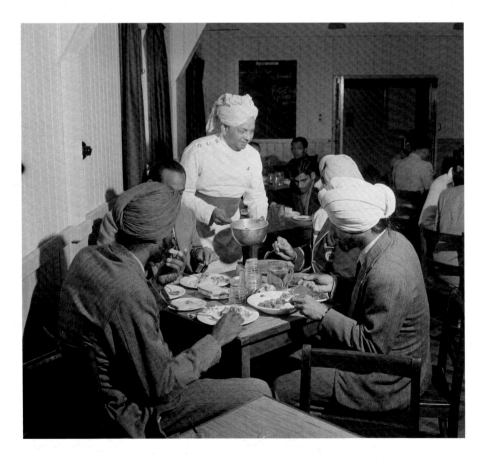

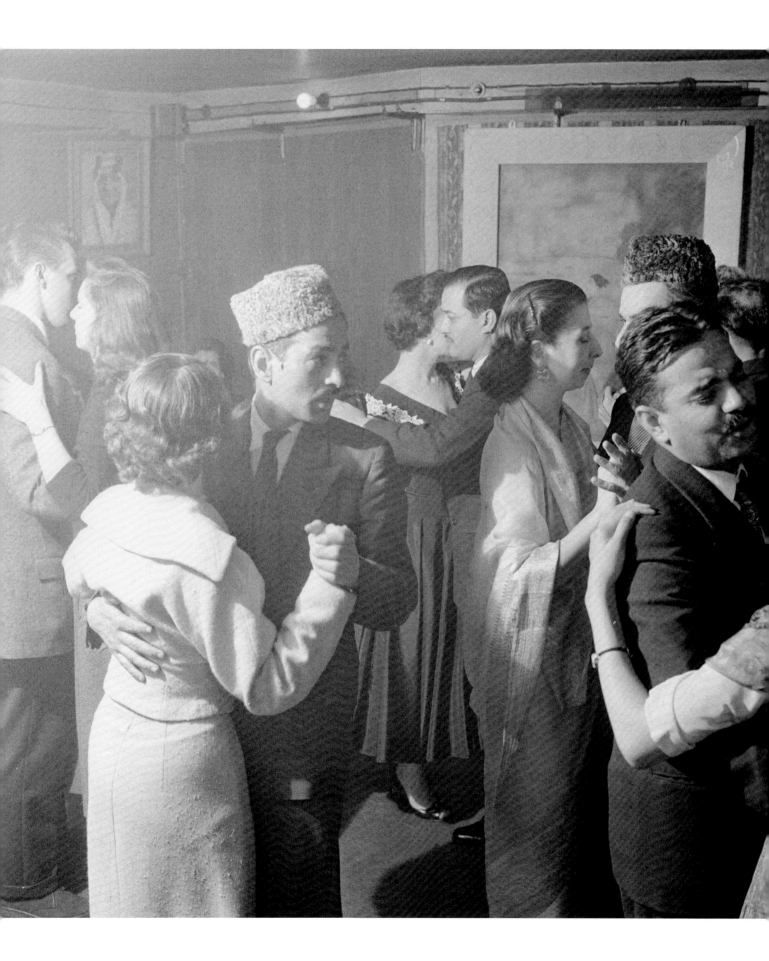

Above: Indian-British family in Surrey, 1956. Most of the descendants, including Susheila Nasta (baby here), still live in Britain today. (1956)

Below: Writer Hanif Kureishi and his father attend a party at the Pakistani Embassy. The family lived in Bromley. (1960)

Facing page: A mixed group of people at a dance in London. (1955)

A group of children
posing for the
camera, London.
(1955)

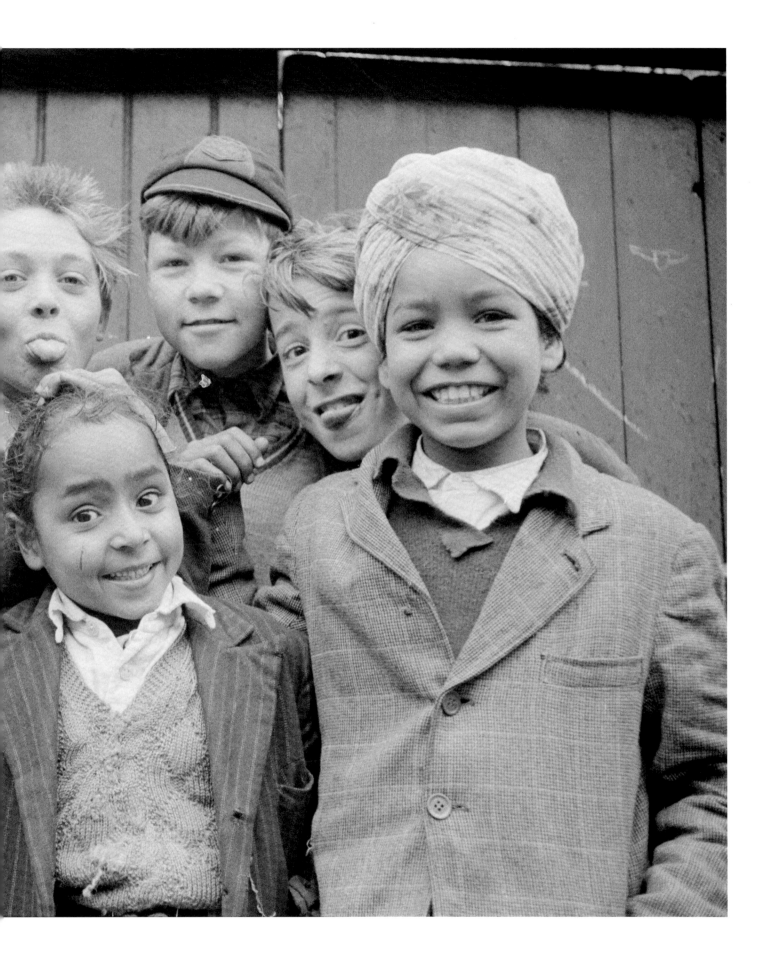

Asian children being bussed to school outside their areas, Southall. (1970)

Previous pages: 9- and 10- year-olds at Barkerend Primary School, Bradford. (1967)

unusual images of mixed-race couples dancing together at a night club. However, this story was not published, perhaps due to continuing prejudice about interracial relationships. Similarly, while several celebratory images of Hindu or Islamic weddings and integrated middle-class family groups suggest an early recognition of the potentialities of a multicultural Britannia, one wonders how the less privileged adapted to the realities of a world where the colour bar continued to restrict fundamental freedoms, limiting choices of housing, jobs or education. And, while the faces of smiling 'ethnic' children pop up regularly, they are almost always depicted against a slum backdrop. Though their friendships with the offspring of white working-class neighbours seem to tokenistically offer the promise of

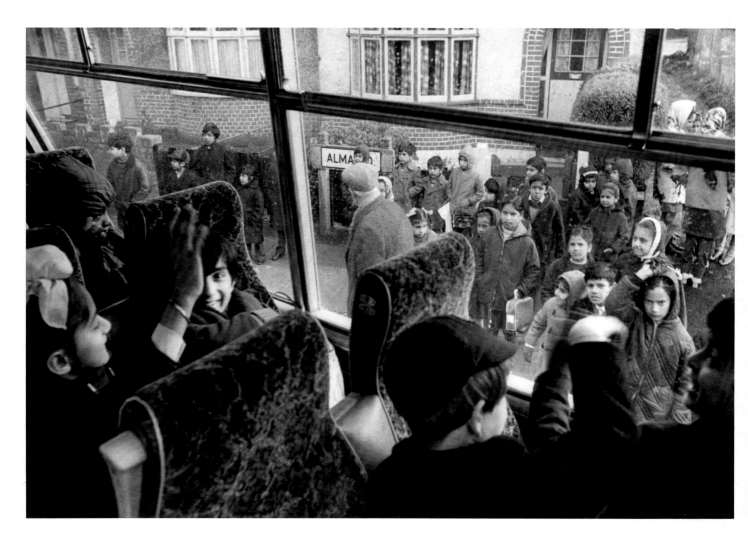

future racial harmony, the educational consequences of the 'bussing' system for Asian children living in highly populated 'immigrant' areas, such as Southall, suggested otherwise. Adopted nationwide in 1965, 'bussing' was ostensibly set up to prevent imbalances in the non-white quota in certain schools, the segregating effects of which were not diminished until the directives of the 1985 Swann Report insisted on equal educational opportunities for all. At the same time, and quite paradoxically in what was clearly an increasingly hostile racial environment, a still pervasive orientalist fascination with the spiritual traditions of the 'East' (evident already in followings of gurus and the poet Tagore in the early twentieth century) manifested itself through Beatle George Harrison's mentorship by Ravi Shankar and

Sushma Mehta teaching a mixed classroom of children. (1968)

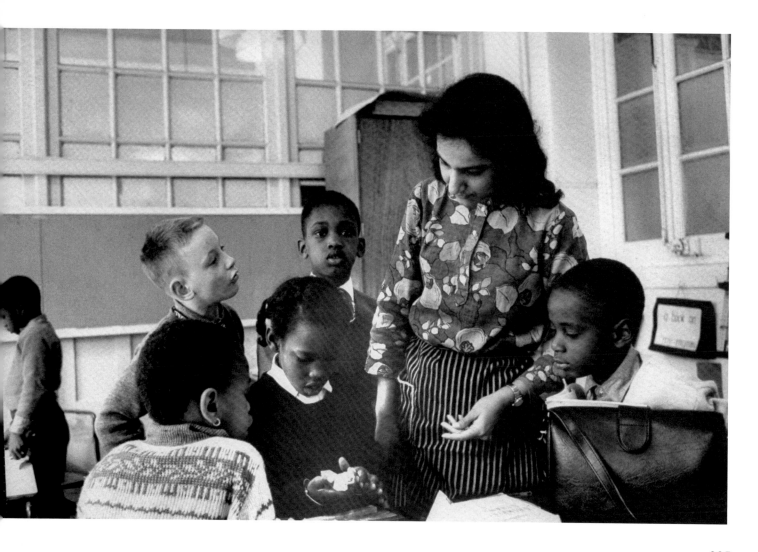

Composer
and musician
Ravi Shankar
popularised the
sitar and Indian
classical music
through his
collaborations with
violinist Yehudi
Menuhin and
pop artist George
Harrison of the
Beatles. (1967)

the symbolic fusion of Eastern and Western traditions, for instance as Ram Gopal, who had set up a dance school in London, mentored the world-famous Russian ballerina Alicia Markova.

As we move into the unhappy phase when Britain's 'unwelcome' black and Asian citizens became the prime focus of racial politics, the photo archive begins to signal, in spite of its quite different intentions, the harsh contradictions of the dual realities this population faced. Curious doublings occur throughout, however, as is evident from two images taken during the threshold year of 1962, the year the first immigration bill explicitly discriminating against Commonwealth citizens from non-white countries was passed. In the first stereotypical

Carmelita Roach and Maud Aven, Britain's first ethnic-minority traffic wardens. (1966)

Facing page: Ram Gopal lived in London from 1947 until his death in 2003, where his work as a dancer and choreographer was widely acclaimed. His 1960 collaboration with Alicia Markova was legendary. (1960)

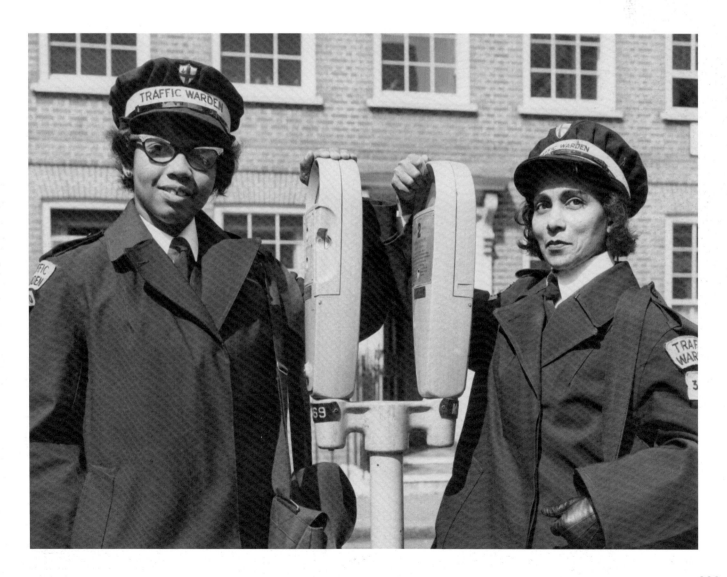

Immigrants arrive at London's Heathrow Airport escaping from a smallpox epidemic in Pakistan. (1962)

Facing page:
Above: After Independence, four Gurkha regiments transferred to the British Army. Wives of Gurkha soldiers relocated with them, here in Tidworth, Hampshire. (1962)

Below: An inspection of 'Kukris' at the Jellalabad Barracks, Tidworth, where they held an 'At Home'. (1962)

image of a nameless immigrant arriving at Heathrow, the original caption infers that the subject and his traditionally clothed Pakistani family were escaping from a smallpox epidemic, an idea no doubt designed to speak to the intended viewer's fears about immigrant contamination. By way of contrast, the homely presence of the stalwart Gurkha regiment, resident with their families in Tidworth, presents quite a different perspective.

It is important to remember that such visual records were not likely to have conjured up feelings of empathy in the white British viewer to create a sense of the difficulties such immigrants faced as they made their way in Britain. In fact, the reverse was true, as the distancing effect of the images not only neutralised emotions but placed 'them' outside any window of recognition. So while a triumphant 1964 image of a turbaned London Transport worker appeared to signal victory in

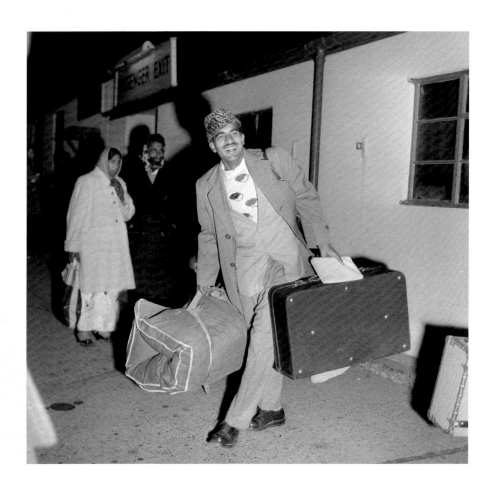

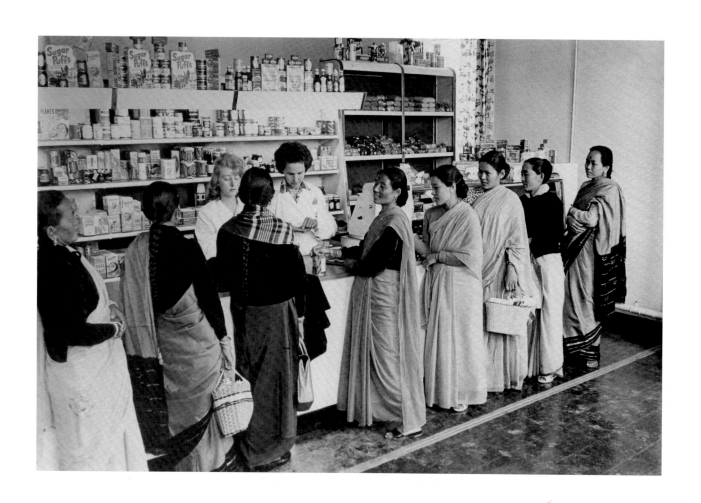

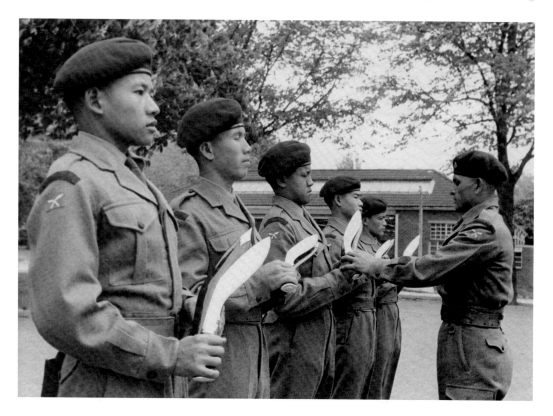

After a lengthy debate, Kenyan-born Harbans Singh Jabbal, stationed at East Ham police station, became the first British police officer to wear a turban on duty. (1970)

Facing page: Amar Singh, from Southall protested successfully to become the first London Underground worker to wear a turban with pin badge, instead of the standard uniform hat. (1964)

Following page: Piara Singh Kenth, the first Asian policeman in London's Metropolitan Police. (1969)

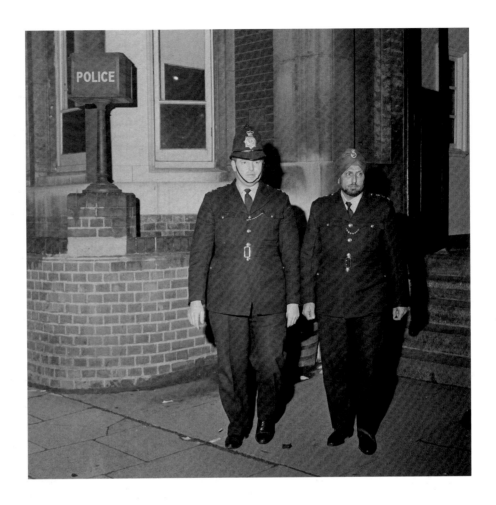

the long Sikh campaign to preserve their rights, one should also recall that it was this very same campaign which had provoked Enoch Powell to incite the nation to abandon toleration and just 'send them back'. That few could think more deeply about what might have been driving this issue had already been flagged up in 1959 by the legal action which surrounded the case of Gyani Sundar Singh Sagar in Manchester. The first to defend his position in what became a long-drawn-out battle, now known as the Sikh 'turban campaign', Sagar had allegedly been rejected for a position as bus conductor because he would not remove his headdress. Using history as a key element in his defence, Sagar reminded the opposition that Sikhs had long been allowed to wear turbans instead of helmets as British army soldiers in both World Wars. Since this successful campaign, turbans, as graphic signifiers of cultural difference, have continued to catch the public imagination as

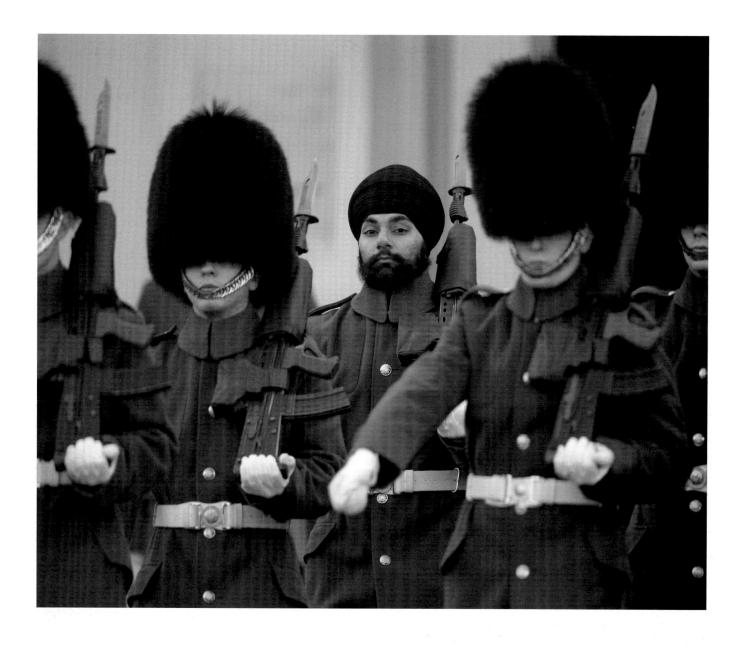

well as the eyes of photographers for many years. Thus, even in 2012 images of Scots Guardsman Jatenderpal Singh Bhullar, said to be the first member of the Queen's Guard to wear a turban rather than the traditional bearskin, can and do make front-page news.

It is unlikely, too, that any desire to empathise was what fired media coverage of the many Asian-led strikes in the 1970s to achieve equal labour conditions. Most images simply featured anonymous groups of angry-looking protesters rather than individuals. When viewed from the perspective of today, however, these sometimes bleak

Jatenderpal Singh Bhullar is the first Sikh Guardsman to wear a turban rather than the traditional bearskin while on duty outside Buckingham Palace. (2012)

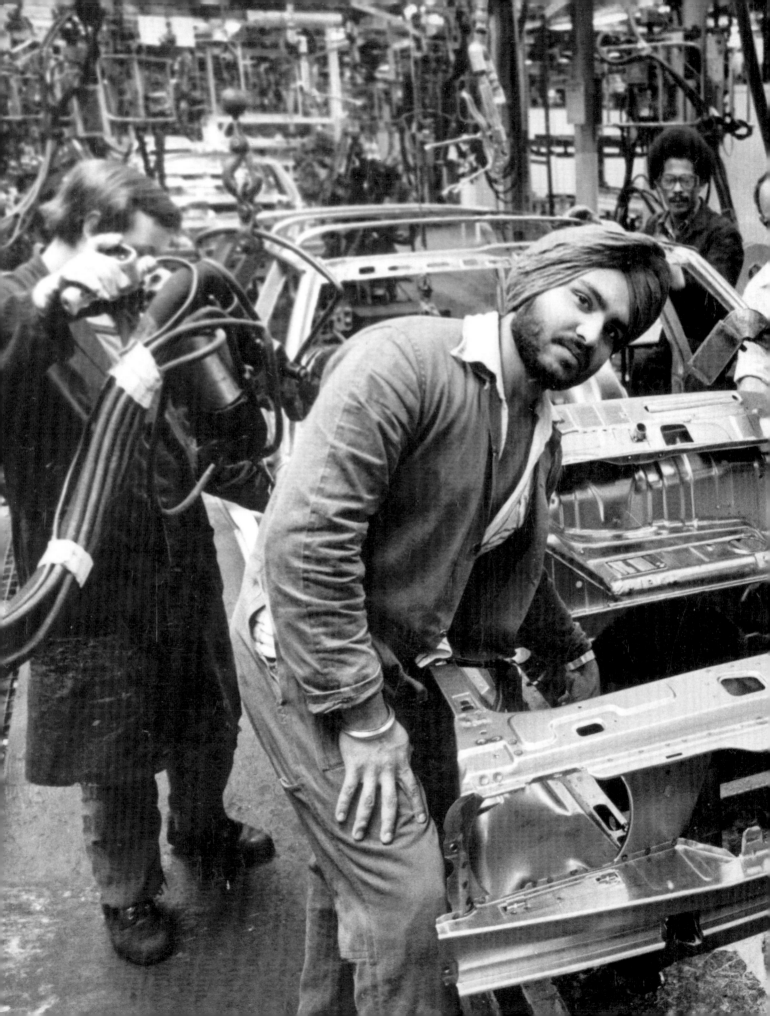

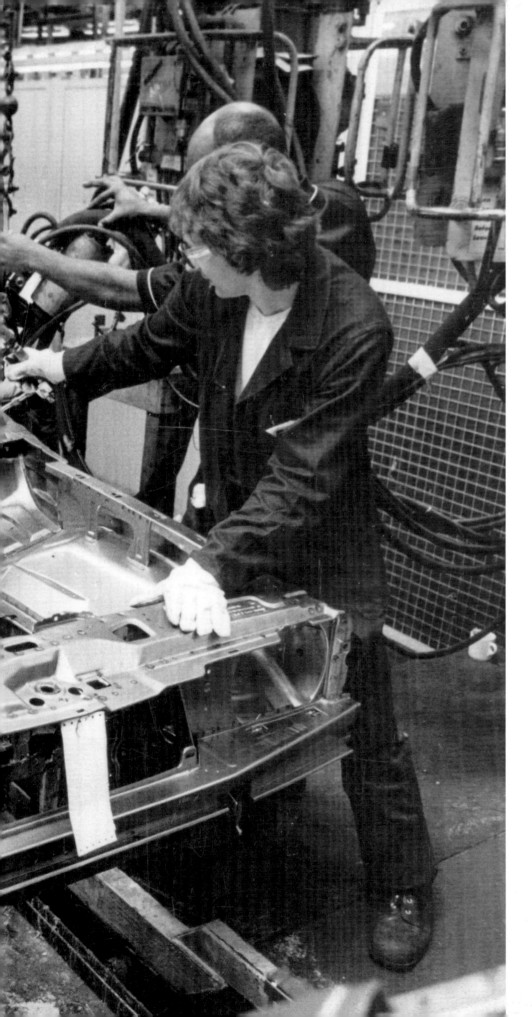

Dagenham's Ford plant employed workers from many different backgrounds. The subject of an industrial dispute over pay in September 1978, it triggered the widespread strikes known as the 'Winter of Discontent'. (1978)

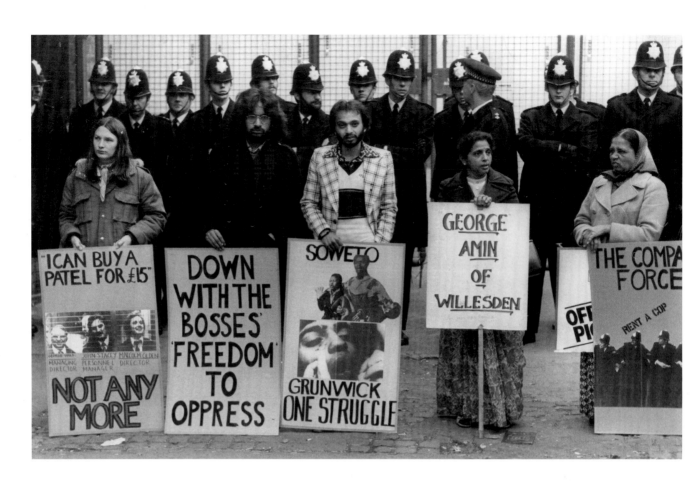

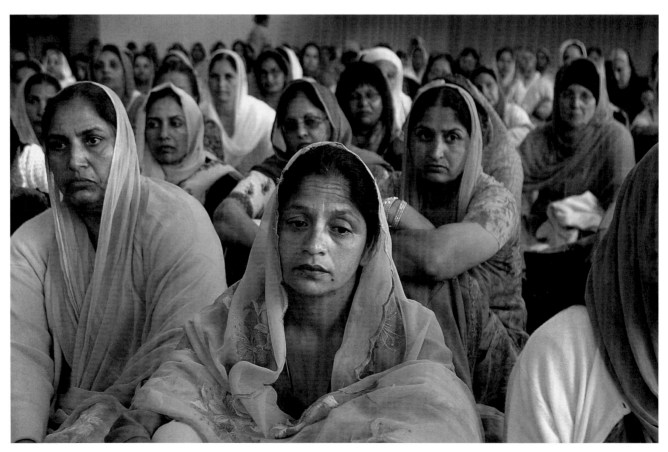

pictures provide clear evidence of the community's growing confidence and persistence. Often working night shifts or filling jobs others were unwilling to take on, these workers began to insist on proper recompense. In 1972, at the Mansfield Hosiery Mill in Loughborough, the predominantly Asian labour force was forced by their conditions to agitate against company and union racism. In Leicester, the Imperial Typewriters dispute was similarly provoked by inadequate pay and harassment, inflicted to achieve production targets not required of white workers. Perhaps most significantly, the Grunwick strike of 1976–78 attracted wide media attention. Not only was it led by women, most notably Jayaben Desai, but, unlike previous disputes, it began to garner the support of white trade unions such as the mineworkers. After fifteen months on the picket lines, Desai strategically invoked Gandhi's tactic of passive resistance and began a hunger strike to attract more attention and counter constant police surveillance. The activism of the many women who participated in the strike for two years cut through neat gender and racist stereotypes of female passivity – although it is worth noting that such stereotyping was what once again inspired media coverage of the 2005 Gate Gourmet dispute.

While most industrial disputes were fought peacefully, the escalation of racist attacks by neo-fascist right-wing groups such as the National Front caused violent conflict on Britain's streets. It may be considered unhelpful for race relations today to dwell on the regular brutalities of such incidents; nevertheless, they formed a significant aspect of daily life at the time. By the mid-1970s, these persistent acts of aggression had mobilised a new generation of British-born Asians who were ready to resist – and fight back. Often wrongly perceived as 'rootless' or caught 'between' two cultures, this home-grown movement became increasingly politicised as it sought to overturn myopic and narrow versions of national belonging. Between 1976 and 1981, the era of 'Paki-bashing' which had begun in the 1960s escalated. In just five years, racially provoked killings

Facing page:
Above: The strike at Grunwick photo-processing laboratory in Willesden (1976–78) was led by Jayabeen Desai. She and fellow strikers campaigned for union recognition and better working conditions. (1977)

Below: Sacked airline catering workers attend a union meeting in Southall's Sikh Temple after 670 were fired by Gate Gourmet in a dispute over working practices. (2005)

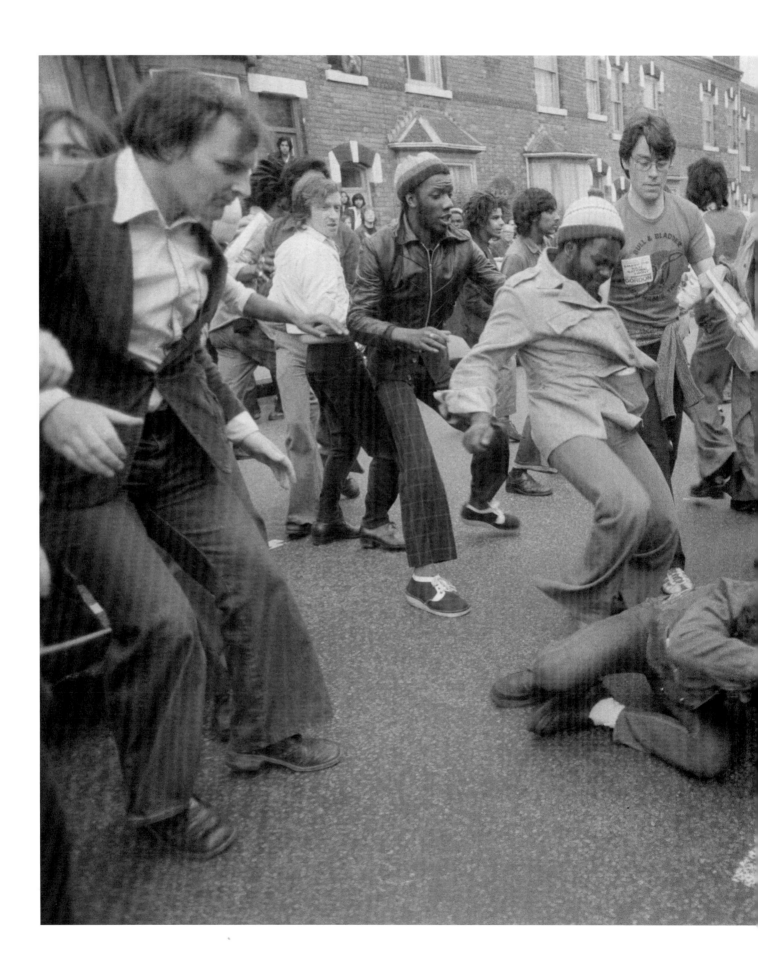

Clashes broke out between National Front supporters and anti-racist campaigners in Lewisham and Birmingham (pictured), where the National Front contested a by-election. (1977)

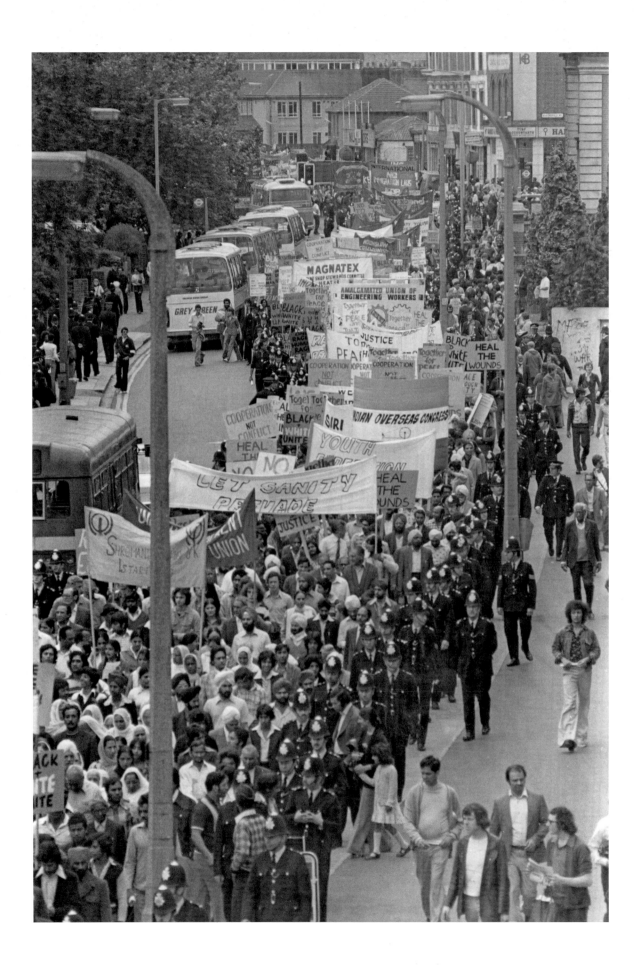

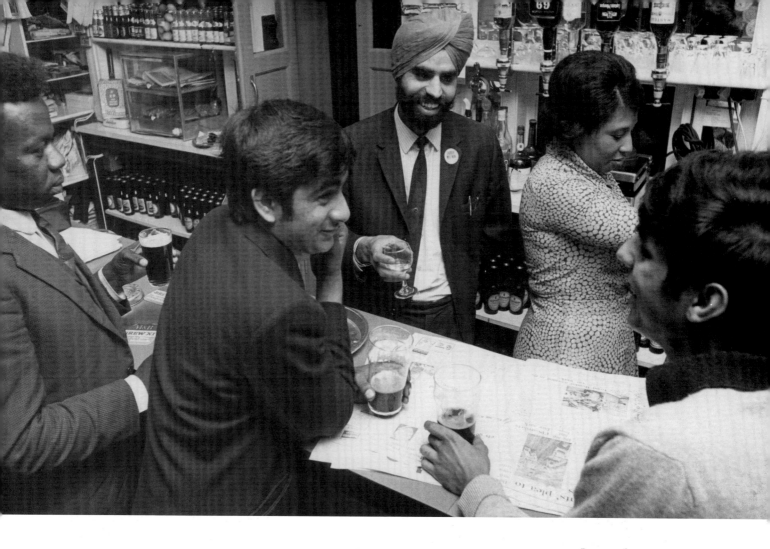

resulted in the deaths of 31 Asian and black people in Britain. Gurdip Singh Chaggar was stabbed to death in Southall by a group of white youths. Altab Ali and Ishaque Ali were killed in Brick Lane. Aktar Ali Baig was murdered in Newham. In addition to these murders were hundreds of muggings, arson attacks and acts of menacing vandalism as bricks were thrown through the windows of shops and businesses, threatening their owners and making it clear that it was time these unwelcome 'aliens' got out. As swelling resistance to this intolerable situation grew, the now well-known slogan 'Come What May We're Here to Stay' was proclaimed in demonstrations across the country.

As these mainly peaceful communities struggled to defend their positions, conflict on the streets resulted in the government authorising more aggressive police controls. In many situations, the police frequently denied responsibility, took action without due cause

An Asian-run pub in Wolverhampton. (1977)

Facing page: Community leaders head a procession through Southall following the fatal stabbing of schoolboy Gurdip Singh Chaggar after a racially motivated attack. (1976)

With the rise of the National Front in the wake of Enoch Powell's 1968 speech, Britain witnessed a sharp increase in racist attacks on Asian shops and businesses. (1970s)

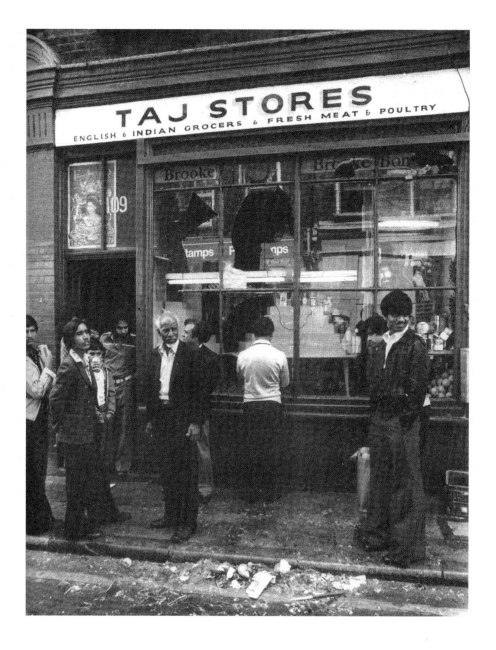

or turned a blind eye to serious charges, often turning victims into perpetrators. One of the many examples of how the situation escalated is provided by the tragic murder by the police of Blair Peach, a white schoolteacher who joined an anti-National Front demonstration in Southall in 1979. This act of violence, inflicted on an innocent member of the public, was triggered by an over-zealous police response to the National Front's provocative move to hold a party meeting in the borough's town hall. Though a mixed group of 5,000 local residents

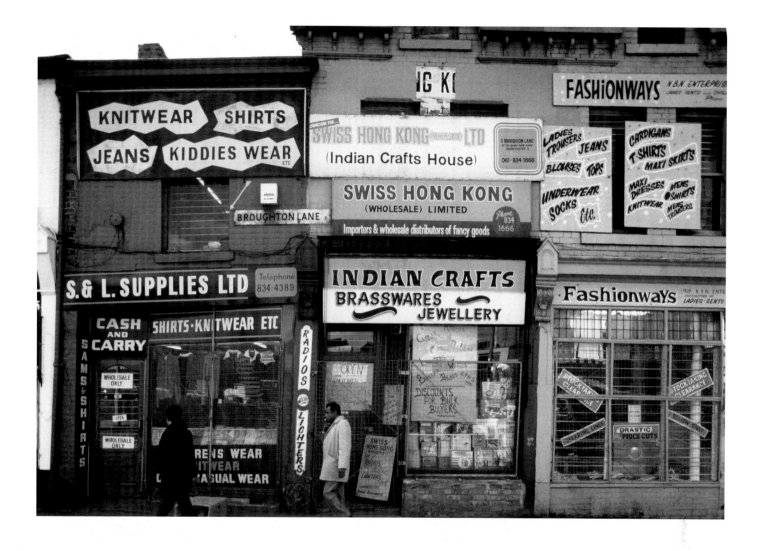

Shop fronts in Manchester. (1977)

had turned out in peaceful protest, the police engaged over 2,500 officers, including Special Patrol Units, dogs and horses, to break up the demonstration. Several demonstrators were arrested and over 300 were injured. Many similar incidents followed but only a few reached the courts. Even then, police evidence was frequently skewed and largely unmonitored, inciting ever more resentment.

Things came to a head soon after the first Thatcher government was elected at the end of the 1970s following an unashamedly anti-immigration campaign to once again stoke racist fears. In response to further police harassment, a series of riots spread across the UK. Exacerbated by government indifference to the deaths of thirteen young blacks in an arson attack in New Cross, these uprisings,

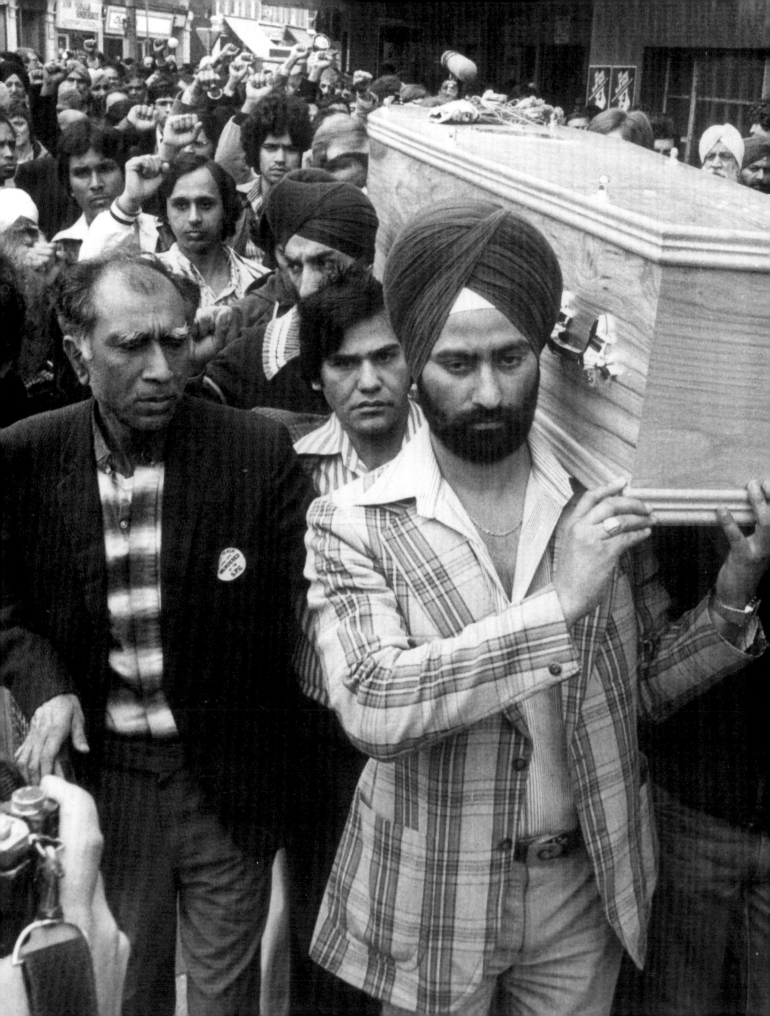

Thousands of mourners attend the funeral of Blair Peach, the New Zealander killed by police in the anti-National Front riots in Southall. (1979)

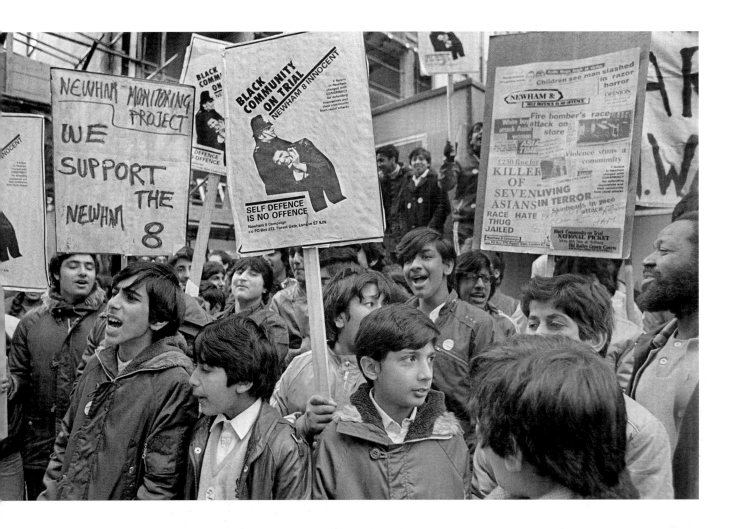

Schoolchildren go on strike and picket the Old Bailey in support of the Newham 8. This was the first school strike against racial violence to take place in Britain. (1983)

Facing page: Two young men in London's Southall. (1976)

which spread from Brixton in 1981, had wide social and political reverberations among the wider black and Asian communities. With symmetry dating back to the beginning of the century, the most vehement resistance was encountered in the old port cities of London, Bristol and Liverpool, all of which shared long histories of mixed-race settlement and racial oppression. As the riots spread, provoking widespread unrest in places like Southall, Leeds, Manchester, Handsworth, Coventry and Edinburgh, it became clear that political and public attitudes to Britain's non-white citizens urgently needed to change. Not only had the 1981 British Nationality Act resulted in increasingly questionable deportations; the heat sparked by national debates on multiculturalism and identity in the wake of the 1985 Honeyford Affair made it blatantly apparent that the liberal attempts

Mrs Manju Patel
is consoled by a
neighbour outside
her home in
Gillingham, Kent,
after the Home
Office threatened
her three sons
with deportation
over immigration
irregularities.
(1979)

Previous pages:
Black and Asian
activists attend an
anti-racism meeting
organized by the
Greater London
Council. (1985)

of various governments to promote 'soft' race relations policies of 'integration' and 'diversity' were inadequate and had failed to address deep-seated structural inequalities and prejudices. Although Honeyford was a local affair which developed out of one Bradford head teacher's public critique of Muslim cultural practices, it raised wider awareness of the nation's ongoing failure to fully confront the needs and rights of its large multicultural population.

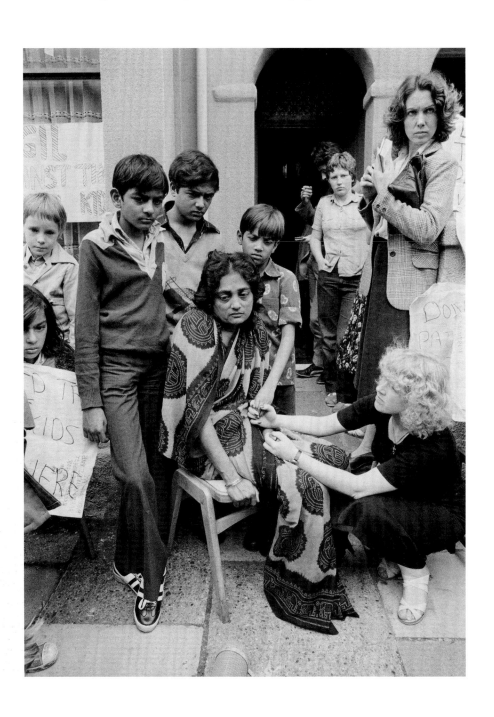

There has been much controversy in recent years over the complex backdrop to past and present understandings of multiculturalism. It is worth recalling here, however, that the brand of British 'multiculturalism', as we now know it, was initially a top-down policy which followed in the wake of the 1981 Scarman Report and that it differed from the dynamics of the unified fight to gain acceptance for cultural difference in the 1970s. Originally commissioned to investigate the causes of the 1981 riots, the Scarman Report concluded that 'racial disadvantage', not 'institutional racism', was the root of so-called ethnic minority 'problems'. While its recommendations led

A girl playing outside a shop in Gravesend. The city has a large Asian community. (1971)

The growth of the Sikh community in Leeds led to a need for larger spaces to worship. A disused church was converted to the Sikh temple in Chapeltown Road. (1971)

to significant anti-racist initiatives, the report failed to open up the main issue of discrimination which had bedevilled policy since the first Aliens Acts were passed in 1919. The crucial issue of endemic institutional racism was not finally addressed until 1999, when Sir

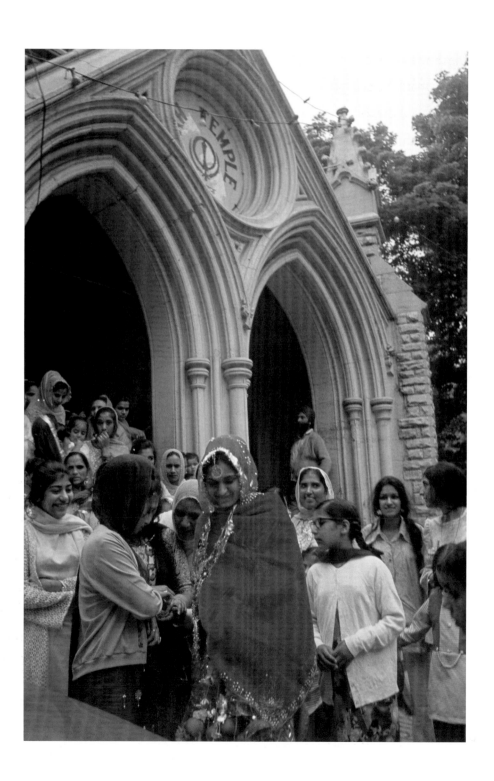

William Macpherson, following up on his judicial predecessor, published a report finally exposing corruption at the heart of the London Metropolitan Police during the investigation following the murder of black teenager Stephen Lawrence in 1993.

Although government-led multiculturalism did not overtly tackle structural inequalities, it did lead to several positive outcomes which slowly began to engender a sea-change in ways of thinking. As local council- and government-funded bodies such as the Greater London Council and the

A family outside their home in London. (1972)

Following pages: Customers and staff in a grocer's shop in Brick Lane, Tower Hamlets. (1978)

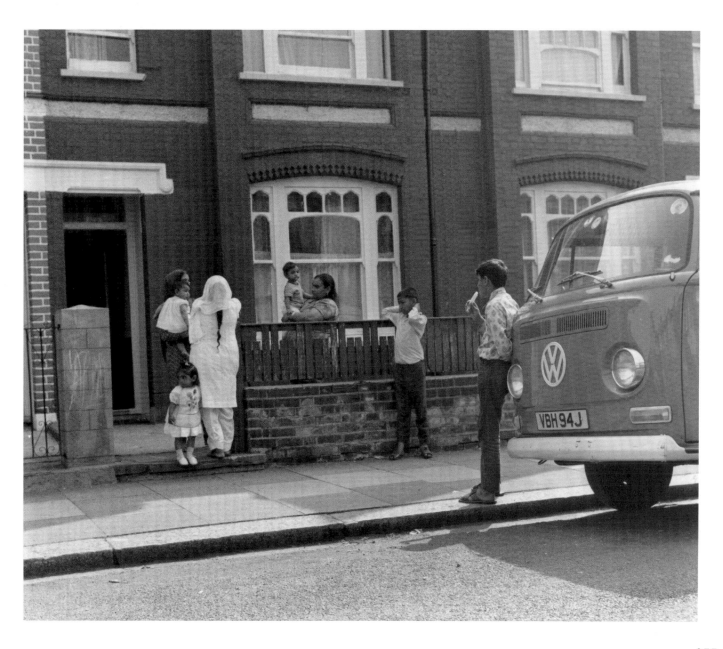

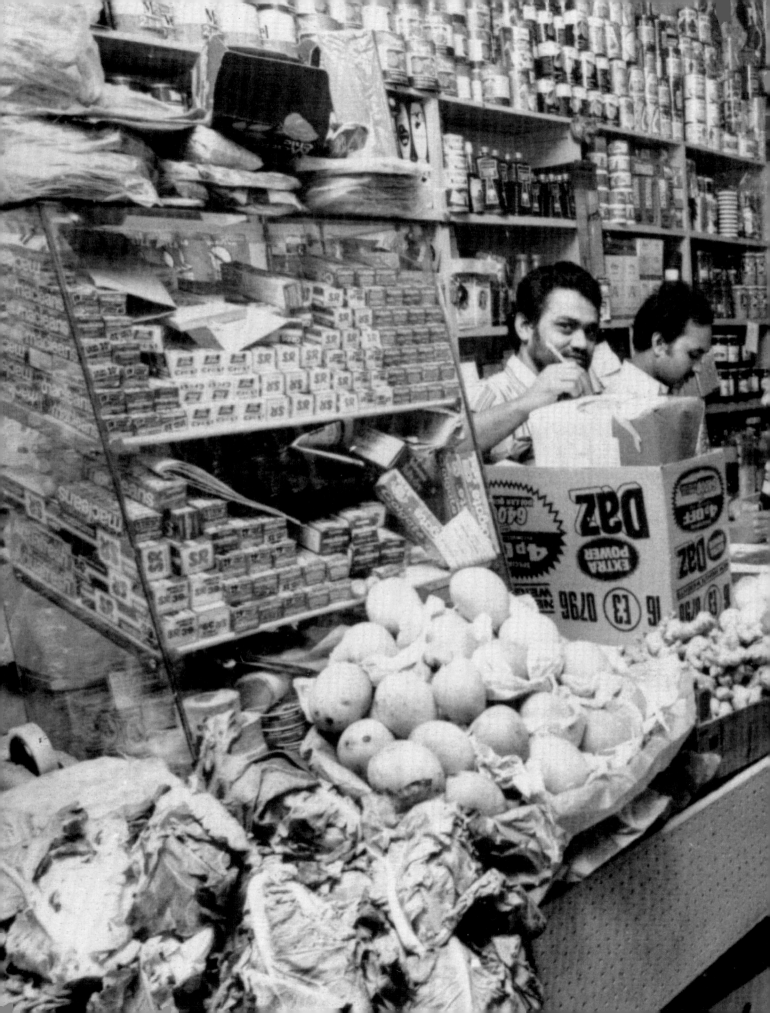

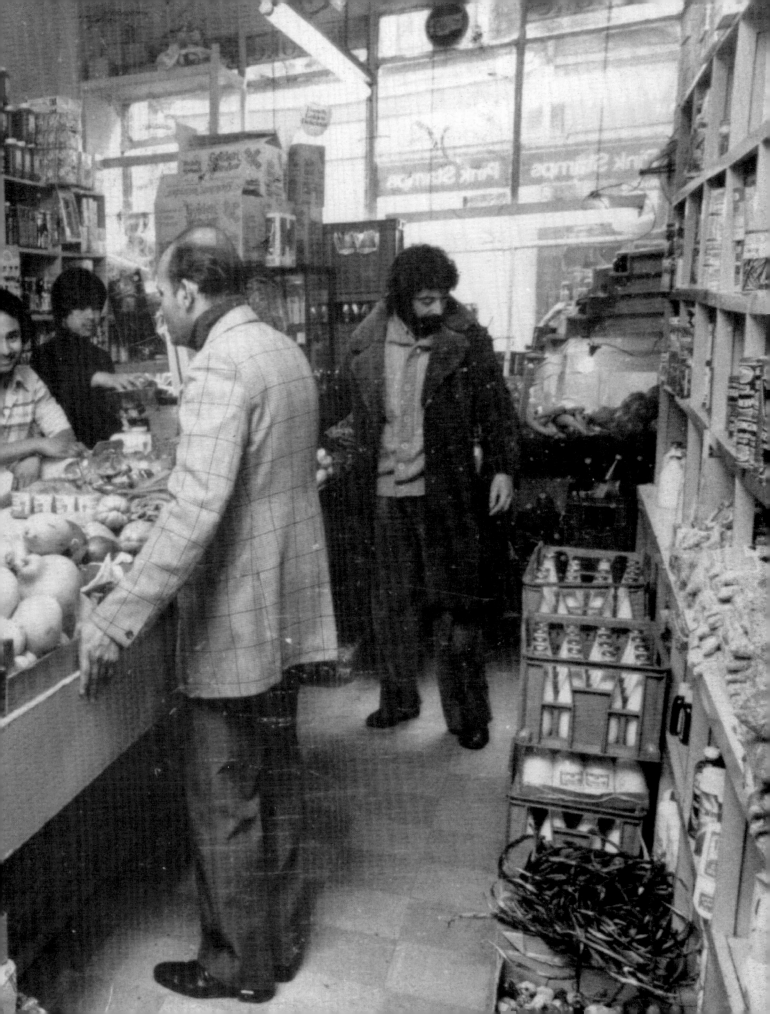

Abdus Salam won the Nobel Prize for Physics and taught at Imperial College, London. (1979)

Previous pages: Narinder 'Peter' Singh ran a Swansea-based Indian restaurant, Gracelands, where he entertained his guests with Elvis songs. He became famous as the world's only Sikh Elvis impersonator. (1989)

Arts Council were specifically targeted to sponsor cultural and educational projects, this led in turn to the increasing visibility of ethnic-led arts organisations, publishers, writers and theatre groups in the 1980s. Although considerable cultural activity was already evident before this, it was this period which saw groundbreaking initiatives such as the Channel 4 television programmes, led by Farrukh Dhondy, getting off the ground. At the same time, many new networks, including the Minority Arts Advisory Service, Southall Black Sisters and the Asian Women Writers Collective were formed, and several publishing initiatives such as *Artrage*, *Bazaar* and *Wasafiri*, now the magazine of international contemporary writing, came into being.

As public awareness began to shift, performing arts companies like Tamasha or Tara Arts began to attract wide audiences as their productions

exploded narrow racist stereotypes and offered new possibilities for reimaging Britain's migrant histories. Many involved with the launch of these seemingly new ventures had lived through the conflict-ridden decades of the 1960s and 1970s. Jatinder Verma, for instance, had launched Tara Arts in 1976 in response to the Southall murder of Gurdip Singh Chaggar and the pernicious reaction of a National Front agitator – 'one dead, one million to go'. Similarly, many British-born writers, artists, actors, dancers and producers, several with pioneering parents from earlier generations, began to gain a significant presence in the mainstream. Hanif Kureishi's iconoclastic screenplay for the film *My Beautiful Laundrette* may have shocked many, but its hybrid creative vision opened up pathways for the articulation of a different kind of Englishness, able to also satirise and flout

Writer, playwright and activist Farrukh Dhondy was commissioning editor for multicultural programming for Channel 4 from 1984 to 1997. (2012)

The Asian Women Writers Collective, founded in 1984, promoted the work of Asian women. In the picture are (from left to right): Leena Dhingra (writer and actress), Ravinder Randhawa (writer and founder), Rukhsana Ahmed (playwright and novelist), Rahila Gupta (writer and member of Southall Black Sisters) and Shazia Sahail. (1984)

traditionalist Asian taboos. As the arts Britain had previously ignored gained widespread acclaim, practitioners began to subvert canonical forms and explore innovative ways to assert the complexity of their multiple identities, a process that continues in the reinvention of Britain today.

Although largely positive, this new brand of British multiculturalism also generated division. As memories of the early alliances formed in the grassroots fights for equality faded, different groups driven by separate political and cultural agendas began to compete for recognition in the multicultural marketplace. At times, vehement articulations of an identity politics was the result. The potentially polarising ramifications of this situation became starkly evident in the reactions of a certain element of the British Muslim community to the publication of Salman Rushdie's novel, *The Satanic Verses*, in 1988.

Although by no means the only example of a controversial faith-led protest, the Rushdie affair, as it came to be known, was particularly significant. For it not only mobilised the voice of what had largely, up till then, been a large but invisible population of Muslim citizens, it also had wide global ramifications. Though most protests were peaceful, some,

Above: Writer Attia Hosain in London with her children: director Waris Hussein (left), who worked on the first series of *Dr Who* and was the first Asian to stage a play at the National Theatre; and filmmaker and producer Shama Habibullah (right) who has worked on films including *Gandhi* and *A Passage to India*. (1970s)

Below: Novelist and screenwriter Hanif Kureishi came to prominence in the 1980s with films like *My Beautiful Laundrette* and, in the 1990s, with novels *The Buddha of Suburbia* and *The Black Album*. (1996)

Above: Ben Kingsley (Krishna Pandit Bhanji) with Richard Attenborough, who directed him in the film *Gandhi*, for which he won an Oscar in 1982. (1983)

Below: Novelist Romesh Gunesekera is author of the Booker-shortlisted novel, *Reef*. He was the first recipient of the BBC Asia Award for Achievement in Writing and Literature. (1995)

Facing page: Teenagers outside a cinema in Southall, screening the latest Indian film hits. (1980)

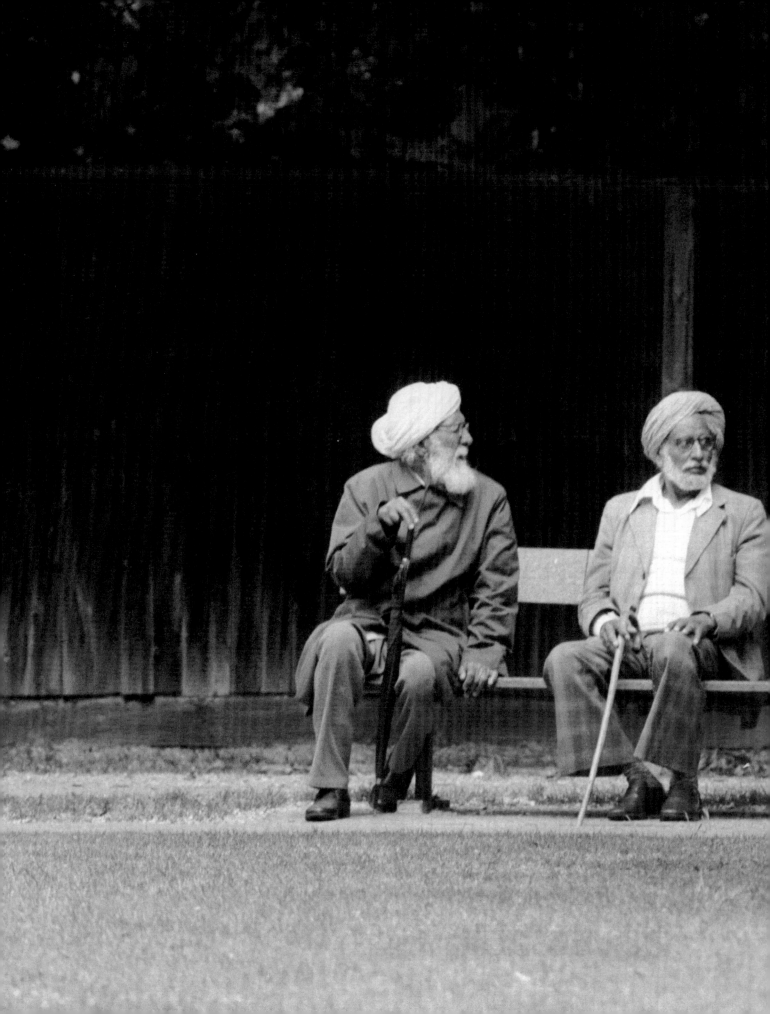

Three elderly men on
a bench in London's
Southall. (1980)

Above: Salman Rushdie won the Booker Prize for his 1981 novel *Midnight's Children*. He worked for the Camden Council for Race Relations in the 1970s–80s. His book *The Satanic Verses* led to a fatwa. (1989)

Below: The publication of *The Satanic Verses* provoked many demonstrations and counter-demonstrations across the UK. (1989)

Facing page: Rapper Aki Nawaz from Bradford formed the band Fun-da-mental, well-known for its anti-racist stance, in 1991. (2006)

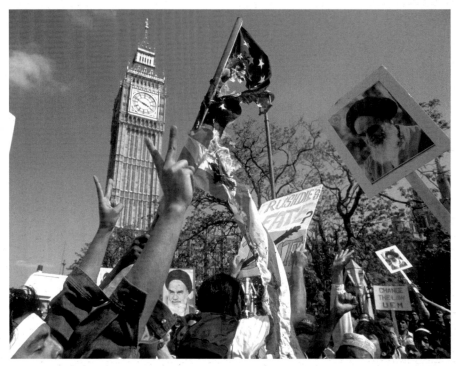

Above: Londoners observe a two-minute silence after the 7 July London bombings. (2005)

Below: Michael Nazir-Ali was the 106th Bishop of Rochester from 1994 to 2009. (1994)

Members of the Muslim Youth Forum participate in a National Assembly Against Racism (NAAR) rally in Brick Lane, East London, following a racially motivated car bomb attack. (1999)

such as the much-publicised book burning in Bradford, turned violent. Ayatollah Khomeini's fatwa placed a death sentence on the author in 1989 and this further inflamed the issue, with the result that Rushdie (himself a lapsed Muslim) was forced into hiding, under state protection, for nine years. By no means all Muslims supported the fatwa. Some were quiet, others joined activist groups such as the newly formed 'Women Against Fundamentalism'. But the media shots of angry Muslims which circulated in the national and global press reinvoked latent prejudices as their content implied it was only groups from the seen-to-be backward and uneducated Muslim working class who were causing the unrest. Moreover, such images were frequently juxtaposed with the apparently peaceful resistance of the broader intelligentsia who, unlike the hordes of protesting 'fundamentalists', supported a secular democracy and Rushdie's case for freedom of speech. As these potent photographs were flashed around the world, much anti-Islamic reaction was provoked. There is no doubt that the affair provided a platform for a previously voiceless underclass of British Muslims to both assert their differences from mainstream British society and their dual identification with a pan-Islamic global identity. Regrettably, however, the controversies raised by the affair resulted in a refuelling of long-held colonialist prejudices.

The year 2001 saw riots in Oldham, Burnley and Bradford, caused by tensions fuelled by far-Right organisations. (2001)

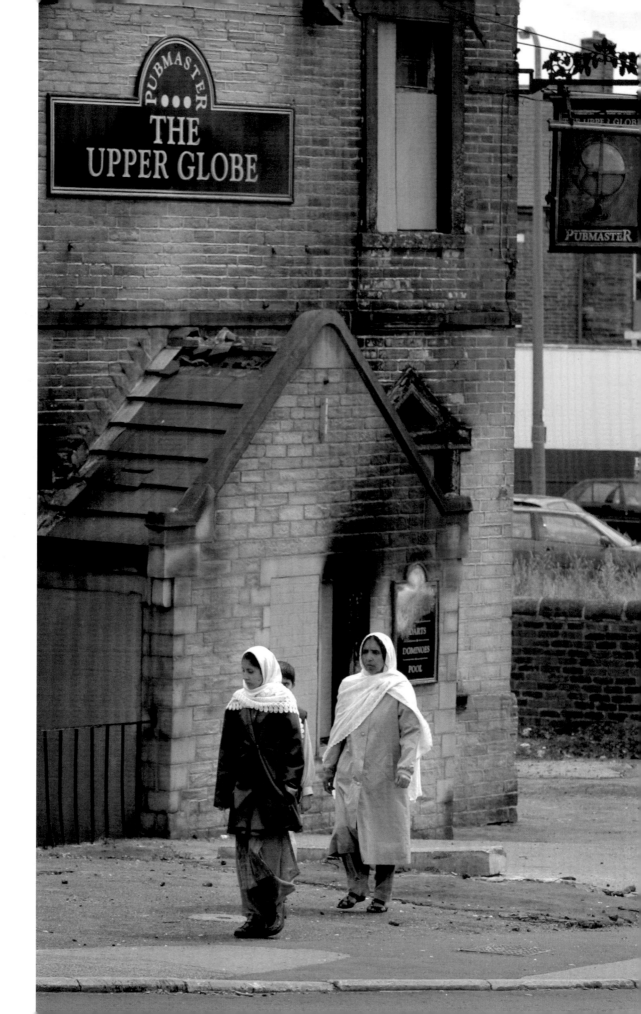

And its aftermath created dissent between a variety of different groups who were unwilling, simply because of their appearance or dress, to be thrown into the general net of the new xenophobic discourse of 'Islamophobia', still very much alive in many Western nations.

These anti-Muslim reactions did not simply emerge out of a domestic context. They were in fact largely exacerbated by worldwide reaction to the frequently cited 'global War on Terror', following the attacks of 11 September 2001 and 7 July 2005. In Britain, the repercussions have led to a growing scepticism with multiculturalism, which has shifted the focus away from race relations to issues of national security. As Trevor Phillips, the then Chair of the Commission for Racial Equality, stated soon after the 2005 attacks, Britain 'is sleepwalking' towards 'segregation'. Although this comment provoked much controversy, it nevertheless reflects a trend which continues to question the consequences of multiculturalism, despite the obvious successes of today's culturally diverse society. This issue will no doubt remain a matter of concern for years to come, particularly as new fears provide justification for increasingly harsh anti-terrorism laws and immigration controls.

Although attention has necessarily been drawn to some of the struggles

Shakeel Javed, publisher of the *Urdu Post*, lives in the Alum Rock area of Birmingham. Numerous Asian-language media and broadcasters have established themselves in Britain. (2008)

Following pages: 2002 saw Asian culture featured prominently through the musical *Bombay Dreams*, written by actress Meera Syal, lyricist Don Black and composer A. R. Rahman. Led by a British-Asian cast, it included Preeya Kalidas, Ayesha Dharker and Raza Jaffrey (left to right), famous for roles on British television and film, here meeting the Queen at a gala performance. (2002)

Poet Daljit Nagra grew up in London and Sheffield. Winner of the 2007 Forward Prize for Best First Collection and shortlisted for the Costa Poetry Award, he won the South Bank Show/Arts Council Decibel Award. (2008)

Britain's Asian and black communities endured in the turbulent decades leading up to the present, it should emphatically be stated that the complex histories constituting the background to Asian Britain can by no means be solely defined by this. To be sure, the free-market policies of two Thatcher

Chairman of the Conservative Anglo-Asian Society, Narinder Saroop was the second Asian Conservative candidate after Mancherjee Bhownagree. He was councillor in Kensington and Chelsea and set up the borough's Community Relations Committee. (1979)

governments led to further economic decline, a situation which exacerbated existing inequalities as traditional employment in Britain's manufacturing industries began to wane. At the same time, however, the last two decades have witnessed the increasing prominence of a large and affluent Asian middle class. And their various occupations as business magnates, in international banking, the catering and retail industries, software companies, pharmaceuticals, fashion or film, are now key to the British economy. Partly influenced by Bollywood fashion, the Asian wedding business alone was recently estimated to be worth over £300 million a year. Similar comments could be made about several other sectors like the clothing and food industries, where supermarkets claim to sell over eighteen tonnes of chicken tikka masala, 'the nation's favourite dish', each week.

One consequence of these various enterprises has been a shift from the traditional Asian backing of Labour, characteristic of voting patterns during the 1960s and 1970s, to support and sponsorship of the Conservative Party. In addition, anti-racist initiatives have finally begun to open previously closed doors for political representation. Although for many decades

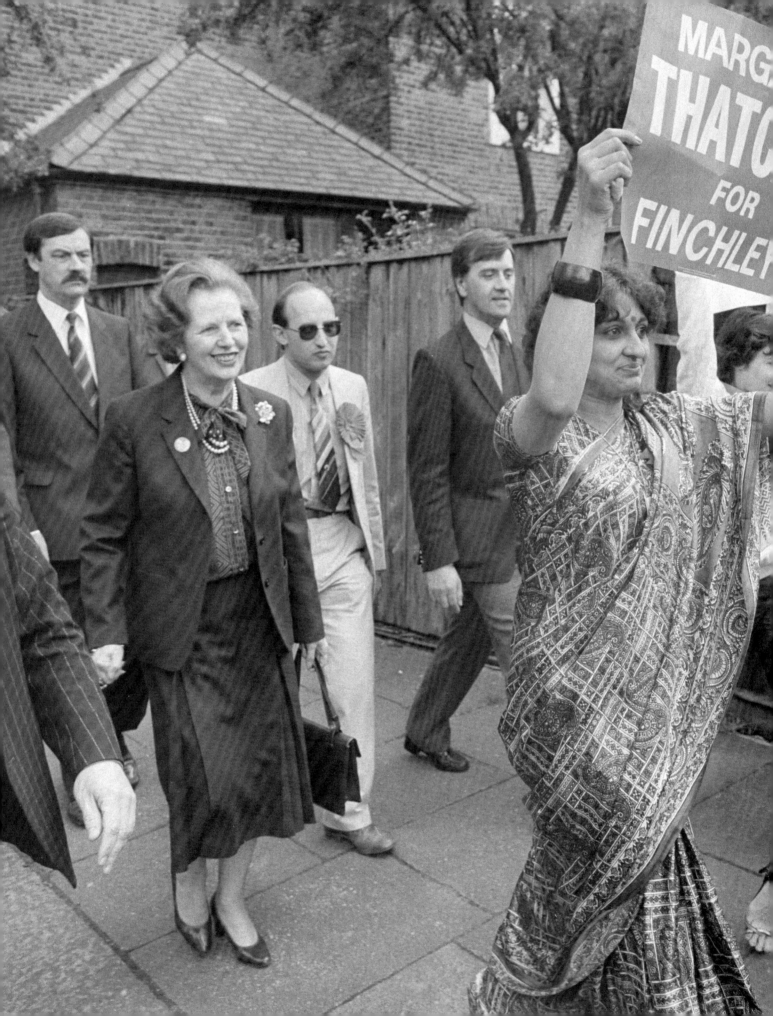

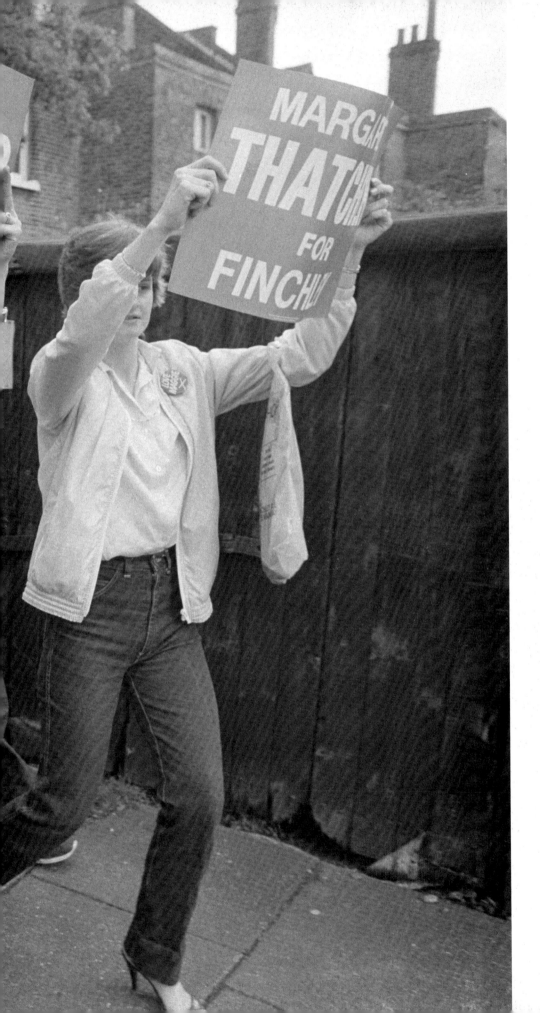

British Conservative prime minister Margaret Thatcher campaigning for re-election in her Finchley constituency. (1983)

Following pages: Labour Party supporters at an Edmonton rally. (1997)

Above: Sadiq Khan addresses the Labour Party conference. He was elected MP for Tooting in 2005 and served in Gordon Brown's cabinet. (2010)

Below left: Yorkshire-born Sayeeda Warsi trained as a solicitor before becoming a Conservative politician. She was made a life peer in 2007 and was a member of David Cameron's cabinet. (2010)

Below right: Economist Meghnad Desai is a Labour peer in the House of Lords. He was Labour Party Chairman from 1986 to 1992. (2009)

The 1987 general election saw the election of four Black and Asian MPs, the first since the 1920s. They included (left to right) Bernie Grant, Paul Boatang, Keith Vaz and Diane Abbott, seen here with Labour Party leader, Neil Kinnock (centre). (1987)

numerous Asians wished to serve as MPs or local councillors, political parties had been wary of selecting them to contest seats due to fears that they would not attract support. But by the general election in 1987, it had become clear that there were strategic advantages in drawing in the large ethnic electorate by selecting candidates who would more widely represent the UK's diverse communities. Keith Vaz's campaign as Labour candidate for Leicester East made him the first Asian MP to be elected since 1929. While the number of politicians is still not proportionate to the size of the British Asian population, several now hold high-profile positions in the House of Commons and the House of Lords and work as national representatives in the European Union.

This visibility, however tokenistic at times, becomes increasingly insistent across the visual record as it leads to the present. While there are occasional representations of ongoing discontent, such the recent protests by

Indarjit Singh was made a life peer in the House of Lords in 2011. Starting his career at the National Coal Board, he is editor of the *Sikh Messenger*. He served on numerous national committees, including the Commission for Racial Equality. (2011)

National Health workers and restaurant owners about the negative impact on resources of current immigration legislation, most contemporary images focus on those who have made it and whose lives seem to reflect a Britain now finally able to celebrate its mixed cultural history. As the angle of the lens shifts across numerous success stories in the arts, the music, media and film industries or sport, those previously newsworthy snapshots of demonstrating workers or newly arrived families fade out. We have instead a plethora of graphic images featuring various Asian *melas*, now part and parcel of the landscape, or celebrity photos of the many who are British

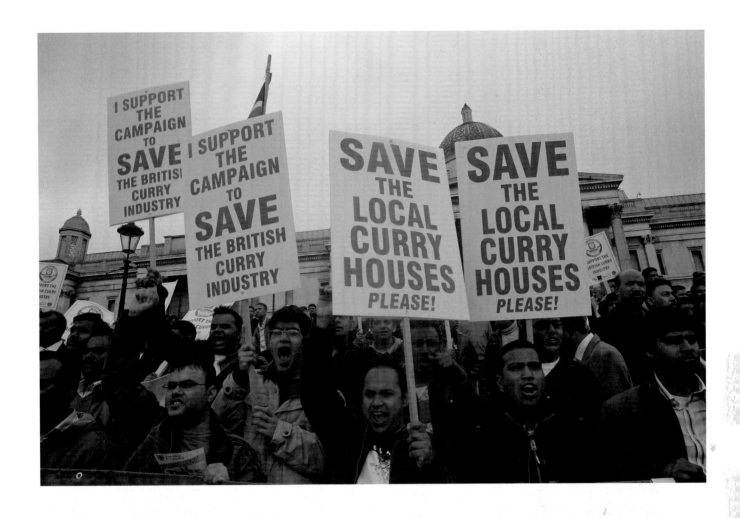

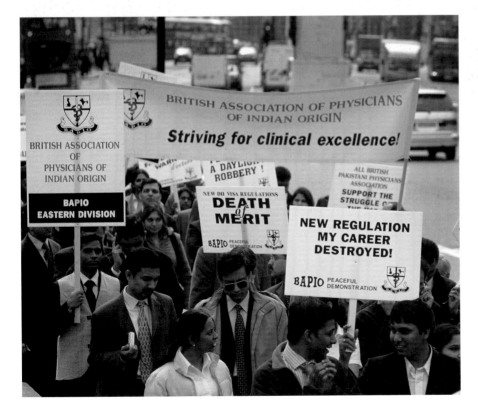

Above: A protest by the Ethnic Catering Alliance against new immigration legislation, threatening recruitment into the restaurant business. The organisation is formed by Chinese, Bangladeshi, Indian, Pakistani and Turkish catering communities. (2008)

Below: Doctors from the British Association of Physicians of Indian Origin (BAPIO) demonstrate in protest over new immigration rules. (2006)

Above: Leicester's Diwali celebrations are one of the largest outside India. (2006)

Below: Britain's first Asian judge Mota Singh QC at the Procession of Judges. He was appointed in 1982. (2001)

household names. Their original media captions frequently highlight the fact that these distinctive figures are the 'first' to qualify for such achievement. As such, they are encouraging role models, evidence of opportunity and symbols of the equality now apparently available to all. This present-day tendency to almost over-emphasise the glitzy diversity of the new nation is not without its ironies, as it inevitably points back to the long years when an

Apache Indian is the stage name of reggae and bhangra DJ, Steven Kapur. He grew up in Handsworth, Birmingham. (1995)

Above: DJ, producer, composer and tabla player Talvin Singh is well known for his fusion of Indian classical music with drum and bass. He won the Mercury Music Prize in 1999 and the UK Asian Music Award in 2010. (2001)

Below: News correspondent and broadcaster George Alagiah is one of many Asian presenters on British television. (2010)

Above: Yasmin Alibhai-Brown is a journalist and writes regularly for *The Guardian*, *The Independent*, the *Observer* and the *London Evening Standard*. She won the 2002 George Orwell prize for political journalism. (2012)

Below: Actress and food writer Madhur Jaffrey helped popularise Indian cuisine. She is the aunt of arts journalist Maya Jaggi. (1996)

Writers and actors Sanjeev Bhaskar, Meera Syal and Kulvinder Ghir (left to right), together with Nina Wadia, challenged Asian stereotypes with their comedy sketch show, *Goodness Gracious Me*. (2012)

Facing page: Journalist, author and broadcaster Sarfraz Manzoor writes for the *Guardian* and *Observer* newspapers and is a regular BBC commentator. He was also deputy commissioning editor at Channel 4 television. (2007)

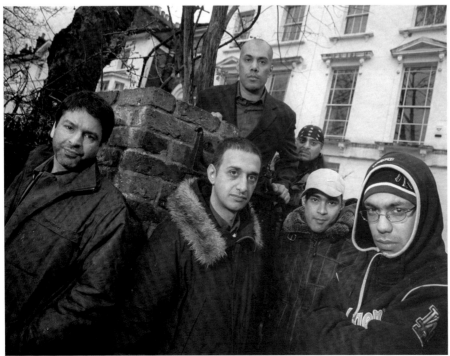

Above: Shreela Gosh became famous as an original cast member of the soap opera *EastEnders*. She retrained as a BBC news reporter. She was the first director of the Free Word Centre, committed to freedom of expression. (1987)

Below: The band Asian Dub Foundation, with Steve 'Chandrasonic' Savale and John Pandit (first and second left). (2003)

Facing page: Sheila Chandra started her career in children's TV serial *Grange Hill*, and was lead singer of the band Monsoon. Famous for their fusion of Indian and Western pop styles, they scored a surprise hit, 'Ever so Lonely'. (1982)

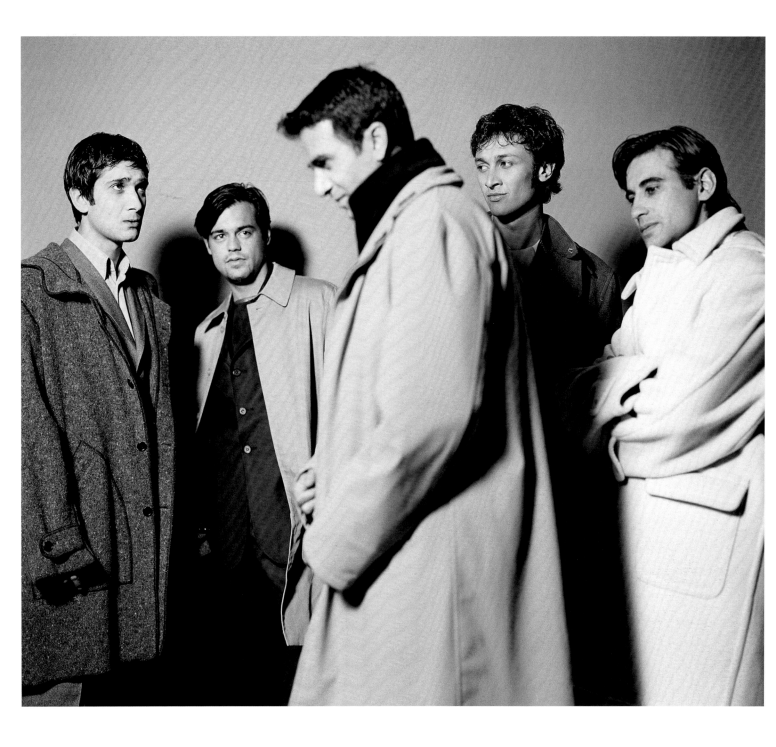

Actors Jimi Mistry, Emil Marwa, Ian Aspinall, Chris Bisson and Raji James (left to right) featured in Ayub Khan-Din's film *East is East,* a major hit in British cinemas and winner of a BAFTA award for best British film. (1999)

almost willing amnesia almost hid such stories from view. So, while Keith Vaz's election was an important symbolic moment in 1987, few captions carry any trace of remembrance of figures such as Dadabhai Naoroji who, as Britain's first Asian MP, preceded him in 1892.

The roll call of those now in the public spotlight is an impressive one. Lisa Aziz, notable for being the first mainstream presenter on British television, was soon to be followed by several others, including George

Alagiah and Rita Chakravarti, Razia Iqbal and Anita Anand. Numerous journalists are also prominent correspondents for national newspapers. Yasmin Alibhai-Brown, an East African migrant, was one of the first female columnists for *The Independent* and Maya Jaggi, niece of Indian cookery guru Madhur Jaffrey, is well-known for her *Guardian* arts interviews. If we turn to theatre, television and the film industry, a similar cast presents itself. Meera Syal, Sanjeev Baskar, Kulvinder Ghir and Nina Wadia first

Bend It Like Beckham, written and directed by Gurinder Chadha and starring Parminder Nagra, remains the most successful British Asian themed film, grossing over $76 million worldwide. (2002)

Above: Ben Ayres (left) and Tjinder Singh of British indie rock group Cornershop, famous for their hit 'Brimful of Asha', remixed by the DJ Fatboy Slim. (1999)

Below: Rochester-born Nitin Sawhney is an award-winning producer, songwriter, DJ, multi-instrumentalist and composer working in music, film, videogames, dance and theatre. (1998)

Above: Known as the 'Hitchin Hurricane', Arvind Parmar competed at Wimbledon and played for Britain's Davis Cup team from 2000 to 2006. (2004)

Below: Birmingham-born Zesh Rehman, along with Newcastle's Michael Chopra, is one of a few British Asian footballers to have played in the Premier League. The lack of professional Asian footballers has been the subject of much media attention. (2004)

Mark Ramprakash, cricketer for England, Surrey and Middlesex, teaches batting at Featherstone High School, Southall. He won the popular BBC show *Strictly Come Dancing* in 2006. (2005)

Facing page: Luton-born Mudhsuden 'Monty' Panesar made his England debut in 2006. A spin-bowler, he first played with the under-19 England team in 2001. (2006)

achieved fame for their comic sketches in *Goodness Gracious Me*. Most significantly, the powerful satiric vision of the series overturned stereotypes by its iconoclastic transgressions of commonly held assumptions, whether British or Indian. As large audiences followed such irreverent translations of British and Asian culture, others like scriptwriter Tanika Gupta influenced more traditional soaps such as *EastEnders*, *Grange Hill* and *Crossroads*, whose casts featured actresses such as Shreela Ghosh and Sheila Chandra. A similar pattern has followed with the large box-office successes of Gurinder Chadha's films, *Bhaji on the Beach* and *Bend It Like Beckham* or Ayub Kahn Din's *East is East*. This taste for 'Asian cool' was already buzzing in the music industry in the 1980s, with the popularity of the Punjabi-derived rhythms of bhangra. As the sounds of bands such as the Asian Dub Foundation or Cornershop filled nightclubs, other musicians like composer and DJ Nitin Sawhney gained a significant following in the mainstream.

Writer Kamila Shamsie's novel *Burnt Shadows* was shortlisted for the Orange Prize for Fiction. She is the niece of writer Attia Hosain. (2009)

Facing page: Bolton boxer Amir Khan won silver at the 2004 Olympic Games in Athens. (2006)

Some of the most iconic images of the twenty-first-century face of mixed Britannia stem from the world of sport, a pattern clearly obvious in the lead up to and coverage of the 2012 London Olympics. As an age-old favourite, cricket has also attracted much attention as players such as Nasser Hussain (England captain in 1999), Mark Ramprakash and Monty Panesar have become national heroes. And although football has not traditionally

Fauja Singh has run more than seven marathons, all after his 89th birthday, and featured in an Adidas advertisement campaign. (2011)

Following page: Liverpool-based artists, Amrit and Rabindra Singh, known as the Singh Twins, have made major contributions to contemporary British art with their modern variation of Indian miniature painting. They were both awarded MBEs in 2011. (2011)

Above: Barrister Shami Chakrabarti grew up in Harrow. Since 2003, she has been director of the UK civil rights organisation, Liberty. (2008)

Below: As part of her Golden Jubilee tour, Queen Elizabeth II visited the Pakistan Social, Cultural and Islamic Centre in Scunthorpe, North Lincolnshire. (2002)

A young professional
in Manchester.
(2006)

Above: A protester in East Ham demonstrating against British National Party (BNP) members standing in local council elections. BNP candidates gained three council seats in the northern English town of Burnley. (2002)

Below: An Asian-run post office in Greenwich High Street, London. Sandeep Singh and his colleague serving customers. (2013)

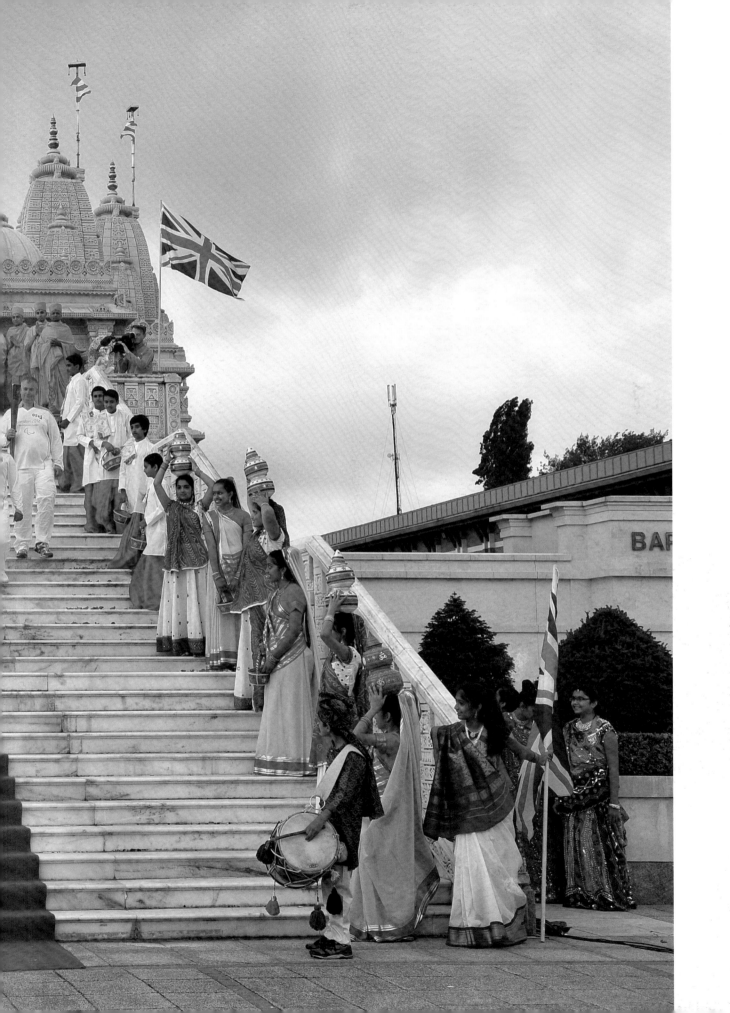

Author Vikram Seth reading from his book *Two Lives*, about his dentist uncle and his German wife who migrated to Britain in the 1930s/40s. (2005)

Previous pages: The Paralympic torch relay visited the Shri Swaminarayan Mandir in Neasden, one of the largest Hindu temples outside India, in 2012. (2012)

included many Asian stars, the situation is shifting with Premier League teams increasingly employing professionals such as Michael Chopra or Zesh Rehman. Perhaps most significant are the widely circulated images of Amir Khan who, draped in a Union Jack, is heralded as Britain's leading boxer.

As the visual record settles on the present, one is inevitably led to ask what has prompted such major changes in the angle of vision. Has the curtain which previously shrouded Asian Britain now finally been lifted? Only a few decades before, such widespread representation might have seemed unthinkable. Has the nation finally come to *see* that its large Asian population has long been an unquestionable part of its makeup? Or is this celebration of Britannia's new culturally diverse face only a veneer, still masking the underbelly of a parallel narrative of discontent, a still-existing

xenophobia, explained away by global politics but, nevertheless, regularly directed at peaceful British Muslims, refugees or asylum seekers? While this book's main aim has been to deepen knowledge and give fuller exposure to all that has been achieved, it is likely that such urgent questions will continue to reverberate.

A dentist examining a girl's teeth. (2000s)

Following pages: A festival celebration in Trafalgar Square, London, where the Sikh Vaisakhi, Hindu Diwali and Muslim Eid festivals draw big crowds annually. (2007)

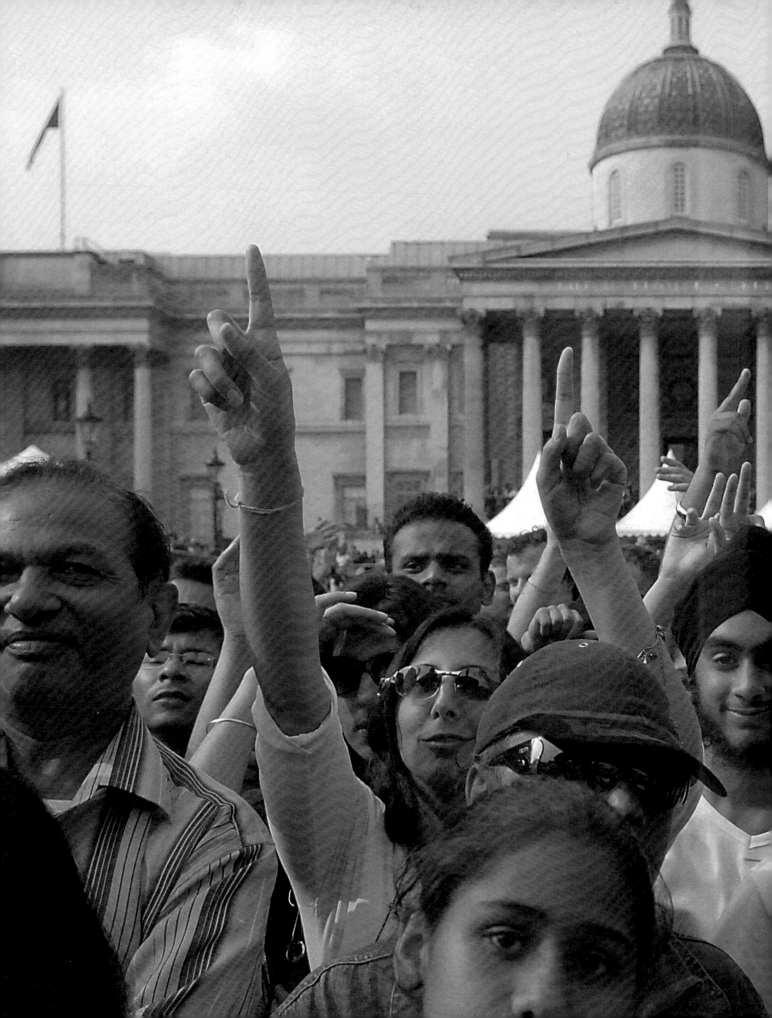

Further Reading

Ahmed, Rehana and Sumita Mukherjee, ed., *South Asian Resistances in Britain 1858–1947*, London: Continuum, 2011.

Alam, My, ed., *Made in Bradford*, Pontefract: Route, 2002.

Ali, Nasreen, V. S. Kalra and S. Sayyid, *A Postcolonial People: South Asians in Britain*, London: Hurst, 2005.

'Asians in Britain', British Library Learning Website, <www.bl.uk/asiansinbritain>

Bance, Peter, *Sikhs in Britain: 150 Years of Photographs*, London: Coronet House, 2012.

Barthes, Roland, *Camera Lucida; Reflections on Photography*, trans. Richard Howard, London: Jonathan Cape, 1982.

---, 'The Rhetoric of the Image', *Image, Music, Text*, trans. S. Heath, London: Fontana, 1977.

Batchen, Geoffrey, *Each Wild Idea: Writing, Photography, History*, Cambridge, Mass: The MIT Press, 2002.

Bell, Geoffrey, *The Other Eastenders: Kamal Chunchie and West Ham's Early Black Community*, Stratford: East-side Community Heritage, 2002.

Berger, John, *Ways of Seeing*, Harmondsworth: Penguin, 1972.

'Black Image: Staying On', *Ten.8: Quarterly Photographic Magazine* 16 (1984).

Bradford Heritage Recording Unit, *Destination Bradford: A Century of Immigration*, Bradford: BHRU, 1987.

---, *Here to Stay: Bradford's South Asian Communities*, Bradford: City of Bradford Metropolitan Council Arts Museums and Libraries, 1994.

Burman, Ashok and Jennifer McCarthy, *Indian Presence in Liverpool*, Liverpool: National Museums & Galleries on Merseyside.

Campaign Against Racism and Fascism/Southall Rights, *Southall: The Birth of a Black Community*, London: Campaign Against Racism and Fascism, 1981.

Chandan, Amarjit, *Indians in Britain*, London: Oriental UP, 1986.

Edwards, Elizabeth, ed., *Anthropology and Photography 1860–1920*, New Haven and London: Yale UP, 1992.

Edwards, Elizabeth and Janice Hart, *Photographs, Objects, Histories: On the Materiality of Images*, London and New York: Routledge, 2004.

Fisher, Michael H, *Counterflows to Colonialism: Indian Travellers and Settlers in Britain 1600–1857*, Delhi: Permanent Black, 2004.

Fisher, Michael H., Shompa Lahiri and Shinder Thandi, *A South-Asian History of Britain*, Oxford: Greenwood World, 2007.

Forbes, Geraldine, *Women in Modern India*, Cambridge: Cambridge UP, 1996.

Fryer, Peter, *Staying Power: The History of Black People in Britain*, London: Pluto, 1987.

Gilroy, Paul, *There Ain't No Black in the Union Jack*, London/New York: Routledge, 2002.

---, *After Empire: Melancholia or Convivial Culture?*, London/New York: Routledge, 2004.

---, *Black Britain: A Photographic History*, London: Saqi Books, 2007.

Goldberg, Vicki, *The Power of Photography: How Photography Changed Our Lives*, New York: Abbeville, 1991.

Gordon, Paul and Francesca Klug, *British Immigration Contorol: A Brief Guide*, London: Runnymede Trust, 1985.

Gundara, Jagdish S. and Ian Duffield, ed., *Essays on the History of Blacks in Britain*, Aldershot: Avebury, 1992.

Hall, Stuart, 'Life and Death of Picture Post', *Cambridge Review*, 92.2201 (1971).

---, *Representation: Cultural Representations and Signifying Practices*, London: Sage, 1997.

Holmes, Colin, *John Bull's Island: Immigration and British Society, 1871–1971*, London: Macmillan, 1988.

Inner London Education Authority, *Marches: Unemployment and Racism*, London: ILEA, 1981.

---, *Marches: Multiracial Britain: Images from this Century*, London: ILEA, 1981.

Institute of Race Relations, *The Fight Against Racism: A Pictorial History of Asians and Afro-Caribbeans in Britain*, London: Institute of Race Relations, 1986.

Jordan, Glenn, ed., *Down the Bay: Picture Post, Humanist Photography and Images of 1950s Cardiff*, Cardiff: Butetown History and Arts Centre, 2003.

Khan, Naseem and Tim Smith, *Asians in Britain*, Verona: Dewi Lewis Publishing, 2004.

Lahiri, Shompi, *Indians in Britain: Anglo-Indian Encounters, Race and Identity, 1880–1930*, London: Frank Cass, 2000.

Layton-Henry, Zig, *The Politics of Immigration*, Oxford: Blackwell, 1992.

'Making Britain: Discover how South Asians Shaped the Nation' database, <http://www.open.ac.uk/research-projects/makingbritain>

Nasta, Susheila, *Home Truths: Fictions of the South Asian Diaspora in Britain*, Basingstoke: Palgrave, 2002

---, ed., *India in Britain: South Asian Networks and Connections*, Basingstoke: Palgrave, 2012

Newham Monitoring Project/Campaign Against Racism and Fascism, *Newham: the Forging of a Black Community*, London: Newham Monitoring Project, 1991.

Panayi, Panikos, ed., *An Immigration History of Modern Britain: Multicultural Racism Since 1800*, Harlow: Pearson Education, 2010.

Pinney, Christopher, *The Coming of Photography in India*, London: British Library, 2008.

---, *Photography and Anthropology*, London: Reaktion Books, 2011.

Pinney, Christopher and Nicolas Peterson, *Photography's Other Histories*, Durham and London: Duke UP, 2003.

Race Today Collective, *The Struggle of Asian Workers in Britain*, London: Race Today Publications, 1983.

---, *The Arrivants: A Pictorial Essay on Blacks in Britain*, London: Race Today Publications, 1987.

Ramdin, Ron, *Reimaging Britain: 500 Years of Black and Asian History*, London: Pluto Press, 1999.

Ranasinha, Ruvani, Rehana Ahmed, Sumita Mukherjee and Florian Stadtler, eds., *South Asians and the Shaping of Britain, 1870–1950*, Manchester: Manchester UP, 2013.

Rattansi, Ali, *Multiculturalism: A Very Short Introduction*, Oxford: Oxford UP, 2011.

Samuel, R., ed., *Patriotism: The Making and Unmaking of British National Identity, Vol. 1: History and Politics*, London: Routledge, 1989.

Sardar, Ziauddin, *Balti Britain: A Journey Through the British Asian Experience*, London: Granta, 2008.

Singh, G. and J. Martin, *Asian Leicester: Britain in Old Photographs*, Stroud: Sutton Publishing, 2002.

Sivanandan, A, *A Different Hunger: Writings on Black Resistance*, London, Pluto Press, 1982.

Sontag, Susan, *On Photography*, London: Penguin, 1979.

Spencer, Ian R. G., *British Immigration Policy Since 1939: The Making of Multi-Racial Britain*, London: Routledge, 1997.

Visram, Rozina, *Ayahs, Lascars and Princes 1700-1946*, London: Pluto, 1986.

---, *Asians in Britain: 400 Years of History*, London: Pluto, 2002.

Wainwright, Martin, *'The better class of Indians': Social Rank, Imperial Identity, and South Asians in Britain, 1858–1914*, Manchester: Manchester UP, 2008.

Warner Marien, Mary, *Photography: A Cultural History*, 3rd edition, London: Laurence King, 2010.

Wells, Liz, *Photography: A Critical Introduction*, London: Routledge, 1997.

---, ed., *The Photography Reader*, London: Routledge 2003.

Wilson, Amrit, *Finding a Voice: Asian Women in Britain*, London: Virago, 1978.

Index

Photo Credits

(a.) above, (b.) below, (l.) left, (r.) right

Yasmin Alibhai-Brown p. 289 (a.)
Odd Andersen/AFP/Getty Images p. 285 (b.)
Archive Photos/Getty Images p. 24-25, p. 70-71
Asian Women Writers Collective p. 262
Scott Barbour/Getty Images p. 270 (a.)
Dave M Benett/Getty Images p. 291
Bloomberg via Getty Images p. 273
Margaret Bourke-White/Time & Life Pictures/Getty Images p. 119
The British Library Board, [Johann Zoffany; Reference: F 597] p. 1, [Reference: P. P. 7611] p. 13, [Sir Louis William Dane Collection; Reference: Photo 761/1(5)] p. 18-19, [Reference: T 12646] p. 21 (a. l.), [Reference: T 12646] p. 21 (b.), [H. D. Girdwood, Record of the Indian Army in Europe during the First World War; Reference: Photo 24/(1)] p. 34, [Reference: P. P. 7611] p. 38, [India and Ceylon Exhibition 1896; Reference: Photo 888/(46)] p. 44, [Hills and Saunders, Eton; Reference: Photo 846/(1)] p. 48, [Reference: 08275 bb. 28] p. 52 (l.), [Reference: 08275 bb. 28] p. 52 (r.), [Reference: T 12646] p. 53 (a.), [Reference: PP.1041.C] p. 54 (l.), [Reference: 10349. h. 12] p. 54 (r.), [Reference: P. P. 7611] p. 58-59, [Reference: T 10636] p. 63, [Reference: 1913 LON 515 [1913] NPL] p. 64, [Reference: P. P. 7611] p. 72, [Reference: P. P. 7611] p. 75, [Reference: 14119.f.37] p. 81, [[H. D. Girdwood, Record of the Indian Army in Europe during the First World War; Reference: Photo 24/(294)] p. 86, [H. D. Girdwood, Record of the Indian Army in Europe during the First World War; Reference: Photo 24/(134)] p. 87, [H. D. Girdwood, Record of the Indian Army in Europe during the First World War; Reference: Photo 24/(23)] p. 88, [H. D. Girdwood, Record of the Indian Army in Europe during the First World War; Reference: Photo 24/(2)] p. 89, [India Office Records; Reference: L/Mil/7/17232] p. 90, [H. D. Girdwood, Record of the Indian Army in Europe during the First World War; Reference: Photo 24/(158)] p. 91, [Reference: P. P. 7611] p. 97 (b. r.), [Reference: P. P. 7611] p. 106, [Reference: SV 503] p. 123, [Reference: SW 107] p. 134 (a.), [Reference: SW 107] p. 134 (b.), [Reference: SW 107] p. 135 (a.), [Reference: SW 107] p. 135 (b.), [Reference: SW 107] p. 137 (a.), [Reference: SW 107] p. 137 (b.), [Reference: SW 107] p. 139, [Reference: P. P. 7611] p. 140, [Reference: SW 107] p. 145 (a.), [Reference: ORW.1986.a.189] p. 145 (b.), [Reference: SW 107] p. 146 (a.), [Reference: SW 107] p. 149 (a.), [Reference: SW 107] p. 149 (b.), [India Office Records; Reference: Mss Eur D 1173/6] p. 160
John Bulmer/Hulton Archive/ Getty Images p. 245

Leonard Burt/Hulton Archive/Getty Images p. 211
Romano Cagnoni/Hulton Archive/Getty Images p. 29, p. 253, p. 254
Camera Press p. 224, p. 243, p. 244
Maya Caspari p. 307 (b.)
Gareth Cattermole/Getty Images p. 276
Central Press/Hulton Archive/Getty Images p. 177, p. 178-179, p. 189, p. 203, p. 217 (a.), p. 232, p. 233, p. 249
Central Press/Hulton Royals Collection/Getty Images p. 76
Phil Cole/Getty Images p. 297 (b.)
Fin Costello/Redferns p. 292
Carl Court/AFP/Getty Images p. 27 (b. l.), p. 284, p. 288 (b.)
Shaun Curry/AFP/Getty Images p. 269, p. 286 (a.), p. 301
H. F. Davis/Hulton Archive/Getty Images p. 142-143
Carl De Souza/AFP/Getty Images p. 285 (a.)
Marc DeVille/Gamma-Rapho via Getty Images p. 268 (b.)
John Downing/Hulton Archive/Getty Images p. 240-241, p. 266-267, p. 278-279
Victor Drees/Hulton Archive/Getty Images p. 200
Steve Eason/Hulton Archive/Getty Images p. 27 (r.), p. 271, p. 280-281
Evening Standard/Hulton Archive/Getty Images p. 32, p. 127 (a.), 199 (a.), p. 208-209, p. 236-237, p. 238 (a.), p. 255, p. 256-257, p. 265
Fox Photos/Hulton Archive/Getty Images p. 132-133, p. 147
Fox Photos/Hulton Royals Collection/Getty Images p. 166-167
Christopher Furlong/Getty Images News/Getty Images p. 37
Gamma-Keystone via Getty Images p. 102, p. 136, p. 161, p. 176 (b.), p. 212, p. 231 (a.)
General Photographic Agency/Hulton Archive/Getty Images p. 83, p. 94-95
Getty Images p. 174, p. 304, p. 308-309
John Gichigi/Getty Images p. 300
Zoltan Glass/Picture Post/Getty Images p. 164
Tim Graham/Getty Images p. 305 (b.)
Alastair Grant/AFP/Getty Images p. 274-275
Henry Guttmann/Hulton Archive/Getty Images p. 50, p. 60-61
Bert Hardy/Picture Post/Getty Images p. 172, p. 173, p. 214-215
Charles H Hewitt/Haywood Magee/Hulton Archive/Getty Images, p. 216
Hindustan Times via Getty Images p. 261
David Hoffman p. 248
Thurston Hopkins/Picture Post/Getty Images p. 126, p. 127 (b.), p. 182-183, p. 184-185, p. 186-187, p. 188 (a.), 188 (b.), p. 218, p. 220-221

Acknowledgements

Images courtesy of:
Yasmin Alibhai-Brown, Asian Women Writers Collective, Kulsum Bouzerda, The British Library Board, Camera Press, Maya Caspari, David Hoffman, Getty Images, Imperial War Museum, Muneer-Uddin Khan, King's College London Archives, Hanif Kureishi, Hills and Saunders, Literary Estate of Attia Hosain, Literary Estate of Sam Selvon, Lokayata/Mulk Raj Anand Archive, London Borough of Hackney Archives, Museum of London, Susheila Nasta, National Archives, UK, Jaya Nicholas, Nehru Memorial Museum and Libraries, New Delhi, Peter McDiarmid/Rex Features, Redferns, The Royal Pavilion and Museums, Brighton & Hove, Staffordshire County Record Office and Archives, and WireImage.

This book has been supported by the Arts and Humanities Research Council [Grant No.: AH/J003247/1], the World Collections Programme, The Open University, the British Library and Getty Images.

We would like to thank the following individuals who have generously shared their time, ideas and research. In particular Rozina Visram, consultant to this book and the AHRC research project, 'Beyond the Frame: Indian British Connections', for making available her personal collection of books, papers and images; Penny Brook, Lead Curator of India Office Records, John Falconer, Lead Curator Visual Arts, and Rachel Marshall of the British Library; Sean Harry, Caroline Theakstone and Catherine Theakstone at Getty Images; Caitlin Adams, Heather Scott, the English Department and Arts Faculty at The Open University; Sharmilla Beezmohun; Conrad Caspari; Lynn Gaspard, Ashley Biles and James Nunn at Saqi Books; and all individuals who have offered family photographs and helpful advice.

We are also grateful for the many insights provided by the work of Stuart Hall and Paul Gilroy in their companion volume *Black Britain* and the research of many historians including especially, Rozina Visram and Peter Fryer, Ron Ramdin, Michael Fisher, Shompa Lahiri and Peter Bance. Finally, some of the background to this book has been enabled by the collaborative research conducted by the Arts and Humanities Research Council-funded project, 'Making Britain: South Asian Visions of Home and Abroad', led by The Open University from 2007–2010.